Renormalization

Laurie M. Brown
Editor

Renormalization

From Lorentz to Landau
(and Beyond)

With 14 Illustrations

Springer-Verlag
New York Berlin Heidelberg London Paris
Tokyo Hong Kong Barcelona Budapest

Laurie M. Brown
Department of Physics and Astronomy
Northwestern University
Evanston, IL 60208
USA

Library of Congress Cataloging-in-Publication Data
Renormalization: from Lorentz to Landau (and beyond)/edited by
 Laurie M. Brown.
 p. cm.
 Includes bibliographical references.
 ISBN 0-387-97933-6.—ISBN 3-540-97933-6
 1. Renormalization (Physics)—History. I. Brown, Laurie M.
QC174.17.R46R46 1993
530.1'43—dc20 92-32376

Printed on acid-free paper.

Production managed by Bill Imbornoni; manufacturing supervised by Jacqui Ashri.
Typeset by Asco Trade Typesetting Ltd., Hong Kong.
Printed and bound by Edwards Brothers, Inc., Ann Arbor, MI.
Printed in the United States of America.

9 8 7 6 5 4 3 2 1

ISBN 0-387-94401-X Springer-Verlag New York Berlin Heidelberg (softcover)
ISBN 0-387-97933-6 Springer-Verlag New York Berlin Heidelberg (hardcover)
ISBN 3-540-97933-6 Springer-Verlag Berlin Heidelberg New York (hardcover)

Contents

Contributors

Laurie M. Brown
Department of Physics and Astronomy, Northwestern University, Evanston, IL 60208, USA

Tian Yu Cao
Dibner Institute for the History of Science and Technology, Massachusetts Institute of Technology, Cambridge, MA 02139, USA

Max Dresden
Stanford Linear Accelerator Center, Stanford, CA 94309, USA, and Program of the History of Physics, Stanford University, Stanford, CA 94309, USA

Robert Mills
Department of Physics, Ohio State University, Columbus, OH 43210, USA

Silvan S. Schweber
Department of Physics, Brandeis University, Waltham, MA 02154, USA

Dmitri V. Shirkov
Laboratory for Theoretical Physics, Joint Institute for Nuclear Research, Dubna, Russia, and Ludwig-Maximilian-Universität, München, Germany

Introduction: Renormalization. 1930–1950

Laurie M. Brown

1.1. Apologia

This book originated in a session of invited papers that I arranged and chaired at the annual Spring Meeting of the American Physical Society in Washington (D.C.) in April 1990. The session bore the title: *Renormalization. From Lorentz to Landau.* Tom von Foerster, of Springer-Verlag, attended our session and afterwards encouraged us to use it as the basis for a book of essays on the history of renormalization. My task was to edit the papers and to write an introduction to the volume.

At the Washington meeting, a rather continuous history was presented, beginning with Max Dresden's account of problems related to the point electron, both in classical theory and in quantum electrodynamics (QED) in its early days. Silvan S. (Sam) Schweber continued the history through the three "Shelter Island Conferences" of the late 1940s, and Tian Yu Cao discussed the development of more recent attitudes toward renormalization growing out of Kenneth Wilson's scaling viewpoint, according to which renormalization is apotheosized from an unfortunate necessity to a shining virtue. Robert L. (Bob) Mills, gave a masterful "tutorial," in which he demonstrated in a simple and straightforward way, just how renormalization replaces the unmeasurable (and infinite!) charge and mass parameters in the original QED Lagrangian function by the corresponding finite experimental quantities. In a simplified version of the theory, he showed how intrinsic properties of elementary particles and probabilities of occurrence of physical processes can be calculated perturbatively, in such a way that higher order corrections are guaranteed to be finite. That is the essence of the renormalization process.

If the resulting articles had followed the above sequence faithfully, there would have been little for me to do in my introduction but to provide a guided tour, so to speak, through the historical papers, referring the reader to Mills's tutorial for explication of the relevant procedures. However, that was not the case; for while the contributions of Dresden and Mills are, indeed, improved and extended versions of their Washington papers, Schweber and Cao have chosen to emphasize still more recent developments, and to stress the philosophical aspects of renormalization. (They are together writing a more detailed book on the subject.) Thus I have been left with the task of presenting a sketch of the classical (a much overused word!) period of renormalization. I shall arbitrarily assume this period to consist of two main parts: the formation

and the struggle for coherence of QED [and of quantum field theory (QFT) in general], from about 1927 to the end of World War II; and the solution of the problem of the infinities, from 1945 to about 1950.

A detailed treatment of this subject would amount to a complete study of the history of QFT, and of its authors and practitioners, that would go far beyond the scope of this introduction. It would require probing original published and unpublished sources, obtaining fresh interviews, engaging in correspondence, and spending much more time for reflection than I have available for this project. Instead, I must be content with an informal history, based upon upon my present knowledge.

To be sure, I am not totally unequipped to present such an account, since I am generally familiar with the physics literature of this period, and I have published scientific papers using renormalization, including my doctoral thesis, done under Richard Feynman's direction at Cornell University during 1948–50. During that time, I was Hans Bethe's research assistant and published a paper with him on the numerical value of the Lamb shift, a small measured splitting of one of the hydrogen spectral lines that would have been calculated as infinite without the use of renormalization. Bethe's calculation of the Lamb shift, following up a suggestion of Hendrik Kramers, was the first application of renormalization theory. I have also worked as a historian on fundamental nuclear theories of the period 1930 to 1960, and especially on the contributions of the Japanese school, who made important contributions to renormalization theory. Thus I feel that I am justified in setting down this informal and introductory history, based on secondary sources and some primary ones. Aware that a more definitive history is needed, I am confident that it will be supplied in good time by others.

1.2. Quantum Electrodynamics: 1926–1930

The great revolutionary developments in quantum theory during the years 1925 and 1926 began with Wolfgang Pauli's discovery of the exclusion principle for electrons. They encompassed the electron-spin concept of Samuel Goudsmit and George Uhlenbeck, and culminated in the creation of three versions of nonrelativistic quantum dynamics: matrix mechanics (Heisenberg, Born, and Jordan), wave mechanics (de Broglie and Schrödinger), and transformation theory (Dirac). This opened up

vast fields of application of the theory to the properties and dynamics of electron systems, atomic and molecular, and subsequently to a description of the microscopic behavior of all kinds of matter.[1]

Almost simultaneously with those far-reaching investigations, the physicists involved extended their research along other paths, running closely parallel to each other. These extensions were: quantum statistical mechanics of assemblies of identical particles (Bose–Einstein and Fermi–Dirac statistics); Dirac's relativistic wave equation for the electron: and the quantum theory of the electromagnetic field. The field theory that describes the mutual interaction of relativistic electrons and the quantized electromagnetic field is called quantum electrodynamics (QED).

Already in the famous *Dreimännerarbeit* of Max Born, Werner Heisenberg, and Pascual Jordan ("the first comprehensive treatment of the foundations of matrix mechanics," according to Abraham Pais[2]), an attempt was made to quantize the degrees of freedom of the free electromagnetic field, which are infinite in number, and Jordan, especially, continued to work along those lines. However, the invention of QED is properly credited, with all the usual historical qualifications of the word "invention," to Paul Dirac.[3] Dirac carried through the quantization of the radiation field and its interaction with electrons. His new relativistic theory of the electron led him to predict an unexpected particle, the positron, and a new kind of matter, antimatter. It was so brilliant that one of Dirac's friendly young rivals, Werner Heisenberg, felt that it did not pay to compete with him in that area.[4]

In treating the emission and absorption of light from atoms prior to 1927, the so-called semiclassical radiation theory was used. In that approach, the classical radiation field was used, but at a certain stage in the calculation it was interpreted ad hoc to consist of light quanta, i.e., of massless particles, each having a frequency v, energy hv, directed momentum of magnitude hv/c, and a quantized polarization. According to Niels Bohr's frequency condition, a transition between two discrete atomic energy levels is accompanied by the emission or absorption of such a light quantum, or photon. With some care and artistry, it was possible to use these same methods also to calculate continuum processes, such as Compton scattering. The rate of spontaneous emission of light from atoms was inferred from the rate for induced emission, using a relation that Einstein discovered in 1917 in analyzing blackbody radiation.

The view Dirac adopted in 1927 was to regard the free classical electro-

magnetic field, expressed as a superposition of harmonic normal modes (i.e., in Fourier transform representation), as the classical limit of a quantum field. Quantization consisted of replacing the classical normal modes by virtual quantized harmonic oscillators. In the vacuum or "zero state," all the virtual oscillators are in their respective ground states. The excitation of a particular set of oscillators to higher states corresponds to a state of the field containing a number of photons of the types represented by the oscillators. The ith quantized oscillator being excited to its n_ith state was interpreted as meaning the presence of n_i photons of type i.

As Dirac said later, in lectures delivered in Australia

[That such a representation is possible] is a rather remarkable fact, and it forms the basis for the reconciliation of the wave and corpuscular theories of light. If we look on light from the corpuscular point of view, then we have the photons, which are bosons, and they have to be handled according to this general theory of bosons. If we look on light from the wave point of view, the different Fourier components of the waves are harmonic oscillators, and they may be handled by the Fock treatment [involving "raising" and "lowering" operators, that correspond, respectively, to the creation and annihilation of photons]. We see now a connection between these two treatments. We see that an assembly of bosons and a set of oscillators are just two mathematical treatments for the same physical reality. The electromagnetic field may be considered either as an assembly of photons or a set of electromagnetic waves.[5]

Dirac did not expect that his relativistic wave equation for the electron would lead to the prediction of the existence of the positive electron, or positron. The latter arose from his attempt to cure what was considered to be a "disease" of the theory.[6] He rejected the known relativistic equation for spinless particles (the "equation with many fathers," now known as the Klein–Gordon equation), which did not follow directly from Dirac's own transformation theory version of quantum mechanics, and which could not describe a particle with half-integer spin. Instead, he hoped to find the spin and magnetic moment (called "duplexity phenomena" by Dirac) in the course of remedying the "incompleteness of the previous theories lying in their disagreement with relativity, or alternatively, with the general transformation theory of quantum mechanics."[7]

The spin of $\hbar/2$ and the Bohr magnetic moment of the electron did follow immediately, and the theory was successfully applied to previously intractable relativistic problems, notably the relativistic fine structure of the hydrogen atom's spectrum (Sommerfeld formula) and the cross

section for Compton scattering (Klein–Nishina formula). However, the theory as first formulated contained solutions for negative total energy, which in the light of Einstein's mass-energy equivalence appeared non-sensical. States of negative energy are also present in classical relativity theory, but it was argued in that case that although such states are solutions of the equations, they do not occur in nature. An "energy gap" of $2mc^2$ prevents any transition (which classically must be continuous) from a positive energy state to one of negative energy. In contrast to the classical situation, in quantum mechanics jumps to unoccupied states are allowed, and even unavoidable.

Dirac soon argued that the unwanted transitions could also be forbidden in quantum theory, provided that all negative energy states were filled, in which case Pauli's exclusion principle, saying that each state can be occupied by at most one electron, would make transitions to these states impossible. Dirac then showed that an occasional unoccupied negative energy state would behave in all respects as a positive electron. (At first, he guessed that these so-called "holes" in the "sea" of unoccupied states might be protons, but he later identified them as positrons.) Although the "hole theory" picture of Dirac, which involved several electrons or holes at a time, was used successfully well into the 1930s, it was first supplemented, and soon supplanted, by a genuine quantum field theory of electrons and positrons, involving an infinite number of degrees of freedom.

In the first papers on QED, the Coulomb interaction of the electrons was treated separately from the radiation field, and only the latter was quantized. This was unobjectionable from the practical point of view, but the resulting equations were not manifestly relativistically covariant, even though the underlying theory was consistent with relativity. Several attempts were made, beginning in 1929, to correct this deficiency which, while perceived as merely a formal difficulty, at the same time seemed to conceal some major problems.[8] The most important of these papers were those by Heisenberg and Pauli, of which Rudolph Haag has said: "The quantum theory of the Maxwell–Dirac fields, whose equations were written down in the papers mentioned, not only turned out to be extraordinarily successful in its own regime but became the prototype of present-day quantum field theories in all 'high-energy' physics."[9] By their use, the full physical content, as well as the problematic aspects, of QED were exposed.

1.3. The Decade of Struggle: 1930–1940

One of the first of the problems which the newer versions of QED made apparent, as noted by Heisenberg and Pauli, was that the calculated electromagnetic mass of the point-like electron was infinite in quantum theory, just as it was in the classical case.[10] Also, since each of the infinite number of oscillators in the ground or "zero" state of the electromagnetic field (i.e., the vacuum) possessed a zero-point energy, this implied that the vacuum had an infinite energy density. In addition, the hole theory seemed to imply that the vacuum had an infinite negative charge density.

These difficulties of the vacuum state were "solved" by redefinition. The infinite sum of zero-point energies of the electromagnetic vacuum was simply subtracted, and the infinite charge density of the Dirac sea was ignored. By definition, the vacuum is that state where there is nothing to observe. And since the time of Aristotle, at least, philosophers and scientists have not been able to come to a firm decision about whether the physical vacuum is completely empty or completely full, a void or a plenum.[11] The infinite self-mass of the electron was understood to be a vestige of an incomplete *classical* electrodynamics, to be eliminated, perhaps, by reformulating the latter properly, prior to its quantization.

However, not everyone was content with a solution of avoidance. Pauli, the "conscience of physics," as his one-time assistant Victor Weisskopf likes to call him, continually railed against the evil "subtraction physics."[12] And, indeed, it did not really solve the problem. Simply not attempting to calculate the mass of the electron was not sufficient, because the energies of, say, the hydrogen atom are proportional to the electron mass. Hence, in higher approximation, the theory predicts that not only the spectral term energies, but their *observable* differences are infinite. Since QED was essential for the interpretation of high-energy phenomena, especially at cosmic-ray energies, the theory was used in lowest approximation (in terms of modern Feynman graphs, in tree approximation—i.e., without loop integrations). When used with that restriction, it gave excellent results; and this was somewhat surprising, since the theory was bound to fail at *some* higher energy.[13]

In part, the misgivings about the applicability of QED were based on misconceptions. Viewed in a suitable rest frame (that of the collision center of mass), most of the electromagnetic processes observed in the cosmic rays were occurring at interaction energies not higher than those

being investigated with radioactive gamma rays as sources in the nuclear laboratories (e.g., in Paris, Berlin, Cambridge, and Berkeley); and in these laboratory experiments, the predictions of QED were confirmed. This point was made by calculating the radiation probability of fast electrons in the nuclear Coulomb field (bremsstrahlung) by the method of impact parameters. In this procedure, carried out in the rest frame of the electron, the field of the relatively fast nucleus is represented by a superposition of photons. The most representative of these photons, by far, have energies either similar to, or less than, those of radioactive gamma rays.[14]

Another infinity, occurring at low photon energy, arises through the emission of an infinite number of photons during any change in an electron's motion; this was called the *infrared catastrophe*. In 1937 it was diagnosed as being related to the normal radiation of an accelerated classical charge, and thereafter it was regarded as relatively benign, and not a defect of QED per se.[15] While the number of photons emitted is, in fact, infinite, the energy, momentum, and probabilities are influenced by them only in a minor and readily calculable way.

What really established QED as a usable theory of processes at high energy (as well as at the lower energies available in the laboratory) was the calculation of the so-called "shower processes": bremsstrahlung (i.e., continuous x-ray production), pair production by a high-energy photon in the Coulomb field of a nucleus, and electron pair annihilation.[16] These processes were combined in a masterful way to explain the electromagnetic or cascade showers which are responsible for the prevalent soft component of the cosmic rays.[17] At the same time, this successful account of the soft component showed that the other part of the secondary cosmic rays, the hard or penetrating component, had to consist of particles other than electrons.

In contrast to these successes, the gains upon the more malignant infinities were hard-won and limited. These infinities, or divergences as they were often called (since they arose from evaluating nonconvergent integrals) appeared whenever corrections were attempted to the lowest order QED results. In the only available approximation scheme, the perturbation method, probability amplitudes were developed as a power series expansion in the fine structure constant $\alpha = e\hbar/mc \approx 1/137$. After the first nonvanishing term in the expansion, terms of a higher order in α were invariably infinite. These infinities were related either to the self-

mass (or electromagnetic mass) problem, or to the so-called polarization of the vacuum.[18] The latter problem arose because an electric charge perturbed the electrons filling the holes of the Dirac sea, repelling those in its neighborhood, while attracting the positive holes. This screening effect of the dielectric vacuum was predicted by QED to be infinitely strong, so that the finite observable electronic charge implied that the unobservable bare or unscreened charge of the electron would be infinite.

Victor Weisskopf has described how, at Pauli's request, he calculated the self-energy of the electron in the positron theory.[19] The calculation involved the virtual emission and recapture of a photon by the electron, which is different in the hole theory and in the one-electron theory, because in the former the filled negative energy states are forbidden by the Pauli principle as possible virtual intermediate states for the electron. In the one-electron theory, the divergence was quadratic (i.e., the mass increased with the square of a cutoff parameter introduced to make the integral over all possible virtually emitted photons finite). By contrast, in the positron theory, the divergence was only logarithmic, and therefore relatively insensitive to the value of the cutoff parameter.[20]

The problem of vacuum polarization was treated by a number of authors. Heisenberg found that it had no observable effects for external fields that were constant in time.[21] However, it gives rise to an unexpected nonlinearity in the theory that permits, for example, the scattering of light by light—something impossible in the classical Maxwell theory.[22] In addition to giving rise to an infinite correction to the charge of the electron, the vacuum polarization, i.e., the virtual electron–positron pairs produced in vacuum by a photon, also produces an infinite self-mass of the photon.[23] Here the theory shows an especially puzzling inconsistency, for *any* photon mass, finite or infinite, contradicts the gauge invariance of the theory. Even after the renormalization theory of the 1940s showed how to calculate finite energy shifts and probabilities, this induced photon mass remained problematic.

In the latter part of the 1930s, there was a great interest in formulating quantum field theories for particles of various spins and with different forms of interaction potentials. In part, this was a study of "model" theories, in an effort to gain a better understanding of the formalism; such was the relativistic spinless particle theory of Pauli and Weisskopf of 1934. In part, it was an attempt to make theories of the weak and strong nuclear forces; such was the theory of Fermi of the nuclear β

decay, applied by Heisenberg and others to the strong nuclear interaction. The discovery in 1937 of a new charged particle of mass intermediate between that of the electron and the proton, called the mesotron, drew attention to a theory of nuclear forces that had been proposed two years earlier by Hideki Yukawa. The result was an upsurge of interest in quantum field theories of all types. After a brief period of optimism, it was discovered that all of these theories had at least as many and severe divergence difficulties as QED. As had happened before, some welcomed the challenge and were not displeased at the thought that a really fundamental reordering of physical concepts would be required in order to make further progress.[24]

Field theories other than QED had presented some novel features (see Wentzel 1943). For example, in the Pauli–Weisskopf scalar charged particle theory, unlike the positron theory, all the states had positive energy; but corresponding to the conserved probability current of the Dirac field, there was a conserved electric charge current in the Pauli–Weisskopf theory. The probability current was, as expected, positive definite, but the Pauli–Weisskopf electric current could take either sign, depending on the sign of the charges carrying the current. As a consequence, pairs of antiparticles could be produced in the scalar theory, without the need (or, indeed, the opportunity) for holes. Pauli was very pleased with this "anti-Dirac" theory, which soon found application as a candidate theory of mesons, charged bosonic particles proposed in 1934 by Hideki Yukawa as the quanta of the nuclear forces.[25]

Earlier than this, in trying to utilize the Fermi theory of β decay as a theory of strong interactions, letting an electron–neutrino pair be exchanged between nuclear particles, Heisenberg found strongly divergent behavior at high energy. But he noted that unlike the case of QED, whose coupling strength is characterized by the dimensionless (and small) fine structure constant α, the corresponding Fermi coupling constant has the dimensions of the fourth power of a length. While the fine structure constant, being dimensionless, cannot provide any scale of distance or energy, the Fermi constant can and does do so. As a result, Heisenberg argued there is a characteristic length δ within which distance perturbation theory breaks down (or, equivalently, for interacting particles with de Broglie wavelengths shorter than δ). Heisenberg maintained that predictions of divergent behavior at high energy, which do not take this new fundamental length into account, should be discounted. Thus he rejected

criticisms of the Fermi field theory of nuclear forces that were based upon this divergence.[26]

Finally, several versions of the meson theory appeared in 1937, after charged particles were observed in the cosmic rays, resembling those whose existence had been conjectured by Yukawa. These theories, however, were characterized by coupling strengths which were so large that perturbation methods were clearly inapplicable, and new approximation methods were sought to deal with them. For example, Gregor Wentzel proposed a theory of strong coupling, in which the field theoretical amplitudes were developed in a series of *falling* powers of the coupling constant.[27] Soon afterwards, Sin-itiro Tomonaga modified this method so that it would be applicable to actual meson–nucleon couplings, of the order of unity, the so-called intermediary coupling method.[28]

While some physicists thought that the divergence problems of QED would be solved if nonperturbative solutions could be found, others thought the solution would be found in a more satisfactory reformulation of classical theory, prior to its quantization. The most important exponents of the latter view were Dirac and Hendrik A. Kramers.

A relatively simple problem, the radiative corrections to the scattering of a relativistic electron from a scalar potential, attracted some interest from theorists in 1939, while much of the world was preparing for the imminent war. (This elastic scattering process would become important after the war, when it was reexamined in Japan as a test problem for methods newly developed there, and after new precise experiments on QED in America forced its reconsideration.) In early 1939, attempts were made to extend to higher energy photons the method of unitary transformation on the Hamiltonian that Bloch and Nordsieck had used to solve the infrared divergence difficulty. In contrast to this, S. M. Dancoff used a more straightforward perturbation approach, being careful about the treatments of the initial and final states, and obtained a rather surprising *finite* result when he used the Pauli–Weisskopf theory of spinless particles to describe the scattered particle.[29] For the Dirac electron theory, however, Dancoff reported that the vacuum-polarization contribution gave a logarithmic divergence. After the war, a Japanese group, headed by Sin-itiro Tomonaga, found the last result to be in error. A correct calculation by Dancoff would have given a finite result, and the history of renormalization, as Tomonaga was later to remark, would have been very different. The Lamb shift and the anomalous magnetic moment of the electron would have followed from a correct calculation.

1.4. The Triumph of Renormalization: The 1940s

The modern covariant formulation of QED and its vindication via re-normalization received major impetus at a conference in June 1947, held at Shelter Island, New York. The proximate cause for the new attention to QED was the presentation at Shelter Island of new experimental results, which cried out for interpretation. As it turned out, most of those who brought about this minor revolution, experimentalists and theorists both, could trace their involvement in the QED problems and solutions to their wartime experiences. (Prominent exceptions to the above rule were Hans Bethe and Kramers, who had been involved with the subject much longer.)

Although there had been important attempts to reformulate QED more suitably, especially by Tomonaga, Julian Schwinger, and Richard Feynman, who eventually shared the Nobel Prize in 1965 for their theoretical solutions, what riveted new attention on this issue were some *experiments* done at Columbia University by Willis Lamb, Jr. and Polykarp Kusch, who shared the Nobel Prize in Physics in 1955, and their associates. Both Lamb and Kusch were actively involved during the war in the microwave techniques instrumental in the development of radar, and both used the molecular beam techniques pioneered at Columbia by I. I. Rabi.

Lamb, trained as a theorist under Robert Oppenheimer, became inter-ested in a reported anomaly in the fine structure of the spectrum of hydrogen,[30] and thought it might be related to a QED modification of the Coulomb field of the proton, a subject on which he had written both his theoretical Ph.D. thesis and other works. With his associate, Robert Retherford, Lamb developed several new and ingenious techniques, using microwaves and other innovative means, to accurately measure a tiny difference in energy between two excited states of the hydrogen atom (the $2S_{1/2}$ and $2P_{1/2}$ states), which the electron theory of Dirac predicted should be exactly zero.[31] This finite nonzero energy difference was dis-cussed at the Shelter Island conference, where it was generally thought to be a higher order QED effect, i.e., a radiative correction, the kind of correction that always seemed to lead to divergent integrals. At the same conference, other experimental results of the Columbia group were re-ported, suggesting that the magnetic moment of the electron also differed slightly from that predicted by the Dirac theory.[32]

These new experiments were highly provocative, and those present

listened attentively to a talk by Kramers (who was, in accordance with the intentions of the conference organizers, the only "foreigner" present, although many of the participants had European backgrounds). According to Max Dresden, Kramers' talk was to a large extent a criticism of the existing QED, but he also presented his own earlier reformulation of QED, one that had been generally neglected.[33] Dresden wrote: "... Kramers analysis of the self-energy problem led to the prediction that there would be energy shifts in the energy spectrum of atomic systems, such as the hydrogen atom, from the values predicted by the Dirac theory."[34] That is, he stressed that the subtraction of the infinite self-energy would leave different nonzero remainders in the energies of the different atomic states. Bethe, apparently, listened to Kramers' difficult talk with special care, for soon after the conference he used Kramers' idea to calculate the energy level "shift" measured by Lamb and Retherford, and found good agreement with the measured value.[35]

Both Schwinger and Tomonaga have said that they were influenced early in their careers by a reformulation of QED by Dirac in 1932, and further developed by him with V. A. Fock and B. Podolsky.[36] In considering the interaction of several electrons with the electromagnetic field, Dirac introduced a state function which depended upon the space-time variables of each electron, rather than upon their space variables and a single common time, as is the usual practice in the Hamiltonian formalism. Dirac and his collaborators proved that their theory was equivalent to the Heisenberg–Pauli formulation, but it provided the advantage of an apparent uniform treatment of space and time variables, as required by the special theory of relativity. Tomonaga, in 1942, extended this formalism to the case where the electrons, as well as the photons, are described by a quantum field. Since the fields have an infinite number of degrees of freedom, this required the specification of an infinite number of times (actually, a time for every space point). The extension from a many-time to a super-many-time theory, as Tomonaga called it, turned out to pose no special difficulty.[37]

Tomonaga had spent two years in Leipzig with Heisenberg, leaving just before the outbreak of war in 1939, and said that he had learned from Heisenberg to appreciate the importance of "field reaction" in quantum field theory, i.e., the effect of a field upon its own source. Tomonaga was, therefore, very interested in the proposal made by another Japanese physicist, Shoichi Sakata, that another conjectured field (which he called

the cohesive force, or C-meson field) might interact with the electron and produce a negative infinite electron mass correction to compensate the positive infinite mass produced by the electromagnetic field.[38] (The same idea was proposed independently by Abraham Pais, who was influenced by Poincaré's proposal, early in the century, of a new field to stabilize the classical electron.) In trying to carry through Sakata's suggestion, Tomonaga, who had formed a group of students and associates to carry out his program for a completely covariant QED based upon super-many-time theory, turned again to the elastic scattering problem as studied by Dancoff. The Japanese group discovered an error in Dancoff's paper of 1939, and they found that the result was finite—without needing the C meson.

After further consideration of the elastic scattering and other processes, they found that all the infinities could be removed by suitable covariant subtractions. As Tomonaga said in his Nobel Lecture:

In this way the nature of the various infinities became fairly clear. Though I did not describe here the infinity of vacuum polarization type, this too appears in the scattering process.... However, Dancoff had already discovered that this infinity could be amalgamated into an apparent change in the electronic charge. To state the conclusion, therefore, all infinities appearing in the scattering process can be attributed either to the infinity of the electromagnetic mass or to the infinity appearing in the electronic charge—there are no other divergences in the theory.[39]

Thus, while the results on renormalization in America were driven by the experimental anomalies reported by the Columbia University groups, the Japanese school independently solved the problem with purely theoretical motivation. After they read about the Columbia experiments (in newsmagazines, e.g., *Time*—for scientific journals were not available in Japan so soon after the war), they calculated what they would have expected from the experiments, and obtained numerical results in agreement with the observations.[40]

Schwinger has traced his interest in reformulating QED covariantly to 1932 when, at the age of 16, he wrote an unpublished paper extending the many-time theory of Dirac, Fock, and Podolsky.[41] During the war, Schwinger worked on the theory of microwave devices used in radar. (Coincidentally, so did Tomonaga in Japan.) Having attended the 1947 Shelter Island Conference, where he was an invited participant but not one of the speakers, afterwards he soon calculated the radiative correc-

tion to the magnetic moment of the electron, to try to explain the deviation from the Dirac moment $eh/2mc$ that was implied by the experiments reported by Rabi at the meeting.[42] Schwinger's theoretical result was remarkably simple and accurate: namely, the moment was increased by the factor $(1 + \alpha/2\pi)$.

In pursuing the magnetic moment anomaly, Schwinger also calculated completely the first radiative correction to potential scattering, i.e., he solved Dancoff's problem, the so-called radiationless scattering problem, and he obtained a *finite* result for the spin 1/2 case.[43] His result was correct, but he was well aware of the ambiguity involved in subtracting one infinity from another. However, Schwinger felt that it could be mitigated (and other possible ambiguities also avoided) by a completely, or in his language, manifestly covariant calculation—i.e., one that would be relativistically covariant at each step of the calculation. His relativistically covariant formulation, like that of Tomonaga, involved doing the field quantization on a general space-like surface, which is the covariant generalization of a plane of constant time in four-dimensional space-time. Schwinger later said that "... all that was in place at the New York meeting [in January 1948]. I must have made a brief reference to these covariant methods; the typed copy contains such an equation on another back page, and I know that Oppenheimer told me about Sin-itiro Tomonaga after my lecture."[44]

Feynman has presented an entertaining account of the eight years of work leading up to his solution of the divergence problems of QED in 1947 in his Nobel Lecture.[45] Schweber has given an excellent, detailed, and scholarly treatment of Feynman's work during this period (Schweber 1986a). Although the importance of Feynman's diagrammatic methods for solving problems in quantum field theory (as well as in quantum statistical mechanics) extends far beyond issues of renormalization, we must be content here with a brief summary of the steps leading to his solution of the latter problem.

When Feynman arrived at Princeton in the fall of 1939 and began his graduate work in physics under the direction of 27 year old assistant professor John Wheeler, he had the idea that the infinite self-energy of the electron could be reduced to zero, simply by reformulating electrodynamics so that the field produced by the electron did not interact with the electron itself. One way to do that would be to consider *only* the interactions between charged particles as fundamental, by expressing

electrodynamics as a theory of delayed action at a distance. That procedure would reduce the electromagnetic field to an auxiliary construction —one that was useful, but without fundamental significance.[46]

Feynman made this bold suggestion to Wheeler, but the latter pointed out that without self-interaction there would be no radiative reaction, so that a radiating charge could not lose energy or conserve momentum. However, Wheeler later suggested that this problem could be avoided, at least in classical electrodynamics, by replacing the interaction, which is normally delayed because of the finite velocity of light, by an interaction that was half-advanced and half-retarded. That kind of interaction had been known as a possible solution of the Maxwell differential equations, but it was rejected as unphysical, because advanced physical effects are never observed. Wheeler and Feynman showed that this difficulty can be circumvented by assuming the presence of sufficient absorbing material (essentially the whole universe), whose advanced effect on the source would, as it turned out, provide just the right amount of radiative reaction, acting at the right time.[47]

To create an analogous quantum theory, Feynman realized that the Hamiltonian method, on which the standard quantum field theory was based, should be replaced, as it was not suitable for keeping track of several particles having their own separate time variables. To do so, he developed his path-integral method, based upon the Lagrangian density, or more precisely, its space-time integral, the "action," which is a relativistically invariant function. In this way, he calculated the overall probability amplitude (whose absolute square is a probability) for a transition between given initial and final states, without explicitly solving the differential equations governing the process. Feynman liked to say that he preferred to emphasize, not the equations, but their solutions. In most respects equivalent to the usual formulation, this had several advantages. It was possible to "integrate out" the variables describing the field degrees of freedom (the "oscillators"), leaving only the particle variables. This new mathematical approach to quantum theory was described in Feynman's Ph.D. thesis, done under Wheeler's tutelage.

Although the examples treated in the thesis were mainly from nonrelativistic quantum mechanics (later published in a review article[48]), the path-integral method could be generalized to be completely relativistic, with the initial and final conditions replaced by boundary conditions on a closed space-time region. (Tomonaga and Schwinger had arrived at

the same boundary conditions, but using other reasoning.) Also, in QED, it permitted the representation of positrons as electrons "moving backward in time." Together, these advantages allowed Feynman to develop his diagrammatic method for quantum fields a few years later.

However, it was the Wheeler–Feynman idea of delayed action at a distance and the rejection of the field concept that were uppermost in Feynman's mind when he joined the faculty and began to do research at Cornell University in the fall of 1946, after leaving his wartime work at Los Alamos (to which work, incidentally, he never returned). Using the principle of least action to define the classical electromagnetic interaction, he devised a relativistically invariant modification of the interaction, a "softening" that avoided the infinite self-mass. That meant the introduction of an arbitrary function and a new parameter, the cutoff. As the cutoff approached infinity, the theory became identical with the standard theory. However, with the cutoff set at an arbitrarily large, but finite, value it was never necessary to deal with infinite quantities. This method, applied in the quantum field theory, was later called "regularization." It is analogous to rigorous methods used by mathematicians to define otherwise divergent sums or integrals (called "summability" or "integrability" methods, respectively).

The new methods for QED, including the mass renormalization, were discussed at a second conference of the Shelter Island series (at Pocono Manner Inn, March 30 to April 1, 1948). Both Feynman and Schwinger gave oral reports, and came to know and appreciate each other's ideas through informal discussions. Their presentations were not, however, particularly successful in convincing the other physicists present (Schweber 1986a and 1986b).

One of the difficulties arose in connection with the problem of the self-mass, not of the electron, but of the photon. According to the electromagnetic principle of gauge invariance (requiring a degree of arbitrariness in the relation between the electromagnetic fields and the potential functions from which they can be derived), the mass of the free photon was necessarily zero, but corrections to the mass of a propagating photon, due to fluctuations of the vacuum field producing virtual electron–positron pairs with which the photon could interact, gave rise to a correction to the "bare" photon mass which was infinite! The same effect, called *vacuum polarization* also entered into a correction to a particle's effective electric charge. It also became necessary to renormalize this

charge, which entered in all higher order perturbation calculations, including that of the Lamb shift.

This well-measured shift of the low lying energy levels of hydrogen and helium became the testing ground for the new theories of renormalization. Bethe's nonrelativistic calculation, with an *arbitrary* cutoff of virtual transitions at relativistic energies, correctly gave the bulk of the effect. What was at stake was a relativistic extension of Bethe's result, eliminating the cutoff. This was successfully accomplished independently by a number of physicists in America and by Yoichiro Nambu in Japan, once the idea of covariant renormalization became generally accepted.[49]

A significant contribution to the Lamb shift comes from the vacuum polarization (40 megacycles out of about 1040). The presence of this contribution convinced Feynman that the vacuum fluctuations were real, and therefore that the electromagnetic field itself was a real entity, and not merely a theoretical construction. Based on the delayed action at a distance hypothesis, he had been willing to consider the photon mass difficulty as an artifact of the field viewpoint, which he had been willing to abandon. He realized at that point that he should learn to express his ideas in the language of operator fields that the other theorists had been using.

The first period of successful renormalization can be said to have closed with two papers by the young English physicist, Freeman Dyson, a graduate student of Bethe at Cornell, who was able to synthesize the results obtained by Tomonaga, Schwinger, and Feynman.[50] In particular, Dyson showed that Feynman's QED was entirely equivalent to the more conventional quantum theory employed by the other two, and he systematized Feynman's method, showing how to construct the Feynman diagrams for processes of arbitrarily high order in perturbation theory and thus, in principle, how to study the corresponding mathematical expressions. He proved (or, to be precise, set up the framework for a proof, later completed) that the renormalizations of mass and charge would guarantee the finiteness of QED correction to any finite order of perturbation theory, though it would not guarantee the convergence of the infinite sum.[51] Dyson's papers were so influential that the diagrams used in quantum field theory are often called Feynman–Dyson graphs.

It would be inappropriate to conclude this brief account of the "classical period" of renormalization without mentioning a parallel (and often seminal) line of development associated with Ernest Carl Gerlach

Stueckelberg of the University of Geneva, Switzerland. He was responsible for many timely innovations in theoretical physics, including his use of the action principle formulation of classical mechanics as applied to electrons, in which electrons with "backward-moving" paths in space-time are interpreted as positrons.[52] This idea takes on great importance in Feynman's diagrammatic representation of Green's functions and S-matrix elements. Indeed, according to Dyson, "Stueckelberg anticipated several features of the Feynman theory, in particular the use of the function D_F (in Stueckelberg's notation D_C) to represent retarded (i.e., causally transmitted) electromagnetic interactions."[53]

The paradigm of renormalizable QED became such a powerful influence that renormalizability of a quantum field theory became elevated (e.g., by Dyson) to be a selective principle. Theories that were unrenormalizable were rejected as candidates for fundamental theories, although they might provide acceptable and useful phenomenology. In the case of the meson theories of nuclear forces, where large coupling constants precluded the use of perturbative expansions, thus making the renormalization even of renormalizable theories impractical, quantum field theory itself was soon abandoned entirely and replaced by dispersion relations, and the S-matrix approach, in which transition amplitudes were expressed in terms of asymptotically free states (Cushing 1990).

At the present time, the so-called Standard Model of elementary particle theory is based on quantum fields that are generalizations of Yang–Mills gauge fields. But Cao and Schweber point out, in their chapters of this book, that the Standard Model is, in some learned circles, viewed as an "effective" scale-dependent theory, which is neither final nor fundamental in any absolute sense. (Indeed, Cao says it resembles the attitude that Schwinger expressed in formulating his "Source Theory.") Cao and Schweber write that this renunciation of a complete scale-independent description is an important shift in philosophical outlook.

Perhaps, however, it may be more accurately described as a shift in the conventional viewpoint. Certainly, the earlier workers in renormalized QED were well aware that they were "ignoring other physics" when they took the renormalization "constants" to infinity. They knew, for example, that they were not including virtual pairs of muons and baryons (even of uranium nuclei)—and later, quarks, etc.—and that weak and strong nuclear interactions would enter significantly in any process at some level of energy and/or accuracy. Thus, while renormalizability as a selective

principle might have had some esthetic appeal, it made little sense to *require* it of theories that were intended to describe a limited range of experience.

Editor's note. After the completion of the text of this book, we had the good fortune to obtain the collaboration of Professor Dmitri V. Shirkov of Moscow University and the Joint Institute for Nuclear Research, Dubna, who has kindly supplied an Appendix on the history of the renormalization group, certainly one of the most important applications of the idea of renormalization. When I was discussing his contribution with Professor Shirkov in Munich, where we were both visiting at the time, he asked why we had chosen the subtitle for this book—and, in particular, the phrase "Landau and beyond." It occurred to me then that we have not explained this in the book, so I will do so now.

During the period 1954–58, Lev Landau and his collaborators at the Institute for Physical Problems in Moscow (including A. A. Abrikosov, I. M. Khalatnikov, I. Ya. Pomeranchuk, and others) obtained high-energy "asymptotic" results for the effective mass and charge of the electron in terms of their usual (low-energy) observed values, using certain limiting procedures and a general covariant gauge.[54] On the basis of these results, they made critical remarks concerning the validity of QED.

In particular, the expression they obtained for the effective charge $e_1(k^2)$ had a behavior for large momentum transfer **k** which they interpreted as implying a complete breakdown of QED at an energy at which the gravitational interaction energy (of a smeared-out charge) becomes comparable in strength to the electromagnetic (about 10^{28} eV). Above this energy there arose even the possibility of $e_1^2 < 0$, implying a "ghost" or "indefinite metric." This became known as the "zero charge" or Landau ghost problem. Thus the significance of "Landau (and beyond)" in our subtitle refers to this attack on the legitimacy of QED and on renormalized field theory in general. (Of course, these arguments do not apply at all to an "asymptotically free" field theory like QCD, but such theories were not known at the time.)

Using renormalization group methods, Bogoliubov and Shirkov obtained results comparable to and going beyond those of the Landau group. However, they emphasized that the approximate nature of the results (both Landau's and theirs) meant that they coud not provide any

evidence bearing on the internal consistency of QED.[55] Thus, we have gone beyond the Landau criticisms.

Notes

1. For an extensive history of the development of quantum theory, see Mehra and Rechenberg 1982+.
2. Pais 1986, p. 254.
3. Dirac's first paper on QED: "The quantum theory of the emission and absorption of radiation," *Proc. R. Soc. London Ser. A* **114** (1927), pp. 243–265, reprinted as Paper 1 in Schwinger 1958. Dirac's equation for the electron: "The quantum theory of the electron," *Proc. R. Soc. London Ser. A* **117** (1928), pp. 610–624.
4. C. F. von Weizsäcker, in L. M. Brown and H. Rechenberg, "Paul Dirac and Werner Heisenberg, a partnership in science," in Kursunoglu and Wigner 1987, pp. 117–162. especially p. 117.
5. Dirac 1978, p. 26. See also J. Bromberg, "Dirac's quantum electrodynamics and the wave-particle equivalence" and P. A. M. Dirac, "Recollections of an exciting era," in Weiner 1977.
6. See Moyer 1981, especially p. 1055ff., for "magic and sickness" characterizations of Dirac's theory.
7. Note 3, "The quantum theory of the electron," p. 610.
8. W. Heisenberg and W. Pauli, "Zur Quantendynamik der Wellenfelder," *Z. Phys.* **56** (1929), pp. 1–61 and *ibid.* **59** (1930), pp. 168–190, reprinted in Heisenberg 1989. See also Enrico Fermi, "Sopra l'elletrodinamica quantistica," *Rend. della R. Accademia Nazionale dei Lincei* **12** (1930), pp. 431–435; P. A. M. Dirac, V. A. Fock, and Boris Podolsky, "On quantum electrodynamics," *Phys. Z. Sowjetunion* **2** (6) (1932), pp. 468–479; reprinted as Papers 2 and 3 in Schwinger 1958.
9. Heisenberg 1989, p. 3. Many physicists found that an equivalent but simpler formulation by Enrico Fermi made the theory more accessible: Fermi 1932.
10. Note 8. See also J. R. Oppenheimer, "Note on the interaction of field and matter," *Phys. Rev.* **35** (1930), pp. 461–477; I. Waller, "Bemerkungen über die Rolle der Eigenenergie des Elektrons in der Quantentheorie der Strahlung," *Z. Phys.* **62** (1930), pp. 673–676.
11. In the current Standard Model of elementary particle interactions, an essential role is played by "spontaneous symmetry breaking" of the vacuum electroweak field, which suggests that the current view of the vacuum is that it is a plenum. Similarly, the curved and active space-time of general relativity theory is hardly a void. For an historical discussion, see L. M. Brown and T. Y. Cao, "Spontaneous breakdown of symmetry," *Historical Studies in the Physical and Biological Sciences* **21** (2) (1991), pp. 211–236. For its philosophy, see Saunders and Brown 1991.
12. Dozens of references to "subtraction physics" can be found in the index of Pauli 1985.

13. See Robert Serber on Robert Oppenheimer's "conviction that quantum elec-trodynamics was wrong ... Oppie at first disbelieved at mc^2 (the rest energy of the electron), then retreated to 137 mc^2." R. Serber, "Particle physics in the 1930s: A view from Berkeley," in Brown and Hoddeson 1983, pp. 206–221. For a discussion of QED and the cosmic rays, see the introduction to the same volume, especially pp. 13–16. Also see: D. C. Cassidy, "Cosmic-ray showers, high-energy physics, and quantum field theories," *Historical Studies in the Physical Sciences* **12** (1981), pp. 1–39; P. Galison, "The discovery of the muon and the failed revolution against quantum electrodynamics," *Centaurus* **26** (1983), pp. 262–316; L. M. Brown and H. Rechenberg, "Quantum field theories, nuclear forces, and cosmic rays (1934–1938)," *Am. J. Phys.* **59** (1991), pp. 595–605.

14. E. J. Williams, "Nature of the high-energy particles of penetrating radia-tion formulae," *Phys. Rev.* **45** (1934), pp. 729–730; C. F. von Weizsäcker, "Ausstrahlung bei Stössen sehr schneller Elektronen," *Z. Phys.* **88** (1934), pp. 612–625.

15. F. Bloch and A. Nordsieck, "Note on the radiation field of the electron," *Phys. Rev.* **52** (1937), pp. 54–59.

16. H. Bethe and W. Heitler, "On the stopping of fast particles and on the creation of positive electrons," *Proc. R. Soc. London Ser. A* **146** (1934), pp. 83–112. See also Heitler 1936.

17. H. J. Bhabha and W. Heitler, "The passage of fast electrons and the theory of cosmic showers," *Proc. R. Soc. London Ser. A* **159** (1937), pp. 432–445; J. F. Carlson and J. R. Oppenheimer, "On multiplicative showers," *Phys. Rev.* **51** (1937), pp. 220–231; L. Landau and G. Rumer, "The cascade theory of elec-tron showers," *Proc. R. Soc. London Ser. A.* **166**, pp. 213–228.

18. That a careful subtraction of the mass and charge divergences would suffice to remove *all* the divergences of observables in QED in each order of pertur-bation theory was essentially shown in the late 1940s by Freeman Dyson.

19. V. F. Weisskopf, "Growing up with field theory: The development of quantum electrodynamics," in Brown and Hoddeson 1983, pp. 56–81.

20. Weisskopf (in Note 19) related that the logarithmic result only emerged after a letter from the American physicist Wendell Furry corrected an error in Weisskopf's first published result.

21. W. Heisenberg, "Bemerkungen zur Diracschen Theorie des Positrons," *Z. Phys.* **90** (1934), pp. 209–231. See also the annotation of A. Pais in Heisenberg 1989, pp. 95–105.

22. H. Euler, "Über die Streuung von Licht an Licht nach Diracschen Theorie," *Ann. Phys.* **21** (1936), pp. 398–448.

23. In Heisenberg's version of QED (Note 21), the photon mass was found to diverge logarithmically in lowest order; later the divergence was found to be quadratic.

24. For example, Heisenberg wrote to Pauli on 5 April 1938: "It was interesting to me that both Bhabha and Heitler obtain [an infinite expression at small separation] for the force between neutron and proton. Such a term means, of course, that the mass defect of the neutron is infinite, or more correctly, that it

depends on the kind of high-frequency cutoff. This result is very sympathetic to me, because it shows again that one cannot proceed further without introducing a universal length." Pauli 1985, p. 563.

25. G. Wentzel, "Quantum theory of fields (until 1947)," in Fierz and Weisskopf 1960, pp. 48–77; also reprinted in Mehra 1973.

26. W. Heisenberg, "Die Grenzen der Anwendbarkeit der bisherigen Quantentheorie," Z. Phys. **110** (1938), pp. 251–266.

27. G. Wentzel, "Zur problem des statischen Mesonfeldes," Helv. Phys. Acta **13** (1940), pp. 267–308.

28. S. Tomonaga, "Zur Theorie des Mesotrons. I," Sci. Papers Inst. Phys. Chem. Res. **40** (1941), pp. 247–266.

29. S. M. Dancoff, "On the radiative corrections for electron scattering," Phys. Rev. **55**, pp. 959–963.

30. W. V. Houston, "A new method of analysis of the structure of H_α and D_α," Phys. Rev. **51** (1937), pp. 446–449.

31. W. E. Lamb, Jr. and R. C. Retherford, "Fine structure of hydrogen by a microwave method," Phys. Rev. **72** (1947), pp. 241–243.

32. J. E. Nafe, E. B. Nelson, and I. I. Rabi, "The hyperfine structure of atomic hydrogen and deuterium," Phys. Rev. **71** (1947), pp. 914–915. More accurate results were given later in H. Foley and P. Kusch, "On the intrinsic moment of the electron," Phys. Rev. **73** (1948), p. 412.

33. See Schweber 1986 and Dresden 1987, Chap. 16. Kramers reformulation was given in Kramers 1938.

34. Dresden 1987, p. 388.

35. H. A. Bethe, "The electromagnetic shift of energy levels," Phys. Rev. **72** (1947), pp. 339–341.

36. P. A. M. Dirac, V. A. Fock, and B. Podolsky, Note 8. Schwinger has written about his own contributions to QED, as well as Tomonaga's, in Brown and Hoddeson 1983: "Renormalization theory of quantum electrodynamics: An individual view," pp. 329–353 and "Two shakers of physics: Memorial lecture for Sin-itiro Tomonaga," pp. 354–375. He has also given a memorial lecture for Feynman: "A path to quantum electrodynamics," Physics Today, Feb. 1989, pp. 42–48 and in Brown and Rigden 1993.

37. S. Tomonaga, "On a relativistically invariant formulation of the quantum theory of wave fields," Prog. Theor. Phys. (Kyoto) **1** (1946), pp. 27–42. This is the English translation of a paper that had appeared in Japanese in 1943 in the journal Riken-iho.

38. S. Sakata and O. Hara, "The self-energy of the electron and the mass differences of nucleons," Prog. Theor. Phys. **2** (1947), pp. 30–31. See Tomonaga's Nobel Lecture: "Development of quantum electrodynamics—Personal recollections" in Nobel Lectures Physics, 1963–1970 (1972), pp. 126–136, New York: Elsevier. Also reprinted in Mehra 1973.

39. Nobel Lecture, Note 38.

40. For the work of the Tomonaga school, see Brown et al. 1988.

41. See Note 8 for Dirac et al. and Note 36 for Schwinger, p. 329.

42. Note 31. J. Schwinger, "On quantum electrodynamics and the magnetic moment of the electron," *Phys. Rev.* **73** (1948), pp. 400–402. This paper, and many of the others referred to are reprinted in Schwinger 1958.

43. J. Schwinger, "On radiative corrections to electron scattering," *Phys. Rev.* **75** (1948), pp. 898–899.

44. J. Schwinger, Note 36, pp. 329–353, especially p. 336.

45. R. P. Feynman, "The development of the space-time view of quantum electrodynamics," *Physics Today*, August 1966, pp. 31–44.

46. My language here attempts to avoid the issue of what is "real."

47. J. A. Wheeler and R. P. Feynman, "Interaction with the absorber as the mechanism of radiation," *Revs. Mod. Phys.* **17** (1945), pp. 157–181. Advanced and retarded potentials had been used by Fokker, who also wrote an action at a distance action principle: A. D. Fokker, "Eine invarianter Variationsatz für die Bewegung mehrerer elektrischer Massenteilchen," *Z. Phys.* **58**, pp. 386–393.

48. R. P. Feynman, "Space-time approach to nonrelativistic quantum mechanics," *Revs. Mod. Phys.* **20** (1948), pp. 367–387.

49. See Weisskopf, Note 19, for the interaction among the four American calculations. Also, see Y. Nambu, "The level shift and the anomalous magnetic moment of the electron," *Prog. Theor. Phys.* **4** (1949), pp. 82–94.

50. F. Dyson, "The radiation theories of Tomonaga, Schwinger, and Feynman," *Phys. Rev.* **75** (1949), pp. 486–502; "The S-matrix in quantum electrodynamics," *ibid.*, pp. 1736–1755.

51. It is perhaps worth stressing that, up to this point, renormalizability was a feature of the perturbation approximation to the field theory problem, and it was not until later considered to be a criterion for the validity of the theory itself.

52. E. C. G. Stueckelberg, "La mécanique du point matériel en théorie de relativité et en théorie des quanta," *Helv. Phys. Acta* **23** (1942), pp. 23–37.

53. F. J. Dyson, "The S matrix in quantum electrodynamics," Note 50, footnote 5.

54. L. M. Brown and H. Rechenberg, "Landau's work on quantum field theory and high-energy physics," in Gotsman et al. 1990, pp. 67–72. Of the many papers on this subject by the Landau school, we cite here only two review articles in English: Landau 1955, Landau et al. 1956.

55. Bogoliubov and Shirkov 1958, p. 394.

References

Bogoliubov, N. N. and D. V. Shirkov (1958), *Introduction to the Theory of Quantized Fields*, New York: Wiley.

Brown, L. M. and L. Hoddeson, eds. (1983), *The Birth of Particle Physics*, Cambridge: Cambridge University Press.

Brown, L. M. and J. S. Rigden, eds. (1993), *"Most of the Good Stuff,"* New York: American Institute of Physics.

Brown, L. M., R. Kawabe, M. Konuma, and Z. Maki, eds. (1988), *Elementary Particle Theory in Japan, 1935–1960*, Kyoto: Research Institute for Fundamental Physics.

Cushing, J. T. (1990), *Theory Construction and Selection in Modern Physics*, Cambridge: Cambridge University Press.

Dirac, P. A. M. (1978), *Directions in Physics*, New York: Wiley.

Dresden, M. (1987), *H. A. Kramers: Between Tradition and Revolution*, New York: Springer-Verlag.

Fermi, E. (1932), "Quantum theory of radiation," *Rev. Mod. Phys.* **4**, pp. 87–132.

Fierz, M. and V. F. Weisskopf, eds. (1960), *Theoretical Physics in the Twentieth Century*, New York: Interscience.

Gotsman, E. A., Y. Ne'eman, and A. Voronel (1990), *Frontiers of Physics*, Oxford: Pergamon.

Heisenberg, W. (1989), *Werner Heisenberg, Collected Works, Series A/II*, W. Blum, H.-P. Dürr, and H. Rechenberg, eds., Berlin: Springer-Verlag.

Heitler, W. (1936), *The Quantum Theory of Radiation*, Oxford: Oxford University Press.

Jackiw, R. et al., eds. (1985), *Shelter Island II*, Cambridge: MIT Press.

Kragh, H. S. (1990), *Dirac, A Scientific Biography*, Cambridge: Cambridge University Press.

Kramers, H. A. (1938), *Quantentheorie des Elektrons und der Strahlung*, Leipzig: Akademische Verlagsgesellschaft.

Kursunoglu, B. N. and E. P. Wigner, eds. (1987), *Paul Adrian Maurice Dirac*, Cambridge: Cambridge University Press.

Landau, L. D. (1955), "On the quantum theory of fields," in Pauli 1955, pp. 52–69.

Landau, L. D., A. A. Abrikosov, and I. Halatnikov (1956), "On the quantum theory of fields," *Nuovo Cimento, Supp.* **3**, pp. 80–104.

Mehra, J. (1973). *The Physicist's Conception of Nature*, Dordrecht: Reidel.

Mehra, J. and H. Rechenberg (1982+), *The Historical Development of Quantum Theory*, 5 Vols., Berlin: Springer-Verlag.

Moyer, D. F. (1981), "Origins of Dirac's electron, 1925–1928," *Am. J. Phys.* **49**, pp. 944–949; "Evaluation of Dirac's electron," *ibid.*, pp. 1055–62; "Vindication of Dirac's electron," *ibid.*, pp. 1120–25.

Pais, A. (1972), *Inward Bound*, Oxford, Clarendon.

Pauli, W. (1985), *Wolfgang Pauli, Scientific Correspondence*, K. v. Meyenn, ed., Berlin: Springer-Verlag.

Salam, A. and E. P. Wigner (1972), *Aspects of Quantum Theory*, Cambridge: Cambridge University Press.

Saunders, S. and H. R. Brown (1991), *The Philosophy of Vacuum*, Oxford: Clarendon.

Schweber, S. S. (1986a), "Feynman and the visualization of space-time processes," *Rev. Mod. Phys.* **58**, pp. 449–508.

Schweber, S. S. (1986b), "Shelter Island, Pocono, and Oldstone: The emergence of American quantum electrodynamics after World War II," *Osiris* **2**, pp. 265–302.

Schwinger, J., ed. (1958), *Selected Papers on Quantum Electrodynamics*, New York: Dover.

Weiner, C., ed. (1977), *History of Twentieth Century Physics*, New York: Academic.

Wentzel, G. (1943), *Einführing in die Quantentheorie der Wellenfelder*, Vienna: Deuticke; English translation by C. Houtermans and J. M. Jauch (1948), *Quantum Theory of Fields*, New York: Interscience.

Renormalization in Historical Perspective—The First Stage

Max Dresden

2.1. Renormalization: The Disappearance and Reappearance of an Idea

It is tempting, but generally wrong and often misleading, to interpret and understand the past of physics in terms of the concept, goals, and problems of the present. It is also tempting, and equally incorrect, to describe the present of physics as an immediate, straightforward, and all but inevitable continuation of the past. There is, finally, a strong temptation to identify a particular event, experiment, paper, or conference as marking the end of one period and the start of another, a period with new concepts and new problems. Even though this sometimes happens, more often than not the imagined sharp break, or scientific revolution, had many antecedents which prepared and suggested the new developments. This chapter discusses and analyzes some of the ideas, background, and struggles which led to the renormalization chapter in quantum electrodynamics.

It must be stressed that the practicing researcher is usually not particularly concerned with the historical background of the ideas which preceded or accompanied the latest radical research reorientation. The demands of a rapidly advancing novel area of investigation often preclude the careful examination of the historical roots of the subject. Quite often, heavily involved researchers rather resent the suggestion that their novel approaches and original results are wholly or partly a continuation of previous ideas. Even so, an analysis of the complicated and tortuous way in which physical ideas coalesce and separate, disappear, change, and reappear, is crucial for an understanding of the evolution and indeed the current status of any field.

Problems considered central at one time become unimportant irrelevant and are often ignored by common consent. The mathematical techniques, the physical ideas change continuously, sometimes so radically that they are hardly recognizable. These changes of viewpoint, reinterpretations, and reorientation tend to take place over a rather prolonged period of time, so that they are often barely realized. However, occasionally, stimulated by new experiments or the recognition of long dormant difficulties, a sudden reanalysis demands major revisions. In light of such revisions, the previous history of physics is continuously rewritten, reassessed, and reinterpreted.

This paper investigates the slow indirect evolution of the ideas and

considerations, which later were organized in a more coherent scheme called "renormalization." The term renormalization was introduced as early as 1936 by Robert Serber in a paper dealing with the vacuum polarization in the Dirac theory. The term referred to a particular problem. The almost incidental use of the method and the name was characteristic for that period. Renormalization became a household word after the Shelter Island Conference in 1947; the method was systematized and found to be especially suited for divergence problems at about the same time. But many of the ideas were implicitly contained in earlier studies, often in different guises and in quite different areas. The present paper is restricted to the first phase of this development, which roughly speaking begins in the middle of the 19th century and terminates with Kramers' two presentations: at the Shelter Island Conference in 1947 and at the Solvay Conference in 1948. It is already a bit of an idealization to call this a "period of development." It was certainly not a monotonic approach to a systematic procedure. Many different and disjoint elements were involved, as were individuals with different scientific orientations. This study illustrates how ideas and concepts changed, how certain questions crucial at one time, seemed to disappear from physics only to reappear in a modified form later. It further shows how much the use and appreciation of mathematical techniques and mathematical concepts changes from physicist to physicist and from generation to generation. In fact, the perception of what problems are fundamental in physics is also strongly generation (and individual!) dependent. In short, all the features mentioned earlier, which make a historical analysis so important and so illuminating, appear in one form or another in the present investigation. Because there are so many different ideas and distinct strands involved in this development, it is helpful to outline the main scientific insights and results which characterized the various stages. Although this helps in surveying the program of ideas, it has the danger of making the development appear too systematic, organized, and inevitable. Retaining a certain amount of confusion and ambiguity is essential, so that the changing ideas and the shifting emphasis can be properly appreciated.

The oldest concept involved has a perhaps unexpected origin, coming as it does from classical hydrodynamics. It was well-known in the middle of the 19th century how to calculate the forces acting on a foreign body (usually solid) moving through a fluid (or any continuous medium). The same hydrodynamical formalism also allows the calculation of the kinetic

energy of the system which consists of a moving fluid and a moving body. It is an interesting observation that for an object moving with constant velocity V, the total kinetic energy of the system can still be written as $\frac{1}{2}MV^2$. However, the mass M is *not* the mass M_0 of the object moving through the fluid, but is $M = M_0 + M'$. The added mass M' depends on the geometry of the system (expressed via the boundary conditions of the problem) and the density of the fluid. It is this same M which (in contemporary language) would be called the renormalized mass, which enters Newton's equations of motion. This is a general result, any object moving through any continuous material medium, no matter what the origin of the motion might be, can be described in terms of that changed mass. This has the interesting consequence that the notion of the mass of an object becomes ambiguous, and would be different depending on the fluid through which it moves. It is interesting to note that if an object could exist only within a particular medium, the operational mass would always be $M = M_0 + M'$. Here M' would depend on the motion that the object performs in that medium. A single measurement of the mass would necessarily yield $M = M_0 + M'$, so it might be possible to determine M for different types of motion and derive a value for M_0. But no direct measurement of M_0 would be possible.

It was part of 19th century physics to believe or assume that the transmission of electromagnetic forces took place through the intervention of a material medium, the aether. The precise nature of that medium was a topic of lengthy, and in the end inconclusive, discussions. Originally the aether was described as an elastic medium; other physicists attributed electric as well as mechanical properties to the aether, but in spite of the different pictures, there was general agreement that the aether was an all-pervasive continuous medium. On that picture it was impossible to separate a charge, whether moving or not, from its surrounding aether (or even to conceive of such a separation), in the same way that in the contemporary view one cannot separate a charge from its accompanying electric field, or a mass from its gravitational field. This picture implies that a moving charge necessarily moves through the aether (still leaving open the question of whether the aether moves or not).

In 1881, J. J. Thomson introduced the important idea of the electromagnetic mass of a charge. (This was 18 years before the same Thomson discovered the electron experimentally.) There were two distinct ideas, which led Thomson to the introduction of an additional mass of a moving

charge. One was a direct appeal to the hydrodynamical experience. If a charge, which was also conceived to be a material object, moved through the aether, a continuous medium, by analogy with the results of hydrodynamics, this charge should acquire an additional mass. The other reason for the added inertia was that a moving charge, according to Maxwell's equations, creates a magnetic field. This magnetic field possesses energy and this must be supplied by the forces which accelerate the charge from zero velocity, to velocity V. This extra energy is manifested as an additional inertia possessed by the charge and this in fact is exactly the electromagnetic mass; it will be denoted by m'.

The precise properties attributed to the aether and the significance of the electromagnetic mass were analyzed and extended in a series of monumental studies by Lorentz. He showed that the electromagnetic mass can be calculated in terms of the geometrical properties of the charge distribution assumed for the charge. He argued, exploiting the hydrodynamics analogy, that the observable mass of an electron should be $m = m_0 + m'$, where m_0 is the mechanical mass (Lorentz called it the "material mass"). Since m_0 is not directly observable and m' depends explicitly on the detailed (unknown) structure of the electron, the experimental mass m has to be determined by experiment. The quantity m is an empirical constant in the Lorentz theory. In a subsequent development, Lorentz (and some others, Thomson, for example) insisted that the mechanical mass of an electron was zero, so that all its mass would be electromagnetic. This is particularly important because the electromagnetic mass of a point charge diverges, which implied that the classical electrodynamics of point particles is a divergent theory.

Both relativity and quantum mechanics, when they appeared, strongly suggested that an electrodynamics based on point particles would be theoretically simpler and conceptually desirable. This created a serious problem; for the otherwise theoretically preferable quantum mechanics and quantum electrodynamics inevitably led to divergences. These divergences showed up in many calculations, the simplest being the calculation of the self-energy of a point charge: the interaction energy of a charged point particle with its own field. Physicists in the period from 1925 to 1947 were painfully aware of the divergence problem; it was often discussed, but little progress was made. One of the difficulties was that it was not known whether the divergences were merely a technical nuisance, or whether they played an important physical role, possibly lead-

ing to new phenomena. To some it even appeared that the divergence problems were an indication of deep lying difficulties with particle and quantum physics, which could be resolved only by radical, perhaps revolutionary, changes in the foundations of quantum physics.

The relationship between the divergence problem and classical electrodynamics, although occasionally discussed, was not at that time (1925–1940) of central interest. It was suspected by a subculture of theoretical physicists and explicitly stated by Kramers, that the divergence problem in quantum theory was directly related to the classical divergence of the electromagnetic mass. In a series of extensive studies from 1937 to 1946, Kramers dealt with the divergence problem by adapting Lorentz's ideas and procedures of classical electrodynamics to quantum theory. It is remarkable that the systematic pursuit of these ideas was one of the pathways which led to the modern theory of renormalization. The period analyzed in this paper was dominated by three individuals: J. J. Thomson, H. A. Lorentz, H. A. Kramers and by three central ideas: the electromagnetic mass, the divergence problem, and the separation of a charge from the field it generates. Thus Secs. 2.2, 2.3, and 2.4 of this chapter are devoted to the contribution of these three persons.

Section 2.2 describes and analyzes Thomson's contributions, using a combination of electrodynamic and hydrodynamical ideas to introduce the electromagnetic mass. Section 2.3 contains a discussion of Lorentz's ideas, which in turn led to a systematic assessment of the role of the structure of the electron in electrodynamics. Section 2.4 outlines Kramers's efforts, following Lorentz's lead, who insisted on the distinction between the experimental and the electromagnetic mass. Section 2.5 contains some speculative comments and conclusions.

As the sequel will show, the notion of the aether played a significant role throughout this development. It would be tempting to characterize the development itself in terms of the changes of the aether concept. In crude qualitative terms, the aether was first conceived as an elastic medium which transmitted electromagnetic forces; it was the medium through which light propagated. Its presumed material properties were adjusted (as time went on) to be compatible with the behavior of charged particles. Eventually, remnants of the aether notion were incorporated in the electromagnetic field concepts. So it is suggestive, if a bit oversimplified, to argue that in rough outline the notion of the aether evolved from an elastic medium (in a space-time region) to a quantized field (in

the same space-time region). In the same, almost symbolic manner of speaking, the electromagnetic mass notion evolved from an additional inertia due to mechanical forces (as in hydrodynamics) or electrical forces (as in electrodynamics) to an added mass due to the fluctuating forces of a quantum field.

There is one rather curious historical aspect of these developments. The role of the aether was certainly central in Lorentz's thinking. With the advent of relativity, it might be expected that Lorentz, and certainly Kramers, who followed his ideas so closely, would reexamine the concepts, ideas, the whole structure of their framework, in a detailed and careful manner. Lorentz never did this at all, and Kramers did it only reluctantly. In the more detailed discussion of Sec. 2.4, it will be seen that Kramers, who was of course thoroughly conversant with relativity, restricted his quantum treatment to a purely nonrelativistic treatment, perhaps in deference to Lorentz. The net effect of the ideas of relativity in the classical electron theory were minimal.

2.2. J. J. Thomson: The Aether as Fluid and the Electromagnetic Mass

Joseph John Thomson's scientific activity consisted of both experimental and theoretical investigations. Although there can be little doubt that his discovery of the electron in 1897 was his single most spectacular result, for the present discussion a theoretical paper he wrote in 1881 was of special importance. In it he introduced, in a rather casual manner, the important electromagnetic mass notion, which later, especially as used by Lorentz, became of great importance. In this paper, Thomson combined his interest in electromagnetic phenomena with his background in hydrodynamics.

J. J. Thomson entered Cambridge in 1876 (he was then 21 years old); his teachers included Reynolds, Cayley, Routh, and Stokes. He was understandably strongly influenced by the extraordinary array of Cambridge physicists, including Kelvin, Maxwell, and Rayleigh. In addition to the intense interest in electromagnetism, Cambridge also had a long standing tradition in classical hydrodynamics. Kelvin, Lamb, and especially Thomson's teacher Stokes, all made significant contributions to the mechanics of continuous media. The mathematical techniques of fluid

dynamics were known in Cambridge, and Thomson was familiar with all aspects of hydrodynamics. In a series of papers starting as early as 1842, Stokes studied the irrotational motion of ideal fluids. Mathematically this motion was governed by the Laplace equation, subject of course to appropriate boundary conditions. Very similar techniques were often used in electrodynamic problems. In 1893 Thomson applied these very methods to a number of problems in electrostatics. The formal mathematical descriptions of electrodynamical and hydrodynamical problems are very similar, and Thomson was familiar with both.

The calculation of the forces on a solid body moving through a fluid can be carried out by solving the equations of hydrodynamics, with the appropriate geometrical boundary conditions. Once these solutions are constructed, the forces on the body and the energies can be obtained. For different geometrical shapes, there will be different boundary conditions and correspondingly different results. The necessary procedures are a well-established part of the theory of partial differential equations. Even so, the actual computations can be complicated and tricky, because the boundary conditions are often untraditional and no standard methods are available. It is therefore quite remarkable that there exist simple and universal features possessed by many different dynamical systems. A number of different examples will illustrate these (system independent) characteristics.

Example (1)

When a circular cylinder of mass M, and radius R, moves with constant velocity v through an incompressible fluid of density ρ, the kinetic energy is given by T_1:

$$T_1 = \tfrac{1}{2}Mv^2 + \tfrac{1}{2}M'v^2 = \tfrac{1}{2}(M + M')v^2. \tag{1}$$

Here $M' = \pi a^2 \rho$ is the mass of the fluid displaced per unit length of the cylinder. It is not difficult to show that if an additional force X acts in the system, the relevant equation of motion is

$$(M + M')\frac{dv}{dt} = X. \tag{2}$$

These formulas show that the motion of the cylinder through the fluid can be completely described by attributing a changed mass $(M + M')$ to the cylinder and forgetting altogether about the fluid. It might appear

that this result is rather obvious, the additional kinetic energy $\frac{1}{2}M'v^2$ is just the kinetic energy of the displaced fluid, which also moves with velocity v. This additional energy is transferred from the moving cylinder to the fluid. Actually this argument is a bit too naive, the general situation, although similar, being more complicated and less obvious.

Example (2)

For a sphere (mass M and radius R) the energy, when moving through a medium of density ρ, with velocity v, the kinetic energy is

$$T_2 = \tfrac{1}{2}(M + M'')v^2, \tag{3}$$

where the added mass $M'' = \frac{1}{2} \cdot \frac{4}{3}\pi\rho R^3$ is just half of the mass of the displaced fluid. Again the effect of the fluid on the motion is completely described by a change in mass. The equation of motion of the sphere is totally analogous to Eq. (2), namely

$$(M + M'')\frac{dv}{dt} = X. \tag{4}$$

This result was discovered by Stokes in 1843.

Example 3

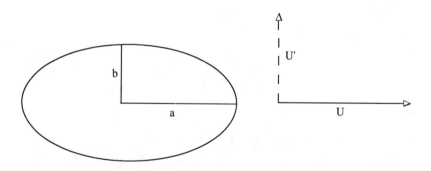

More complicated geometries give rise to a similar but more complicated and less intuitive result. If an elliptical cylinder moves with a velocity, two cases must be considered. If the velocity U is parallel to the major axis a, the kinetic energy T_3 is

$$T_3 = \tfrac{1}{2}(M + M''')U^2, \quad M''' = \pi\rho b^2. \tag{5a}$$

If the velocity U is parallel to the minor axis b, the kinetic energy T_4 is

$$T_4 = \tfrac{1}{2}(M + M'''')U^2, \quad M'''' = \pi\rho a^2. \tag{5b}$$

Example 4

If a sphere of radius R moves parallel to an infinite fixed wall, a distance h from the wall, with a constant velocity V, the system possesses a kinetic energy T_5:

$$T_5 = \frac{1}{2}(M + M^*)V^2, \quad M^* = \frac{2}{3}\pi\rho R^3\left(1 + \frac{3}{16}\frac{R^3}{h^3}\right). \tag{6}$$

Example 5

If a sphere of radius R moves in a large sphere of radius b, with velocity V, the kinetic energy of the system is T_6:

$$T_6 = \frac{1}{2}(M + \overline{M})V^2, \quad \overline{M} = \frac{2}{3}\pi\frac{b^3 + 2R^3}{b^3 - R^3}\rho R^3. \tag{7}$$

In all these examples M was the mass of the moving object, outside of the fluid. The fluids were all incompressible, of density ρ. In all these instances, the motions of an object through a fluid (a continuous medium) can be totally described in terms of a change of mass of the moving object. The change in mass (the mass renormalization) depends in a rather complicated manner on the geometrical configurations and on the details of the motion, as formulas (6) and (7) indicate. The resulting formulas are also very far from being intuitively obvious. These examples are all instances of a general situation. A rigid body moving through a continuous medium can be described as the same type of body moving, not through the medium, but with its mass changed by a computable amount. If a particular body is compelled to always move through a continuous medium, its observed mass will be $M_0 + M'$, where M' is one of the kind of masses calculated before, while M_0 is, under the conditions stipulated, not directly observable.

In 1881 Thomson investigated the magnetic effects of moving charges. He noted an analogy between the motion of a solid body through an incompressible fluid and the motion of a charged body through its own electromagnetic fields (or through the aether—that distinction was not made too explicitly). In the formal calculation based on Maxwell's equations, he observed that in analogy to the hydrodynamical calculation, the

charge experienced a change in mass. This effect is reasonably easy to understand. When a charged body is put in motion, a displacement current is produced. By Maxwell equations, this creates a magnetic field which possesses energy. Thus the outside forces, which do work in order to speed up the charge, must at the same time provide the energy necessary to create the accompanying magnetic field. This implies an effective increase of the inertia of the charged particle. For a sphere of radius a, charge e, Thomson computed the kinetic energy as

$$T = \frac{1}{2}\left(m + \frac{4}{15}\frac{\mu e^2}{a}\right)v^2, \qquad (8)$$

μ being the magnetic permeability of the medium. Thomson called the extra mass the electromagnetic mass. The detailed form of the electromagnetic mass depends in the charge distribution. For a uniformly charged sphere the electromagnetic mass is

$$m' = \frac{2e^2}{3ac^2}. \qquad (9)$$

There is a clear similarity between the change of mass when an uncharged body moves through a fluid, and the additional mass a charge acquired by just moving through its own field (or through the aether). In his paper mentioned, this formal similarity between hydrodynamics and electrodynamics is mentioned in just a single sentence as if such analogies were either totally obvious, or in any case well-known.

One reason that the hydrodynamical analogy was very natural was the common belief in an all-pervading continuous medium, the aether in which all electromagnetic phenomena took place. To Thomson it was not only the medium which transmitted the electromagnetic forces, but also the seat of electromagnetic fields. Whatever the properties attributed to the aether might be, there was general agreement that the medium mimicked many of the properties of a classical fluid, making the hydrodynamical analogy almost irresistible.

Inverting the fluid analogy, Thomson also ascribed a considerable degree of substantiality to the aether. In some researches published in 1893, Thomson considers the aether as a "store house of mechanical momentum." By invoking the hydrodynamical analogy once again, Thomson had come very close to the idea of electromagnetic momentum. He maintained his ideas about the "substantiality," indeed the "materiality,"

of the aether all through his life; if anything, he became more adamant as time went on. As late as 1909 (four years after Einstein's seminal paper on special relativity) he exclaimed in a presidential address: "the aether is not a fantastic creation of the speculative philosopher, it is as essential to us as the air we breathe ... It is the seat of electric and magnetic forces ... it is the bank in which we may deposit energy and withdraw it at our convenience ..." A more exuberant description of an all-pervasive aether is hard to imagine—and it would surely not be surprising if the aether medium would behave exactly like a classical fluid, including altering the mass of objects which moved through it.

2.3. Lorentz: His Aether, Electron, and Program

In formulating the basic equations of the theory of electrons, Lorentz had to struggle hard and long to overcome a number of personal and scientific prejudices. In addition, the conceptual foundations of electrodynamics were rather confused in 1890, and the discovery of the electron did little to clarify the situation. Lorentz had to rethink and reanalyze the basic electrodynamic notions to arrive at a systematic viable theory of electrons. In this process he made a number of important contributions, which taken together define and delineate Lorentz's electrodynamic world view.

1. Lorentz systematized and classified Maxwell's ideas. Some physicists had referred to Maxwell's writing as obscure and mysterious.
2. Lorentz insisted that there was one electromagnetic entity described by two vectors: electric and magnetic (\mathbf{e}, \mathbf{b}). This is distinct from Maxwell's formulation which employs four vectors (\mathbf{E}, \mathbf{D}), (\mathbf{B}, \mathbf{H}). Two of these vectors (usually taken as \mathbf{D} and \mathbf{B}) can be obtained from the structure of matter, together with the other two vectors.
3. There is only one universal, all pervasive, immobile aether. In fact Lorentz gives a much more detailed description of the aether than had the previous physicists.
4. The electron was a finite charge distribution, whose stability was explicitly assumed.

The radical nature of Lorentz's ideas [especially (2) and (3)] was especially appreciated by Einstein who recalled in 1949, "The physicists of

the present generation regard the point of view achieved by Lorentz as the only possible one. At that time however it was a surprising and audacious step without which the later development would not have been possible."

It might appear surprising that the ultimate formulation of Lorentz's theories in their deceptive simplicity and clarity ("a system is made up of particles and their electrons and the aether") took such a long time to establish. But electrodynamics was still involved and complicated in 1890, the structure of matter incompletely understood, and the role of the aether was viewed very differently by different physicists. Stokes, for example, assumed that the motion of the aether was the irrotational motion of an incompressible fluid. Helmholtz thought of the aether as a frictionless compressible fluid. To Maxwell the aether was an elastic material medium, capable of receiving, storing, and transmitting energy. He left open the possibility that the aether in glass and the aether in vacuum might be two continua with distinct properties. Maxwell's aether did not necessarily have to be all-pervasive, it might well be an unusual form of matter, but it certainly did satisfy Newton's equations. Evidently Lorentz's insistence that there was just one universal, material-independent aether, and one electromagnetic field, also material-independent, represented a major departure from Maxwell's thinking. It is equally clear that without the recognition of the universality, and material independence of both aether and electric magnetic field, the transition to Einstein's relativity would have been difficult if not impossible.

Actually Lorentz went further than that; contrary to Maxwell and Thomson, he made a sharp distinction between matter and aether. The aether to Lorentz was not only all-pervasive, it was the seat of the electromagnetic field; all electromagnetic interactions were transmitted via the aether. The aether possessed energy and momentum. Thus to Lorentz an electromagnetic field was a state, a particular configuration of the aether. Charges moving through the aether (as all must!) can change the state of the aether. Lorentz was still explicit that his aether had a certain degree of substantiality; in spite of this he made a sharp distinction between (ordinary) matter and the aether. He specifically assumed that even though the aether acts and influences charged matter, the charges in turn did not act on the aether, leaving the aether motionless. No part of the aether can be in motion relative to any other part of the aether.

Lorentz's aether is just simply geometrical space endowed with certain dynamical properties. But it is clear that with the stipulations of a degree of material substantiality and an influence from the aether on the (material) charges but no influence from the charges on the aether, one has come in direct conflict with Newton's third law. Lorentz was well aware of this; he was willing to abandon this basic law and maintain the paradoxical properties of the aether he needed. He expressed this candidly in a paper written in 1895. "Admittedly this conception would violate the law of action and reaction, since we have reason to say that the aether exerts forces on ponderable matter—but as far as I can see there is nothing to compel raising that law to a fundamental law of unlimited validity." This was the "surprising and audacious step" to which Einstein referred, but Lorentz in his own inimitable style did not "make a big fuss about it." He was a controlled, serene revolutionary (in true Dutch tradition).

Surprisingly enough, Lorentz never, not even after Einstein's special relativity, gave up the idea of an all-pervasive immobile aether. He retained his beliefs in a Euclidean, Newtonian space time, and in absolute simultaneity, but he was quite willing to introduce a non-Newtonian aether and he accepted an electron with most curious, nonvisualizable features in good grace. To Lorentz an electron was a finite charge current distribution, with definite boundaries. It is important to realize that the various charge elements within the electron could exert electromagnetic forces on each other. Consequently electromagnetic fields were assumed to exist inside the electron. Lorentz left open the possibility there might be other types of force as well. Poincaré at one time specifically assumed the existence of nonelectrical forces to stabilize the charge distribution, but within the Lorentz theory the stability is just assumed. Since the aether was an all pervasive medium it also had to be present inside an electron—the aether is of course also present outside the electron. This observation leads to a most important distinction between external and self-fields. The outside field(s) is generated by external sources (charges, currents, magnets); the self-field (of an electron) is due to the interaction between the internal charge distribution and the surrounding aether. How this interaction manifests itself depends on the precise motion of the electrons through the (of necessity) stationary aether. If no external forces act, the charge will move uniformly in spite of the finite charge distribution. More precisely, if there are no outside forces the

electron moves exactly like a point charge, its velocity vector **v** is constant (this excludes any rotations, there is *no* spin).

Lorentz was clearly pleased (and perhaps a little surprised) with this result for he writes "This shows that if free from external forces an electron, just like a material point, will move with constant velocity not withstanding the presence of the surrounding aether." The mechanical description of the spatially extended object is still that of a point mass. In a more general situation, when **v** is not constant, energy and momentum can be exchanged between the aether and the moving charge. Lorentz often used the terms \mathbf{E}_{self} and \mathbf{B}_{self} to denote the fields which monitor the interaction between the (internal) charge distribution and the aether.

Using the equations of motion of an electron and especially the conservation laws, Lorentz derived the force which an electron experiences when moving through the aether (when moving through its own field) as

$$\mathbf{F} = \frac{2}{3}\frac{e^2}{c^3}\dddot{x}. \tag{10}$$

In this calculation it is necessary to assume that the charge distribution is rigid and spherically symmetric. A closely related consequence of this same interaction between the charge distribution and the surrounding aether is the acquisition of additional inertia by the moving charge in its motion through the aether, its electromagnetic mass. Lorentz considered this additional mass as most important, and he gave two different derivations of this result. One was based on the energy momentum conservation law of the combined particle-aether system. The other employs a close analogy with the fluid motion derivations as given by Stokes and Thomson. Lorentz makes explicit use of Stokes' hydrodynamical result that the kinetic energy of a sphere moving through a fluid is $T = \frac{1}{2}\alpha v^2$ (v is the velocity, α is a constant to be computed). In a perhaps slightly patronizing manner, Lorentz contrasts his rather fancy computation with Thomson's older result "not obtained by the modern theory of the electron." For a rigid homogeneous electron, he obtains Thomson's expression for the electromagnetic mass:

$$m = \frac{2}{3}\frac{e^2}{c^2}. \quad m = \frac{2}{3}\frac{e^2}{ac^2}. \tag{11}$$

Here a is the radius of the charge distribution. In a general motion the acceleration **a** can be decomposed into normal and tangential compo-

nents a_\perp and a_\parallel:

$$\mathbf{a} = \mathbf{a}_\perp + \mathbf{a}_\parallel. \tag{12}$$

In this case, the force on the electron due to its own electromagnetic field is determined by two parameters, interpreted as two distinct electromagnetic masses m' and m'' (the transversal and longitudinal masses; for specific models, m' and m'' can be calculated). This perhaps somewhat strange result is reminiscent of the earlier result quoted for the additional mass an elliptical cylinder acquired when moving through a fluid. If the velocity \mathbf{v} of the cylinder makes an angle θ with the major axis a,

the additional kinetic energy T is given by

$$T = \tfrac{1}{2}\pi\rho(b^2\cos^2\theta + a^2\sin^2\theta)v^2. \tag{13}$$

This shows that each different velocity direction (each θ) has its own effective mass. Note if $a = b$, a circular cylinder, the angular dependence disappears. This example illustrates the remarkable and unintuitive results of motions of unusual shapes in continuous media, so the existence of two distinct masses is perhaps not so surprising.

If a mechanical mass m_0 is attributed to the charge, Newton's equations for the charge became

$$\mathbf{K} = (m_0 + m')\mathbf{a}_\perp + (m_0 + m'')\mathbf{a}_\parallel, \tag{14}$$

where \mathbf{K} is the given external force. For small velocities $v \ll c$, one finds

$$m' = m'' = \frac{2}{3}\frac{e^2}{ac^2}. \tag{15}$$

The precise expressions for m' and m'' depend on the details of the charge distributions, so the numerical coefficients have no special significance. However, Lorentz took the general idea of the electromagnetic mass extremely seriously. It was a general, inevitable consequence of his whole approach. He felt strongly that the mechanical mass m_0 (the material mass) should be put equal to zero, so that the total electron mass was electromagnetic. He had an explanation of the mass of a fundamental particle as the inertia of the motion of the charge through the aether. Since the aether is all-pervasive, the mass experimentally measured is $m_0 + m'$, hence a single experiment cannot disentangle the mechanical from the electromagnetic mass. Since Lorentz could calculate the electromagnetic mass (based on a certain model), he knew the velocity dependence of m'. Then by measuring the mass at different velocities, m_0 and m' could separately be determined, provided of course that m_0 did not depend on v. Assuming that m_0 is zero, Lorentz could compare the calculated velocity dependence of m' with that experimentally observed. The excellent agreement confirmed his strong conviction that the electromagnetic mass was zero, that the electron indeed was a finite, uniform, spherical charge distribution. It strengthened his faith in the basic correctness of the whole approach, including the reality of the aether.

In spite of these unquestioned successes, Lorentz was well aware that his electron had become a rather curious object. (The aether was unusual all along—not satisfying Newton's third law.) The unusual properties of the electron included:

1. It was a finite negative charge distribution.
2. In spite of the fact that the different charge elements would exert repulsive forces on each other, the structure was permanent and stable.
3. The mechanical mass of this material object was zero.
4. It was a mechanically rigid system.

Lorentz recognized these almost paradoxical properties: "After all by our own negation of the existence of material mass, the negative electron has lost much of its substantiality. We must make it preserve just so much of it, that we can speak of forces acting on its parts, and that we can consider it as maintaining its form and magnitude. This must be regarded as an inherent property in virtue of which the parts of the electron cannot be torn asunder by the electric forces acting on them." Perhaps the difficulties and problems of visualizing the aether inside and outside the

electron, the interaction of the aether, and the aether itself should not be taken too seriously. In his inaugural address in Leiden (1878) Lorentz said, "But one can also have too much of a good thing and thus by visualizing too much, one can overshoot the mark and place so much emphasis on what should serve as a picture, that it is taken too much for the thing itself."

Visualizable or not, Lorentz's picture of the electron and the aether led to two major results: the radiation reaction force

$$F = \frac{2}{3}\frac{e^2}{c^3}\dddot{x}$$

which explained an impressive array of results in classical optics, and the idea of the electromagnetic mass, a basic ingredient in the development of the subsequent renormalization scheme. With these two consequences, it appeared that the formal role (not the conceptual role) of the aether was exhausted. Just as the introduction of an additional mass in the dynamics of a body moving through a fluid makes it possible to forget about the fluid, with the recognition of the electromagnetic mass and the radiation reaction it is possible to forget about the aether.

2.4. Kramers: The Unexpected End of the First Phase

It is remarkable that Kramers, who venerated Lorentz's physics, wrote his first paper on classical electrodynamics in 1938, some 20 years after he became an active researcher. Almost all his previous investigations had dealt with quantum problems and the quantum theory of radiation. In these studies he was strongly influenced by Bohr and his approach to physics. While preparing an organized, systematic exposition of the quantum theory of particles and radiation, he found it necessary to re-examine and scrutinize the foundations of classical electrodynamics. As a consequence, he became interested, not to say obsessed with, the necessity to combine the classical electrodynamics of Lorentz with the quantum ideas of Bohr in a single harmonious coherent structure. Kramers (happily) accepted all the basic tenets of Lorentz' electrodynamics: the electron as a finite charge distributions, the separation of the self-fields from the total fields, the distinction between the electromagnetic and the experimental mass, and the Lorentz calculation of the self-force. Kramers

was remarkably noncommittal about the aether, he was somewhat ambivalent toward relativity.

It is almost unnecessary to stress that Kramers followed Bohr's approach to quantum theory, especially the correspondence principle. These quantum ideas were according to Kramers best expressed through the formalization of a canonical quantization. Thus Kramers embarked on his quantization program, following the classical approach of Lorentz as closely as possible, while adhering to the established quantization procedures. The Lorentz scheme had a few difficulties. One was that the structure of the electron, through the electromagnetic mass, occurred explicitly in the formalism. Going to the limit of a point mass, $a \to 0$, caused a divergence in the electromagnetic mass. It is in many ways desirable to take this point-mass limit, for this eliminates the need to discuss the internal structure of the electron. Needless to say, to Lorentz this was no advantage, but it was seen as a great advantage by the quantum theorists, who objected to a framework with "in principle" unobservable features. Thus the point charge limit was important and it made the divergence of the mass inevitable.

The second problem, perhaps of more concern to Kramers than many other physicists, was the total absence of a correspondence principle role for Lorentz's expression for the radiation reaction term

$$F = \frac{2}{3}\frac{e^2}{c^3}\dddot{x}.$$

This expression was the basis for the description of all classical optics, but it seemed to lack a natural quantum counterpart. The accepted quantum theory of radiation at that time, the Dirac theory, had no obvious correspondence principle limit. This to Bohr and Kramers was a most objectionable feature, almost a fatal flaw.

Kramers hoped and expected that his quantization program, based squarely on Lorentz's classical theory, would give quantum transcriptions of two salient features of Lorentz's investigation: the electromagnetic mass and the radiation reaction. The basic equation of motion is according to the Lorentz theory (in Kramers version)

$$m_0\ddot{x} = \mathbf{K} + \mathbf{F}_{ext} + \mathbf{F}_{self}, \tag{16}$$

where m_0 is the mechanical (material mass), \mathbf{F}_{ext} the external force, \mathbf{F}_{self} the self-force, and \mathbf{K} a nonelectromagnetic force.

It was one of Lorentz's great triumphs that he could explicitly calculate the force the aether exerts on the charge distribution of the electrons:

$$
\mathbf{F}_{\text{self}} = -\frac{2}{3c^2} \ddot{\mathbf{x}} \iint d^3x \, d^3x' \frac{\rho(\mathbf{x})\rho(\mathbf{x}')}{|\mathbf{x} - \mathbf{x}'|} + \frac{2}{3}\frac{e^2}{c^3}\ddot{\mathbf{x}}
$$

$$
+ g\frac{ae^2}{c^4}\dddot{\mathbf{x}} + (a^2) + \cdots, \tag{17}
$$

where a is the radius of the charge distribution $\rho(\mathbf{x})$. In the equation of motion, the \ddot{x} term in Eq. (1b) combines with the mass terms in Eq. (16). This term is just the electrostatic self-energy of the charge distributions; it is proportional to the electromagnetic mass m'. This term diverges for a point charge ($a \to 0$). It can be combined with m_0 to yield the experimental mass

$$
m_{\text{exp}} = m_0 + m'. \tag{18}
$$

Introduction of Eqs. (17) and (18) into Eq. (16) eliminates the self-fields and introduces the experimental mass in the basic equation

$$
m_{\text{exp}}\ddot{\mathbf{x}} = \mathbf{K} + e\left(\mathbf{E}_{\text{ext}} + \frac{[\mathbf{v} \times \mathbf{B}_{\text{ext}}]}{c}\right) + \frac{2}{3}\frac{e^2}{c^3}\dddot{\mathbf{x}}. \tag{19}
$$

To Kramers this was a perfect equation as it contained the directly observable experimental mass and the observable external fields.

It was this procedure that Kramers chose to emulate in his efforts to construct a satisfactory quantum theory of radiation. Of course m_{exp} contains m' the model-dependent divergent, electromagnetic mass m' but the divergence, so to say, "knows its place." It is always combined, quarantined, and hidden in the experimental mass, which should be determined by observations anyhow. Kramers' procedure included these elements:

1. The starting point is an extended, classical charge distribution of a radius a, interacting with a given external electromagnetic field.
2. The first serious problem to be considered was the construction of an exact or approximate Hamiltonian for that system.
3. Next is the separation of one electromagnetic field into a self-field and an external field, and a concomitant separation of the mass into an electromagnetic and mechanical mass. Introducing these separations into the Hamiltonian leads to a dynamical formulation which contains a mixture of structure-dependent and structure-independent terms.

4. The next step is the elimination of the structure-dependent terms from the Hamiltonian by one or a series of canonical transformations. This should lead to an autonomous structure-independent Hamiltonian. Possibly the structure-dependent terms can be amalgamated in empirical parameters, but such terms cannot occur as dynamical variables.

5. Once such a structure-independent formulation is obtained, it should in principle be possible to carry out the limit $a \to 0$, which should be finite.

6. Based on a structure-independent presumably finite Hamiltonian, the canonical quantization should be straightforward to carry out.

Although this is a well-conceived and well-defined procedure it is not at all clear that the individual steps can be executed, or that it is implementable as a whole. It does represent a formal systematization of Lorentz's philosophy. The Kramers' program was never fully implemented. An important approximation always made was the restriction to dipole radiation. This means that in the Fourier decomposition of the electromagnetic field, only Fourier components with wave length $\lambda > a$, were taken into account. This is technically much simpler, and there are good physical arguments, very much in the spirit of renormalization theory, to introduce this limitation.

If electromagnetic waves of wavelength $\lambda < a$ were included they could in principle probe the interior of the electron. Since the interior is something to be eliminated, rather than probed, it makes sense to limit the electromagnetic waves to those with $\lambda > a$. In the spirit of the renormalization idea, it should in principle be impossible to know or probe anything about the interior of the electron. Thus the dipole approximation is justified by the limitations renormalization imposes.

It was a great success of Kramers' methodology that in the process of eliminating the structure-dependent terms in the Hamiltonian a mass renormalization term is automatically produced. Formally the result is very similar to the amalgamation of the mechanical mass m_0 with m' as in Eq. (18).

Even before the implementation could be considered seriously, there were several questions of principle which had to be considered. Most physicists would agree that the divergences, classical and quantum, were serious defects of the theory. But there was no agreement as to whether this was a mere computational handicap, a technical nuisance to be over-

come by improved technical refinements, or a major conceptual problem whose resolution would give rise to new phenomena and new physical insights. The second issue was whether a classical starting point, however sophisticated, would necessarily yield a divergence-free quantum theory. Kramers had strong opinions on both topics. He was thoroughly convinced that the formulation of classical electrodynamics had to be divergence-free, consistent, and complete before a quantization should be attempted. He often criticized the Dirac radiation theory on the grounds that "it makes no sense to quantize a wrong theory and make amends later." This "wrong way around procedure" was (according to Kramers) the reason that the quantum theory of radiation was divergent and had no correspondence theory limit.

By following his program as outlined he also followed in Lorentz's footsteps, something of great importance to Kramers. Regarding the first item, whether the elimination of structure-dependent terms and the ensuing renormalization would lead to new phenomena, Kramers was less explicit. He strongly suspected that there would be new physics (he in fact made specific suggestions to that effect), but the renormalization principle was more fundamental. In a satisfactory theory the structure-dependent features, or more generally the unobservable features, had to be eliminated, and this process will usually give rise to a redefinition or renormalization of the remaining parameters in the theory.

Unfortunately this clearly formulated program and this explicitly spelled out principle encounters many difficulties. For example, the required splitting of the total field into the self-field and external field becomes ambiguous in the limit $a \to 0$, the point-charge limit. In that limit both the total field and the self-field diverge at the location of the charge, but their difference is finite. (Kramers realized this ambiguity only after his book was written. It is actually incorrect in his book.)

Another serious difficulty is the Hamiltonian formulation of a system of interacting charges and a radiation field. Kramers solved these and many other problems in successive stages, all approximate. He gave the first organized public presentations of his many years of endeavor (10 years) at the Shelter Island Conference in June 2–4, 1947. There was a great deal of interest in the divergence problem and new approaches were very welcome. Kramers' approach, although based on old ideas, was nevertheless unconventional at that time. Kramers, implementing his program, had succeeded in constructing a Hamiltonian (and equation

of motion) which contained the experimental mass and not the mechanical mass. His Hamiltonian was different from the conventional Dirac Hamiltonian and he indicated that this should lead to observable differences in the hydrogen spectrum from what was predicted by the Dirac theory. Kramers expected that using the experimental mass in his new theory would render the theory finite (which turned out *not* to be the case).

It is unlikely that the rather involved and unfamiliar details of Kramers' program were appreciated by everybody. Willis Lamb, for example, at a meeting (in Shelter Island II, 1983, celebrating the anniversary of the first Shelter Island conference) recalled only that Kramers had given a long complicated talk.

However, Kramers' general ideas of renormalization were understood and appreciated. The explicit introduction of the experimental mass, which amalgamated the unknown mechanical mass with an infinite electromagnetic mass, was recognized as most important. It further became clear very soon that the infinite interaction of a charge with its own field (the infinite self-energy) did have definite, even computable, consequences if one subtracted the infinite contribution of the electromagnetic mass. Thus only that part of the infinite self-energy not already contained in the electromagnetic mass would be observable and finite. This in turn suggested that the self-energy for a bound particle (in a potential V) would be different from the self-energy of a free particle. Call the self-energy of a free particle $W_0(m_0, a)$, that of a bound particle $W_L(m_0, a, V)$. Observe that these are extremely unphysical qualities, they depend on the electromagnetic mass m_0 and the electron radius a, neither is observable. For finite models, a and m_0 are finite and computable, and Kramers computed them. He conjectured, and for some models showed, that

$$\lim_{a \to 0} \left[W_L(m_0, a, V) - W_0(m_0, a) \right] = \text{finite}. \tag{20}$$

This conjecture was the motivation for Kramers's suggestion in the summer of 1938 in Ann Arbor, Michigan that "The young people should calculate the self-energy difference between an s electron in hydrogen and a free electron, both are infinite and you should take the difference which is hopefully finite and that may be the Pasternack effect." (This was an observed shift in the hydrogen spectrum.) Equation (20) is the formal expression of Kramers' suggestion. It is clear that Kramers did suspect

(or knew) that the self-interaction of electrons in atoms would cause level shifts in those atoms—but he did not calculate the shifts. The most complete and most transparent formulation of Kramers' renormalization program is contained in Nico Van Kampen's thesis "Contributions to the quantum theory of light scattering"(Leiden, January 16, 1952). It is based on Kramers' renormalization program and the derivation of the mass renormalization is especially elegant. Within the limits imposed by Kramers, the treatment is nonrelativistic, in dipole approximation, Van Kampen's thesis completes Kramers' program. It is possible to eliminate the structure of the electron, and in so doing obtain an autonomous Hamiltonian formalism where the appropriate parameters (in this case just the mass) are renormalized. The spectrum of the Hamiltonian is different from that of the original unrenormalized Hamiltonian. The succeeding development, which started with explosive suddenness after the Shelter Island Conference, was certainly unanticipated by Kramers. It is doubtful that this nonrelativistic formulation had a direct effect on the relativistic version which immediately followed. Even though it was definitely the end of a phase—a nonrelativistic renormalization theory in the spirit of Lorentz—the end did not lead continuously into the next relativistic phase. It took a considerable time before Kramers' ideas were appreciated and his contributions were finally recognized.

2.5. Comments and Conclusions

1. Kramers' presentation at Shelter Island, repeated in 1948 at the Solvay Conference, did not appear in print until the Proceedings of the Solvay Conference were published in 1950. Although it was a more detailed treatment, it was still based on Lorentz's ideas and still difficult to understand. But by that time the full power of the relativistic treatment was already known. The nonrelativistic classically oriented treatment was superseded by the conceptually and technically brilliant studies of Schwinger, Tomonaga, Feynman, and Dyson.
2. Kramers' presentation at Shelter Island had at best a mixed reception. Weisskopf, Schwinger, and Oppenheimer were generally aware of the renormalization idea. Actually Schwinger was the only person who recognized that Kramers in his 1938 textbook had constructed a nonrelativistic classical theory in which he tried to eliminate the self-field.

Schwinger liked this approach; he comments on Kramers' work: "Very good if we lived in a nonrelativistic world," but then he proceeded to develop his own relativistic theory [Schwinger, J. Phys. (Paris) **12**, 43, (1982)]. Whereas Schwinger and some others were familiar with the renormalization idea, Bethe heard of Kramers' renormalization at Shelter Island for the first time. With his usual incisive insight Bethe recognized instantly that Kramers' method would provide an explanation of the Lamb shift.

3. It is interesting to speculate why Kramers was so stubbornly unwilling to consider a relativistic version of the renormalization scheme. It is possibly connected with his unalterable conviction that every theoretical structure had to have a classical substrate. (This connection is no doubt a result of Kramers' long and intense association with Bohr.) Thus when Kramers declared "I think there does not exist a really consistent relativistic classical theory of (interacting) charges (Kramers, *Rapports du Huitième Consul de Physique*, Solvay 1950), he sees this as a complete justification for restricting his studies to nonrelativistic considerations. Perhaps Kramers' unwillingness to consider a relativistic theory was a repetition of Lorentz's refusal to alter his views regarding the aether because of the advent of relativity. Kramers was certainly aware of the two significant ideas which were obtained using the aether concept, but which remained after the demise of the aether— the electromagnetic mass and the radiation reaction. But Kramers never said unequivocally that the Einsteinian view was preferable over Lorentz's (more and more contrived) aether. This factor might well have kept Kramers from pursuing a relativistic study.

4. It is finally interesting to record how the physics community reacted to these developments. The self-energy problem and generally the divergences were viewed as deep, profound difficulties, which might well demand major revisions and radical innovations. Occasionally isolated attempts were made to try out such new ideas, but they were not successful. It was further commonly believed that the resolution of the divergence problems would result in major changes and major new insights, such as the calculation of the fine structure constant. Although rarely articulated this was the prevailing view of the "quantum generation": Pauli, Heisenberg, Bohr, Dirac, Fermi, and most others.

Thus Kramers' efforts, which were classically inspired and on the conservative side, were generally ignored. Pauli always argued that one

should look for a formulation of quantum electrodynamics (or field theory in general) which would mathematically not allow the description of a charged particle without its electromagnetic field, or as Lorentz would say, without its aether. So when the brilliant relativistic extensions and refinements by Schwinger, Feynman, Dyson, and Tomonaga of a basically conservative, old idea, were spectacularly successful, there was general disappointment. As a solution to the old and deep problems they struggled with, the solution appeared like a superficial, acrobatic mathematical trick. There appeared to be little or no new physics, and the renormalization was to the quantum generation, not the hoped-for, anticipated new scientific revolution—or a deep new synthesis to rival the quantum resolution—but a collection of strange mathematical tricks. Schwinger was considered too formal, Feynman too original—and one distinguished member of the quantum generation exclaimed—"These infinitely clever young people all need to be renormalized."

But as in so many generational alterations, the assessment by the quantum physicists of the renormalization ideas was wrong. The succeeding development was certainly a major technical advance with ramifications in many parts of physics. It provided a new and different insight into the structure of physical theories; the renormalization idea led to a reorientation of all thinking about field theory. And there was new physics. Certain old problems remained unsettled, but whether the renormalization was a genuine revolution or not does not really matter. It defined to a considerable extent the direction of theoretical physics in the second half of the 20th century. No revolution could have done more.

References

Serber R. (1936), *Phys. Rev.* **49**, p. 545.

Thomson, J. J. (1881), *Philos. Mag.* **5**, pp. 11, 229.

Einstein, A. (1949), "Autobiographical Notes," in *Albert Einstein, Philosopher–Scientist*, P. A. Schilpp, (New York).

Lorentz, H. A., Collected papers Vol. 5.

Lorentz, H. A. (1952), *Theory of Electrons* (Dover, New York), p. 37.

Lorentz, H. A. (1952), *Theory of Electrons* (Dover, New York), p. 43.

Lorentz, H. A., Collected papers Vol. 9, pp. 1–25.

Tutorial on Infinities in QED

Robert Mills

3.1. Introduction

The purpose of this section is to give you a sketch of how quantum field theory works, where Feynman graphs come from and why they are so useful, where the infinities come from, and how we have learned to deal with them without compromising the physical principles involved. I am purposely treating the problem at the level of the 1940s and 1950s, so as to keep the basic ideas clear and avoid the more difficult problems and more sophisticated methods of recent years. I shall relate my discussion simply to quantum electrodynamics (QED) since that is the most familiar case and the case that was in the forefront from the beginning (though in fact I shall ignore many of the special complications that have to be dealt with when you quantize a gauge field). The methods I shall be describing are applicable to all sorts of quantized fields: the detailed factors are different but the structure of the logical development is just the same. Not surprisingly, though, the renormalization procedure breaks down if the theory in question is nonrenormalizable. Whether nonrenormalizable theories are theories at all is a matter for debate; in any case, they hold no practical interest for physicists since they are essentially unusable.

Quantum electrodynamics was devised in 1927 by Dirac, less than a year after the Schrödinger equation appeared and before the Dirac equation for the relativistic electron had been invented. Once Schrödinger had shown how to apply quantum theory to a general dynamical system it was quite natural, at least for somebody smart, like Dirac, to apply it to the electromagnetic (EM) field as described by Maxwell's equations. For the first time since photons had appeared on the scene 27 years before (implicitly, in Planck's radiation formula), it became possible to say what a photon *is*. Let me tell you:

1. The electromagnetic field, like any extended linear system, can be completely described in terms or its normal modes of oscillation.
2. Each normal mode of oscillation is dynamically equivalent to a simple harmonic oscillator.
3. A simple harmonic oscillator has discrete equally spaced energy levels with spacing hv, where h is Planck's constant and v is the classical frequency of the oscillator.
4. The states of the quantized field are therefore completely described by giving the excitation level of each normal mode.

5. If a particular mode is in its nth excited state then the excitation energy is nhv, somewhat as if there were n particles present each of energy hv.
6. Such a state is also an eigenstate of the three components of the electromagnetic field momentum. The eigenvalues are the components of a vector of magnitude nh/λ in some definite direction, where $\lambda = c/v$, the wavelength of the mode, as if each of the "particles" had momentum h/λ. (You have to use traveling wave modes to do this, which is allowed if the field region is unconfined.)
7. The word "photon" is seen as a linguistic device to describe this particle-like character of the excitations of the EM field.
8. The complete indistinguishability of photons directly follows from this description, since they are not separate entities. Logically, photons hardly deserve the dignity of a noun. When you speak more correctly of different levels of excitation of the modes of the field the question of the identity of the photons becomes meaningless. They are truly faceless.

The natural question now is whether all of the particles of nature should be viewed in the same way, i.e., as quanta of appropriate fields. The idea that they should, which is the basic idea of quantum field theory (QFT), was developed first by Heisenberg in 1934, when he treated electrons and positrons as quanta of excitation of a field whose *field* equation is the Dirac equation. This is a bit funny, since the Dirac equation was first proposed in order to describe the quantum behavior of a single particle, as a relativistic generalization of the Schrödinger equation. Now it is as if that Schrödinger equation itself—Dirac's version—were being treated as a classical field equation on a par with Maxwell's equation, and quantized along the lines I described above. You have to make some modifications in the field theory in order to satisfy Fermi–Dirac statistics—the essential change being the replacement of commutation relations among the operators of the theory by anticommutation relations. The result of this is that each normal mode is a modified oscillator, called a "Dirac oscillator," with only one excited state. The absence of additional excited states is the QFT equivalent of the Pauli exclusion principle: two quanta in the same mode would be the equivalent of having two electrons in the same single-particle state.

It was immediately clear that QED gives a beautiful description of the noninteracting EM field and of simple processes involving absorption or emission of real photons. It also appeared very quickly that when you try

to do perturbative calculations involving virtual intermediate states you get into deep trouble. The sums over intermediate states prescribed by perturbation theory simply diverge. The problem was not new. It is closely related to the ultraviolet divergence in black-body radiation recognized in the late 1800s and dealt with by Planck in 1900, and also to the divergent electromagnetic energy of a point charged particle. Problems at high energies and at small distances are related: the trouble here is simply that there are so many possible high-energy states for the photon—i.e., so many high-frequency modes for the EM field—that any sum over such modes tends to blow up. What came to be recognized in time is that there is hardly any hope of our fully understanding the consequences of what happens at really small distances and really high energies. Not only are there virtual photons and virtual electron–positron pairs to be summed over, but virtual *anything*: virtual protons and neutrons, virtual atoms and molecules, and virtual Mack trucks (as M. L. Goldberger once put it). We have no way of knowing whether the sums over virtual states, when *all* possible states are included, converge or diverge. If they converge then the theory is OK even though we may never be able to see it.

The success of the renormalization program is due to the fact that, when a theory is renormalizable, physics at the ordinary level turns out to be insensitive to these high-energy virtual processes. This insensitivity is in fact what makes a theory renormalizable. The infinities that we see in perturbation theory turn out to be due to a small number of infected constants that in fact are physically unobservable. When a careful job is done of expressing physical predictions in terms of only physically measurable parameters, the infinities disappear and the resulting calculations are completely do-able to any order in perturbation theory. This procedure is certainly tricky, but the logic is straightforward and honest. It does not require magic. The approach that I am going to sketch here is essentially that due to Freeman Dyson, whose achievement in bringing rationality and clarity to the subject cannot be overemphasized.

3.2. Subtracting Infinity

Let me start with a couple of toy models of infinities to show how what looks like a meaningless expression can in fact have a lot of useful content, concealed by one or two meaningless constant parameters. The

function $f(x)$ is defined, let us say, by the expression

$$f(x) = \int_1^\infty dy/(x + y). \tag{1}$$

As you can see, the integrand goes like $1/y$ for large y; it goes to zero, but not fast enough to keep the integral from diverging logarithmically. On the face of it, the function $f(x)$ is undefined for every x. The variables x and y are playing the roles of energy variables, and the integral represents one of the sums over virtual states that we have to deal with. A large class of the divergent expressions that we meet are in fact logarithmically divergent. To see some meaning in this expression for $f(x)$, look at the difference for two different values of x. In particular, compare $f(x)$ with its value at $x = 0$:

$$f(x) - f(0) = \int dy[1/(x + y) - 1/y], \tag{2}$$

where I have taken the subtraction inside the integrand—illegitimate but not unreasonable. In this section all integrations are from 1 to ∞. Combining the terms in the integrand you get a convergent integral, namely,

$$f(x) - f(0) = -x \int dy/y(x + y) \tag{3}$$

$$= \bar{f}(x), \tag{4}$$

where I have introduced the notation $\bar{f}(x)$ for the right side of Eq. 3. Apart from an infinite additive constant, in other words, $f(x)$ is a perfectly well-behaved function of x. For future reference, I shall write this as

$$f(x) = A + \bar{f}(x), \tag{5}$$

where A is the infinite constant and $\bar{f}(x)$ is the well-behaved function. It needs to be emphasized strongly that not all divergent integrals can be controlled by simple subtractions in this way. It is a very special property of this example and of the integrals we encounter in QFT that they can be so controlled.

For my next example I want to make the integral more divergent by inserting a factor y into the integrand:

$$g(x) = \int y\,dy/(x + y). \tag{6}$$

As you see, the integrand in this case is constant as $y \to \infty$, and the integral is linearly divergent. Let us try the subtraction trick again and see what happens:

$$g(x) - g(0) = \int y\,dy[1/(x+y) - 1/y] \tag{7}$$

$$= -x \int y\,dy/y(x+y) \tag{8}$$

$$= -x \int dy/(x+y) \tag{9}$$

$$= -xf(x). \tag{10}$$

The remainder is still divergent, but apart from the factor $-x$ it is our friend $f(x)$. Using the form we found for $f(x)$ [Eq. (5)], we can write $g(x)$ in terms of two divergent constants and a well-behaved function:

$$g(x) = g(0) - x[A + \bar{f}(x)] \tag{11}$$

$$= B - Ax + \bar{g}(x). \tag{12}$$

The constant term and the linear term involve infinite constants, but everything else about the x-dependence of $g(x)$ is now understood. The only divergences that we meet in QED are logarithmic and linear divergences, and these prototypes will serve as a guide for isolating the divergent components.

3.3. The Perturbation Expansion

For noninteracting particles the corresponding field theory description is one of linear field equations, completely soluble and easily quantized. Particle interactions, on the other hand, correspond to nonlinear terms in the field equations, and the quantum theory of nonlinear fields is a deep gloomy mess, with hardly any rigorous mathematical foundations at all. Our only hope for most practical purposes is to treat the interactions—the nonlinear terms—as a perturbation and look for a power series expansion in the interaction strength. In QED the interaction parameter is the electron charge e, and you end up with an expansion in powers of e^2, which on the relevant scale is the fine structure constant

$\alpha = e^2/\hbar c \approx 1/137$. The smallness of α means that you can get very nice convergence in low orders, without having to struggle with the question of whether the power series itself converges, which it probably does not. In strong interactions the expansion parameter is of order unity, and life gets particularly difficult since the perturbation expansion does not converge at all and nothing else works; I shall not try to deal with that problem here, though in fact a certain amount of progress has been made in dealing with it.

A fairly tidy way of introducing the perturbation expansion is through the time-development operator $U(t, t_0)$, defined by

$$\Psi(t) = U(t, t_0)\Psi(t_0), \qquad (13)$$

which expresses the state vector at an arbitrary time t in terms of the state vector at some initial time t_0. This relation is the result of formally integrating the time-dependent Schrödinger equation in the Interaction Picture, in which the time dependence of $\Psi(t)$ is governed by just the interaction term V in the Hamiltonian. The famous Heisenberg S matrix, which is the set of probability amplitudes for all possible physical processes and therefore contains all of physics, can be written as a set of matrix elements of $U(\infty, -\infty)$, the time-development operator for all of time:

$$S_{fi} = \langle f| U(\infty, -\infty)|i\rangle, \qquad (14)$$

taken between initial and final eigenstates of H_0, the free-particle Hamiltonian. (This expression in fact contains a divergent phase factor corresponding to the energy shift of the vacuum state due to the nonlinear terms in the field equations, i.e., a shift in the zero-point energy due to virtual interactions. This phase factor is unobservable, and is dealt with by dividing out the vacuum-to-vacuum matrix element of the S matrix. It does not constitute a practical problem at all, and I shall ignore it in the interest of tidiness.)

The perturbation expansion of the S matrix exhibits in a particularly neat form the role of virtual processes and virtual intermediate states:

$$S_{fi} = \delta_{fi} + \delta(E_f - E_i)[V_{fi} + \sum_\alpha V_{f\alpha}(E_i - E_\alpha)^{-1}V_{\alpha i}$$
$$+ \sum_{\alpha, \beta} V_{f\beta}(E_i - E_\beta)^{-1}V_{\beta\alpha}(E_i - E_\alpha)^{-1}V_{\alpha i} + \cdots]. \qquad (15)$$

(I am using a private system of units in which $\hbar = c = 2\pi = i = 1$.) The leading delta function δ_{fi} says that in zeroth order—in other words, in

the absence of any interactions—the final state must be the same as the initial state with probability one. The remaining terms all have an energy-conservation delta function and involve varying numbers of virtual intermediate states α, β, etc., with corresponding energy denominators that reflect energy nonconservation in virtual states. The states i, f, α, etc., are eigenstates of the unperturbed Hamiltonian H_0, with corresponding unperturbed energies E_i, E_α, and so on. Since these are not eigenvalues of the true Hamiltonian you need not expect exact energy conservation in these intermediate states. The expression $V_{\beta\alpha}$ is the matrix element of the interaction term between eigenstates α and β. In QED the interaction term has the general form

$$V = j_\mu A^\mu, \tag{16}$$

where the current j_μ is expressed in terms of the operators of the Dirac field:

$$j_\mu = e_0 \overline{\psi} \gamma_\mu \psi. \tag{17}$$

I am expressing the charge here as e_0, the charge parameter that appears in the Hamiltonian, which will turn out to be different from the physically observed charge e.

Because of the fact that H_0 describes an independent-particle system, each eigenstate i, f, α, β, etc., in the expansion (15) can be described in terms of single-particle states involving various numbers of photons, electrons, and positrons, and each virtual interaction $V_{\beta\alpha}$ corresponds to the emission or absorption of a virtual photon by an electron or positron, together possibly with the annihilation or creation of an electron–positron pair. It follows from this that any term in this expansion can be described pictorially, with the succession of electron, positron, and photon states represented by lines in a diagram. A few of the diagrams for Compton scattering are shown in Fig. 3.1, with time running from right to left to correspond to the order of factors in Eq. (15). You should note that these diagrams can be thought of as precursors of Feynman graphs, but are not Feynman graphs themselves, as I will presently explain. The solid lines represent electrons and positrons, with the convention that an arrow directed forward in time represents an electron, and an arrow directed backward represents a positron. There is no question here of an electron traveling backward in time, though Feynman himself liked to think in those terms; the state α in the third diagram is simply a

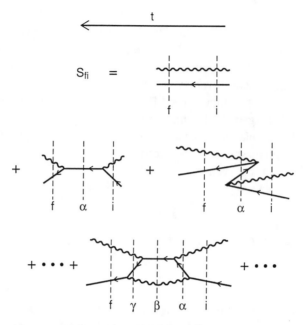

FIGURE 3.1. Pictorial representation of the perturbation expansion for Compton scattering. Solid lines with arrows toward the left represent electrons, solid lines with arrows toward the right represent positrons, and wavy lines represent photons. Time runs from right to left. These are *not* Feynman diagrams.

state with two electrons, two photons, and a positron. The direction of the arrows is chosen to give continuity to the electron/positron line as it runs through the picture, and reflects the conservation of electron number.

The first diagram in Fig. 3.1 corresponds to the first term in Eq. (15), in which the photon misses the electron. In the second diagram the initial photon is first absorbed, so that the intermediate state α consists of just a single electron, which subsequently emits a photon in the appropriate final state determined by $|f\rangle$. Note that the system could go into all sorts of different final states; what we are calculating is just the amplitude for a particular choice of $|f\rangle$. The third diagram is a distortion of the second, corresponding however to a very different set of virtual processes. First comes the spontaneous creation of a photon and an electron–positron pair (without any interaction with the electron and photon of the initial state), and then the positron annihilates the initial

electron while absorbing the initial photon, leaving the other electron and photon in the final state $|f\rangle$. All these virtual processes are perfectly possible since we do not require that energy be conserved in intermediate states. The fourth picture represents a typical higher-order term involving both virtual electrons and a virtual photon.

3.4. Feynman Graphs

The perturbation expansion that we have been looking at is global in character, and can be applied to any physical system. When the unperturbed Hamiltonian describes a system of independent particles, as ours does, it becomes possible to reduce the expansion to components involving the individual particles and their interactions, rather than working with eigenstates of the entire system. The result of such a reduction is the Feynman graph expansion, which is perhaps best characterized in this way. Feynman graphs are thus not especially associated with QFT, except through the fact that QFT is a way of representing a system of interacting particles; if you start with the many-particle Schrödinger equation, for example, and reduce the perturbation expansion to single-particle components you can get a Feynman graph expansion without bringing in QFT at all.

The result of this reduction in the case of QED is an expansion whose terms are in one-to-one correspondence with a set of diagrams very much like the ones in Fig. 3.1, but without any specified time ordering of the virtual interactions. Thus the second and third diagrams of Fig. 3.1 are included in a single Feynman graph that can be drawn to look like either one of those two. The components of the Feyman graph are electron/positron lines (solid lines with an arrow), photon lines (wavy lines without an arrow), and vertices where three lines come together, along with a prescription giving the appropriate factor for each of these components. The prescription takes different forms depending on whether you are working in configuration space or momentum space, and I give first, in Fig. 3.2, the form it takes in configuration space since that is most directly related to the sequences of virtual interactions familiar from conventional perturbation theory.

In an nth-order graph there are n vertices, with each vertex labeled with a location x_i in space time. Associated with that vertex there are

$$P_x : \quad \text{(diagram)} \quad = e\gamma_\mu \int d^4 x$$

$$\text{(diagram, } x_2,\mu \text{ to } x_1,\nu) \quad = D_F^{\mu\nu}(x_2 - x_1)$$

$$\text{(diagram, } x_2 \text{ to } x_1) \quad = S_F(x_2 - x_1) \qquad \text{(4x4 Spinor Matrix)}$$

	e^-	e^+	γ
f:	$= \bar{u}(x)$	$= \bar{v}(x)$	$= w^{\lambda *}(x)$
i:	$= u(x)$	$= v(x)$	$= w^\lambda(x)$

FIGURE 3.2. The Feynman graph prescription. Particles present in the initial state i are represented by lines entering from the right, and particles present in the final state f are represented by lines leaving on the left.

factors $e_0\gamma_\mu$, where γ_μ is the Dirac matrix 4-vector, and an integration over x_i. Each photon line corresponds to a Green's function $D_F^{\mu\nu}(x_j - x_i)$ which represents the causal propagation of a photon from the earlier of the two arguments to the later. It was one of the special achievements of Feynman to develop these causal propagators, widely referred to as Feynman Green's functions, so that the x integrations can be done freely without regard to time ordering, and each Feyman graph can include all possible time orderings in a single expression. The electron line corresponds to another Feyman Green's funtion $S_F(x_j - x_i)$ which represents the propagation of an electron from x_i to x_j if x_i is the earlier time, and the propagation of a positron from x_j to x_i if x_j is earlier. In each case the Green's function is strictly causal. The electron Green's function has the character of a Dirac spinor matrix: a 4×4 matrix function of the arguments. Both D_F and S_F are known functions (Bessel functions with carefully defined singularity structures on the light cone), and are Green's functions for Maxwell's equations and the Dirac equation, respectively. The final ingredients of the prescription are the external lines associated with the initial and final states $|i\rangle$ and $|f\rangle$. They correspond

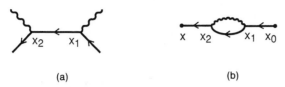

(a) (b)

FIGURE 3.3. Feynman graphs corresponding to (a) Eq. (18) and (b) Eq. (19).

to simple spinor wave functions for the initial or final electrons and positrons, and simple factors in the case of photons that can be thought of as wave functions representing specified polarization states.

By way of example, look at the expressions corresponding to the two diagrams shown in Fig. 3.3. Figure 3.3(a) is a term in the S matrix for Compton scattering, corresponding to the sum of the two second-order terms in Fig. 3.1:

$$S_{fi}^{(a)} = e_0^2 \int d^4x_1\, d^4x_2\, w_f^{\nu*}(x_2) u_f(x_2) \gamma_\nu S_F(x_2 - x_1) \gamma_\mu u_i(x_1) w_i^\mu(x_1). \quad (18)$$

Figure 3.3(b) represents a subgraph, running between two vertices of some larger graph. This type or subgraph is called a self-energy graph because it contributes to a shift in the measured rest mass of the electron, as I shall presently show you. The corresponding expression, following the prescription, is

$$G^{(b)} = e_0^2 \int d^4x_1\, d^4x_2\, S_F(x - x_2)$$

$$\times\ \gamma_\mu S_F(x_2 - x_1) \gamma_\nu S_F(x_1 - x_0) D_F^{\mu\nu}(x_2 - x_1). \quad (19)$$

This turns out to be one of our diseased expressions, because the singularity of $S_F(x_2 - x_1)$ sits right on top of the singularity of $D_F^{\mu\nu}(x_2 - x_1)$ at $x_2 = x_1$, creating an undefined singularity. This is the manifestation in configuration space of what we will see as an ultraviolet divergence in energy-momentum space. For the present I shall ignore these difficulties, since I am only trying to set up the formalism at this point. Note that in both of these examples the integrations over space time are unrestricted, so that in Eq. (19), for example, there are 24 possible orderings for the 4 space-time points x, x_2, x_1, and x_0, which would have had to be separately enumerated if it were not for the special inclusiveness of the Feynman Green's functions.

$$R : \quad = e\gamma_\mu \, \delta^4(p'-p-k)$$

$$\quad = \int d^4k D_F^{\mu\nu}(k) \cdots \qquad D_F^{\mu\nu} = \frac{g^{\mu\nu}}{k^2+i\eta}$$

$$\quad = \int d^4p S_F(p) \cdots \qquad S_F = (\gamma{\cdot}p - m_0 + i\eta)^{-1}$$

	e^-	e^+	γ
f:	$= \bar{u}(p)$	$= \bar{v}(p)$	$= w^{\lambda *}(k)$
i:	$= u(p)$	$= v(p)$	$= w^{\lambda}(k)$

FIGURE 3.4. Feynman graph prescription in momentum space.

It is formally straightforward to rewrite the prescription in energy-momentum space (which I shall often refer to simply as momentum space). Each Green's function and wave function is expressed in terms of its four-dimensional Fourier transform, which means that each of the variables x_i appears only in exponential functions of the form $e^{iq\cdot x}$. Each integration over a space-time variable x_i now yields a four-dimensional delta function involving the 4-momenta of the three virtual particles that interact at x_i, and you end up with a new prescription, illustrated in Fig. 3.4. Each vertex still has the factors $e_0\gamma_\mu$ as before, with the space-time integration replaced by a four-dimensional delta function expressing conservation of energy and momentum in that virtual interaction. Each electron line gives a Fourier transformed Green's function $S_F(p)$ and an integration over the 4-momentum p, while each photon line gives a transformed Green's function $D_F^{\mu\nu}(k)$ and an integration over the 4-momentum k. The external lines correspond to transformed wave functions which have a simple form that is not relevant to our discussion. The transformed Green's functions have the following simple algebraic forms:

$$S_F(p) = (\gamma \cdot p - m_0 + i\eta)^{-1}, \tag{20}$$

$$D_F^{\mu\nu}(k) = g^{\mu\nu}/(k^2 + i\eta). \tag{21}$$

The Minkowski space metric tensor $g^{\mu\nu}$ that appears as a factor in $D_F^{\mu\nu}$ is the simple end result or some manipulations that depend in a somewhat devious way on how you deal with gauge freedom in the process of quantizing the EM field. The parameter η is an artificial positive infinitesimal introduced to give unambiguous definition to these functions where they become singular. The particular way η appears here is chosen so that the Green's functions satisfy the Feynman causality conditions mentioned previously, as I will explain at the end of this section. The quantity m_0 is the electron mass parameter that appears in the Hamiltonian. It is not expected to be equal to the physical mass because the latter is affected by virtual interactions with the EM field as I have mentioned.

The Green's functions become singular when the energy-momentum 4-vector satisfies the free-particle relation:

$$k^2 = 0 \tag{22}$$

in the case of photons and

$$p^2 = m_0^2 \tag{23}$$

in the case of electrons. This singularity surface (hypersurface, really) is referred to as the "mass shell"; in conventional terms it is where the energy has its free-particle value as a function of the momentum. For electrons this is of course simply

$$E = \sqrt{|\mathbf{p}|^2 + m_0^2}, \tag{24}$$

and for photons it is

$$E = |\mathbf{k}|. \tag{25}$$

You will notice that both energy and momentum now appear to be conserved in each virtual interaction because of the energy-momentum delta function associated with each vertex, but that is deceptive. The energy of each virtual particle is not the free-particle energy given by Eq. (24) or (25), but an independent variable of integration. Thus there is an energy variable, which you might call the "virtual energy," that *is* conserved, while the violation of energy conservation shows up in the fact that the 4-momenta p and k are generally not on the mass shell. Energy and momentum variables are now on a completely equal footing.

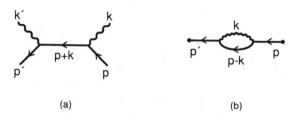

FIGURE 3.5. Feynman graphs in momentum space corresponding to (a) Eq. (18) and (b) Eq. (19).

The two sample diagrams of Fig. 3.3 are redrawn in Fig. 3.5 with labeling appropriate to the momentum-space prescription, and the corresponding expressions are

$$S_{fi}^{(a)} = e_0^2 \delta^4(p' + k' - p - k) w_f^{\nu*}(k') \bar{u}_f(p') \gamma_\nu S_F(p + k) \gamma_\mu u_i(p) w_i^\mu(k), \quad (26)$$

$$G^{(b)} = e_0^2 \delta^4(p' - p) S_F(p') \left[\gamma_\mu \int d^4k\, S_F(p - k) D_F^{\mu\nu}(k) \gamma_\nu \right] S_F(p) \quad (27)$$

$$= \delta^4(p' - p) S_F(p) \Sigma(p) S_F(p). \quad (28)$$

In the first expression, Eq. (26), the two momentum delta functions have been combined to give an overall delta function expressing the conservation of energy and momentum between the initial and final states, and one of the two original delta functions has been used to eliminate a 4-momentum integration for the virtual electron. The internal delta functions in every graph can always be combined to give an overall 4-momentum delta function expressing the global conservation law. In the second expression, Eq. (27), one of the delta functions is again used to reduce the number of integrations. The expression in square brackets, representing the loop part of the graph, is formally just a function of p, referred to as a "proper" self-energy graph, which I have called $\Sigma(p)$ in Eq. (28) and which I will define more carefully in Sec. 3.5.

By counting powers of k in the integrand in Eq. (27), you can see that the integral is linearly divergent. There are just three basic kinds of divergent graphs, which I will describe in Sec. 3.5. They are the electron self-energy graphs, photon self-energy graphs, and "vertex graphs," which are subgraphs connected to the other parts of a graph by just two electron lines and one photon line.

I would like to return here to the infinitesimal η that appears in

the Green's functions of Eqs. (20) and (21), and its relation to causality. What is relevant here is a mathematical property of Fourier transforms: the causality properties of a function of the time $f(t)$ are related to the analytic properties of its Fourier transform $g(\omega)$. This can be seen in two ways. Suppose $f(t - t')$ is a time-propagation function, and its transform is given by

$$g(\omega) = \int f(t)e^{i\omega t}\, dt, \tag{29}$$

where the integral is from $-\infty$ to $+\infty$. For f to be causal means that $f(t - t')$ is zero when $t' < t$, i.e., when the argument is negative. That means that the integral in Eq. (29) is in fact an integral from 0 to ∞, and converges to an analytic function of ω for any complex ω in the upper half-plane I_+. *The Fourier transform of a causal function is analytic in the upper half-plane.* Conversely, you can express $f(t - t')$ in terms of $g(\omega)$ by the inversion theorem

$$f(t - t') = \int g(\omega)e^{-i\omega(t-t')} \tag{30}$$

apart from numerical factors. If the function g is reasonably well-behaved then for $t - t'$ negative the integration contour can be closed in I_+, and the integral is zero by Cauchy's theorem if g has no singularities in I_+.

A toy model for a Green's function could be a function of a single energy variable ω:

$$g(\omega) = 1/(\omega - \omega_0), \tag{31}$$

with the "free-particle energy" represented by the value ω_0. There is an arbitrariness in how to deal with the singularity at ω_0 in doing the Fourier inversion (30), corresponding exactly to the arbitrariness in choice of boundary condition for the Green's function as a function of time: $f(t - t')$. The way to make $f(t - t')$ causal is to displace the singularity in $g(\omega)$ to the negative half-plane by adding $i\eta$ to the denominator:

$$g(\omega) = 1/(\omega - \omega_0 + i\eta). \tag{32}$$

You can easily check that the transform of g involves the step function $\theta(t - t')$, so that it is zero for $t < t'$:

$$f(t - t') = -i e^{-i\omega_0(t-t')}\theta(t - t'), \tag{33}$$

and that it satisfies the Green's function-type equation:

$$(i\partial/\partial t - \omega_0)f(t - t') = \delta(t - t'). \tag{34}$$

In the covariant Green's functions of Eqs. (20) and (21) the role of η gets more complicated. The functions are not causal in the conventional sense that their transforms are simply zero for $t < t'$, but rather causal in the Feynman sense, described earlier: the part of $S_F(x - x')$ describing electrons is zero for $t < t'$, and the part describing positrons is zero for $t' < t$. Similar appropriate constraints are satisfied by the photon Green's function.

3.5. Self-Energy Graphs and Vertex Graphs

I want to introduce you now to the "dressed" electron propagator $S'_F(p)$, defined as the sum of all the possible subgraphs that join just two vertices. It is depicted in Fig. 3.6, first as a vague blob to represent all the different things that might appear, and then given the symbol of a double line so that it can be included as a component of Feynman graphs where appropriate. As Fig. 3.6 goes on to suggest, $S'_F(p)$ is the sum of many graphs, each of which consists of a sequence of proper self-energy parts joined by single Green's functions $S_F(p)$. When you have summed over all the different ways this can occur you end up with a geometric series in which the factors are matrices:

$$S'_F(p) = S_F(p) + S_F(p)\Sigma(p)S_F(p) + S_F(p)\Sigma(p)S_F(p)\Sigma(p)S_F(p) + \cdots. \tag{35}$$

FIGURE 3.6. The electron self-energy function.

Here $\Sigma(p)$ now represents the sum of *all* proper self-energy graphs, where "proper self-energy graphs" are those that cannot be drawn as two or more parts joined by single electron lines. This series can be formally summed, just like a simple geometric series, despite the fact that the terms involve matrices. To see this, you go through the following steps:

$$S'_F(p) = S_F(p) + S_F(p)\Sigma(p)[S_F(p) + S_F(p)\Sigma(p)S_F(p) + \cdots] \tag{36}$$

$$= S_F(p) + S_F(p)\Sigma(p)S'_F(p). \tag{37}$$

You now multiply both sides on the left by $S_F(p)^{-1}$, which by Eq. (20) is just the matrix $\gamma \cdot p - m_0$ (the infinitesimal η can be neglected here, it turns out), and you get

$$(\gamma \cdot p - m_0)S'_F(p) = I + \Sigma(p)S'_F(p), \tag{38}$$

from which, collecting terms and solving for $S'_F(p)$, you get

$$S'_F(p) = [\gamma \cdot p - m_0 - \Sigma(p)]^{-1}. \tag{39}$$

You may wonder about the convergence of the infinite series (35) which I have rather casually summed for you. In fact, the nonperturbative relation (39) is more fundamental in character than the expansion (35), and if the series does not converge you can still rely on Eq. (39). The dressed propagator $S'_F(p)$ contains a complete description of the physical free electron, accompanied by its cloud of virtual photons and pairs as represented by the sequence of subgraphs shown in Fig. 3.6.

The physical mass is determined by the singularity structure of $S'_F(p)$. A pole in the propagator corresponds to a value of the 4-vector p for which the propagation is undamped, so that, for that 4-vector, p^0 is the energy of a physical particle of momentum \mathbf{p}. The location of a pole in the variable p^0, then, determines the mass shell for the physical electron. For reasons of covariance the determinant of the matrix $[\gamma \cdot p - m_0 - \Sigma(p)]$ can only be a function of p^2, so that the pole is in fact a pole in $S'_F(p)$ with respect to the variable p^2, at a definite value m_R^2:

$$p^2 = m_R^2 \tag{40}$$

or

$$E = \pm\sqrt{|\mathbf{p}|^2 + m_R^2}, \tag{41}$$

and m_R is the physical or "renormalized" electron mass. It is the presence of the self-energy function $\Sigma(p)$ in Eq. (39) that causes the shift in the

$$D_F'(k) = $$

$$= $$

$$\Pi(r) = $$

FIGURE 3.7. The photon self-energy function.

pole of $S_F'(p)$ from m_0^2 to m_R^2, which is why it is called the self-energy function.

Note that even in a theory with no divergences at all you would not know m_0 to start with. It has to be determined by fitting m_R to the observed physical mass. If you do have divergences, it is m_0 that takes on a crazy value; m_R is given experimentally. For the present I am just pointing out that $\Sigma(p)$ is one of the infinite functions, analogous to $g(x)$ in Eq. (6) actually, that we shall have to deal with.

The discussion of the photon self-energy function, called $\Pi(k)$, and the dressed photon propagator $D_F'(k)$ (omitting indices) follows exactly the same lines as that for the electron. The pictures are in Fig. 3.7, and the sum looks just like the previous one, with

$$D_F'(k) = D_F(k) + D_F(k)\Pi(k)D_F(k) + D_F(k)\Pi(k)D_F(k)\Pi(k)D_F(k) + \cdots \quad (42)$$

$$= [k^2 - \Pi(k)]^{-1}. \quad (43)$$

This is again a matrix equation, in the indices μ and ν, and again the infinitesimal η can be dropped, basically because the self-energy functions Σ and Π themselves carry negative imaginary parts. There are some major differences between this and the electron case, due to the complications associated with gauge invariance and the various possible ways or choosing the gauge. One particular difference is that the photon mass is zero, both before and after renormalization, which gives you a kind of formal proof that the apparently divergent quantity $\Pi(0)$ has to be zero!

The third kind of divergence we have to deal with occurs in the "vertex function" $\Gamma_\mu(p', p)$, shown in Fig. 3.8, which is the sum of all the subgraphs joined to the outside world by just two electron lines and a photon line. These three legs are not allowed to have self-energy parts on them. It is

$$\Gamma_\mu(p',p) =$$

$$= \quad + \quad + \cdots$$

$$= \gamma_\mu + \Lambda_\mu(p',p)$$

FIGURE 3.8. The vertex function.

convenient for our discussion to split $\Gamma_\mu(p', p)$ into a simple vertex γ_μ and a divergent part Λ_μ:

$$\Gamma_\mu(p', p) = \gamma_\mu + \Lambda_\mu(p', p). \tag{44}$$

The vertex functions are only logarithmically divergent, and play the role of $f(x)$ in our toy model, Eq. (1).

As you might guess from the examples, graphs tend to be more convergent the more legs they have. On the face of it, by simple-minded counting of powers of p and k plus an appeal to charge conservation in the case of the four-photon function, the graphs with four or more legs should be convergent so long as they do not have divergent self-energy or vertex subgraphs. The graph with three photon legs has to be identically zero by an argument due to Furry, and can therefore be neglected even though it looks divergent. The detailed proof that there are no further pitfalls is very difficult, and was finally accomplished by Steven Weinberg in 1960. My description ignores a number of such problems in the interest of making the general picture as clear as possible.

What we have done is to isolate the virus: the difficulties arise in vertex and self-energy parts, which may occur in all sorts of places throughout a given Feynman graph. The next question is whether we can unambiguously locate these divergent parts in a given graph, so that we can analyze the effect of the infinite constants that they contain. The answer turns out to be yes, except in the interior of a self-energy graph where the divergent vertex parts can actually overlap. We can get around this problem in various ways, the most elegant being the use of

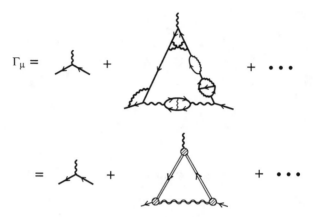

$$\Gamma_\mu = \quad + \quad + \cdots$$

$$= \quad + \quad + \cdots$$

FIGURE 3.9. Self-energy and vertex subgraphs.

the Ward–Takahashi identity, which relates the electron self-energy function explicitly to the vertex function, as I shall describe in Sec. 3.6. Another trick, which I shall not go into, deals similarly with the photon self-energy.

The next step in the discussion is to express each Feynman graph in terms of the functions Γ_μ, S'_F, and D'_F, in much the same way as when I used the full self-energy functions Σ and Π to construct the propagators S'_F and D'_F. This procedure is illustrated in Fig. 3.9, where a typical graph in the vertex function Λ_μ is seen to have all kinds of vertex and self-energy subgraphs. All of these components, and in fact lots of other graphs with the same basic structure, will automatically be included if you insert the full vertex function Γ_μ at each of the three corners and the dressed propagators S'_F and D'_F in the appropriate places, as shown in the second line of Fig. 3.9. This process can be carried out consistently for all Feynman graphs except self-energy graphs, as I mentioned, and provides the basis for a systematic analysis of how the infinite constants affect a given graph, as I shall show you in Sec. 3.6.

3.6. Primitive Renormalization

In three space-time dimensions life is really simple. The vertex function is convergent and only the self-energy diverges. The electron self-energy diverges logarithmically, and we can control it with a single subtraction as in Eq. (4). You would then write

$$\Sigma(p) = A + \bar{\Sigma}(p), \tag{45}$$

where A is an infinite multiple of the unit matrix (by covariance) and $\bar{\Sigma}(p)$ is a finite matrix function of p. When you plug this into Eq. (39) you get

$$S_F'(p) = [\gamma \cdot p - m_0 - \Sigma(p)]^{-1} \tag{46}$$

$$= [\gamma \cdot p - m_0 - A - \bar{\Sigma}(p)]^{-1}, \tag{47}$$

and you exercise your freedom to adjust m_0 to make the combination $m_0 + A$ finite. By making a finite shift in the way you perform the separation (45) you can in fact set $m_0 + A$ *equal to* m_R:

$$m_0 + A = m_R, \tag{48}$$

and still keep the pole in $S_F'(p)$ at $p^2 = m_R^2$ as required by Eq. (40). So you have

$$S_F'(p) = [\gamma \cdot p - m_R - \bar{\Sigma}(p)]^{-1}, \tag{49}$$

and everything is finite. I am ignoring the photon, which is a bit more difficult, because I am really just leading up to the additional difficulty that we have in four space-time dimensions, where $\Sigma(p)$ is linearly divergent.

The toy model, Eq. (12), says that $\Sigma(p)$ has two bad terms, the constant and a term linear in p. Because of covariance it must take the form

$$\Sigma(p) = B - A\gamma \cdot p + \bar{\Sigma}(p), \tag{50}$$

and then $S_F'(p)$, after substitution of this into Eq. (46), would have the form

$$S_F'(p) = [(1 + A)\gamma \cdot p - (m_0 + B) - \bar{\Sigma}(p)]^{-1}. \tag{51}$$

This is not so nice. You cannot ignore the infinite factor on $\gamma \cdot p$, so there is no way you can make $S_F'(p)$ a finite function.

What Eq. (51) seems to be saying is that you have to rescale $S_F'(p)$, and write

$$S_F'(p) = (1 + A)^{-1} [\gamma \cdot p - \cdots]^{-1}, \tag{52}$$

with the hope that when the dust settles the other terms inside the brackets will turn out to be OK. $S_F'(p)$ is not itself a measurable quantity; the physical properties of the electron are given by the functional dependence of $S_F'(p)$, especially the location of the pole, but are not affected by

the rescaling. You have to recognize, though, that every Feynman graph has factors $S_F'(p)$ inside it as subgraphs, so these rescaling factors are going to produce a possible rescaling of every Feynman graph. *This rescaling operation is called the "renormalization program," and forms the meat of this chapter.*

3.7. The Renormalization Program

We start with an ansatz, asking that each of the three basic functions Γ_μ, S_F', and D_F' be equal to a finite function apart from some scale factor. Taking advantage of some inside information to relate some of the scale factors so as to avoid extraneous explanations, I propose the scaling relations:

$$\Gamma_\mu(p',p) = Z_1^{-1}\Gamma_\mu^R(p',p), \tag{53}$$

$$S_F'(p) = Z_1 S_F^R(p), \tag{54}$$

$$D_F'(k) = Z_3 D_F^R(k), \tag{55}$$

together with a charge renormalization (since the observed charge will clearly differ from the charge parameter in the Hamiltonian, just like the mass):

$$e_0 = Z_3^{-1/2} e_R. \tag{56}$$

We have to try to show that by suitably adjusting the scale factors Z_1 and Z_3 and the bare mass and charge m_0 and e_0 we can make the scheme internally consistent, with all three of the renormalized functions Γ_μ^R, S_F^R, and D_F^R finite except at their physically appropriate singularities. And there is a final requirement: the S-matrix elements must also be finite. You are not allowed to rescale the S matrix, because it is a set of probability amplitudes and probabilities are physical. I shall focus on the requirement of self-consistency among the renormalized functions, and only say a few words later on about the additional steps needed to deal with the S matrix itself.

Let us start with the vertex function Γ_μ, expressed in terms of its divergent part Λ_μ by Eq. (44). Look at the leading term in Λ_μ as shown in Fig 3.9, expressed now in terms of the basic functions we are interested in. Schematically the rescaling works like this:

$$\Lambda = e_0^2 \int \Gamma\Gamma\Gamma S_F' S_F' D_F' \tag{57}$$

$$= (Z_3^{-1/2} e_R)^2 \int (Z_1^{-1}\Gamma^R)(Z_1^{-1}\Gamma^R)(Z_1^{-1}\Gamma^R)(Z_1 S_F^R)(Z_1 S_F^R)(Z_3 D_F^R) \tag{58}$$

$$= Z_1^{-1}\tilde{\Lambda}, \tag{59}$$

where

$$\tilde{\Lambda} = e_R^2 \int \Gamma^R\Gamma^R\Gamma^R S_F^R S_F^R D_F^R, \tag{60}$$

an expression with all the scale factors removed and a finite integrand, but still logarithmically divergent. It is pretty easy to show that for more complex graphs of the sort shown in Fig. 3.9 the overall scale factor always reduces to Z_1^{-1}, just as here. To see this, consider what happens when you insert a photon line: in addition to the photon line you get two more vertex functions, two more electron propagators, and two more factors of e_0. This produces additional scale factors Z_3, Z_1^{-2}, Z_1^2, and Z_3^{-1}, respectively, or a net factor of 1. Since an arbitrary graph can be built up by adding photon lines, and occasional new electron loops which do not alter the count, we see that the scale factor is always the same. Assuming (rightly, in fact) that every such graph gives a contribution to $\tilde{\Lambda}$ that is simply logarithmically divergent when all the various integrations are pulled together, and that a single subtraction, as in the toy function $f(x)$, Eq. (3), is enough to control the divergence, you can proceed as follows:

First,

$$\tilde{\Lambda}_\mu = A\gamma_\mu + \bar{\Lambda}_\mu, \tag{61}$$

where the constant term must be proportional to γ_μ for covariance. You substitute this into Eq. (59) and then make successive substitutions into expressions (44) for Γ_μ and (53) for Γ_μ^R, giving

$$\Gamma_\mu^R = Z_1 \Gamma_\mu \tag{62}$$

$$= Z_1(\gamma_\mu + \Lambda_\mu) \tag{63}$$

$$= Z_1[\gamma_\mu + Z_1^{-1}(A\gamma_\mu + \bar{\Lambda}_\mu)] \tag{64}$$

$$= (Z_1 + A)\gamma_\mu + \bar{\Lambda}_\mu. \tag{65}$$

Note the cancellation of scale factors in the interesting term $\overline{\Lambda}_\mu$. Now Z_1 is at our disposal, so we can use it to reduce the first coefficient to unity, and since $\overline{\Lambda}_\mu$ is understood to be finite we are in business:

$$\Gamma_\mu^R = \gamma_\mu + \overline{\Lambda}_\mu. \tag{66}$$

You see that the single infinite constant generated by the logarithmic divergences in all the vertex graphs can be absorbed in a physically unobservable scaling factor.

Next we look at the electron self-energy function $\Sigma(p)$, which is linearly divergent. Following the example of the toy function $g(x)$, let us start by subtracting $\Sigma(0)$, which reduces the remainder to a logarithmic divergence. By a happy chance there is a famous relationship, known as the Ward–Takahashi identity, that expresses this difference in terms of the vertex function Λ_μ, which we have already dealt with. The relation is

$$\Sigma(p) - \Sigma(0) = -p^\mu \Lambda_\mu(p, 0), \tag{67}$$

where the repeated index μ is summed over by the usual summation convention. You could proceed without such an identity, but the unambiguous handling of infinities is made much easier with it. Using the expression already obtained for Λ_μ [Eqs. (59) and (61)] we can immediately write $\Sigma(p)$ as

$$\Sigma(p) = B - Z_1^{-1} p^\mu [A\gamma_\mu + \overline{\Lambda}_\mu(p, 0)] \tag{68}$$

$$= B + Z_1^{-1}[-A\gamma \cdot p + \overline{\Sigma}(p)], \tag{69}$$

with a new infinite constant B [$\equiv \Sigma(0)$] to be dealt with and with the finite function $-p \cdot \overline{\Lambda}$ represented by $\overline{\Sigma}$. Now work out $S_F^R(p)$, or better yet $[S_F^R]^{-1}$, using this result along with Eqs. (39) and (54):

$$S_F^R(p)^{-1} = Z_1 S_F'(p)^{-1} \tag{70}$$

$$= Z_1[\gamma \cdot p - m_0 - \Sigma(p)] \tag{71}$$

$$= Z_1\{\gamma \cdot p - m_0 - B - Z_1^{-1}[-A\gamma \cdot p + \overline{\Sigma}(p)]\} \tag{72}$$

$$= (Z_1 + A)\gamma \cdot p - Z_1(m_0 + B) - \overline{\Sigma}(p). \tag{73}$$

So what have we got? The coefficient of $\gamma \cdot p$ is the same as the coefficient of γ_μ in Γ_μ^R, Eq. (65), which we have set equal to 1 by choosing Z_1. We still have the freedom to choose m_0, and so we can make the constant term equal to $-m_R$, the physical mass, and end up with the finite form

$$S_F^R(p)^{-1} = \gamma \cdot p - m_R - \overline{\Sigma}(p). \tag{74}$$

FIGURE 3.10. A contribution to Compton scattering involving wave function renormalization.

I want to make it clear that I have not dealt dishonestly with our infinities. We do not ignore them, but carefully show that they affect only certain unobservable scale factors and unobservable mass and charge parameters.

I am not going to work out here the renormalization of the photon propagator $D'_F(k)$, mainly because there are complications that would spoil the clarity of my presentation and open up a collection of side issues that are not relevant to the main idea of this chapter. In brief, the photon self-energy function $\Pi^{\mu\nu}(k)$ is on the face of it even more divergent than the electron self-energy, but it then turns out that the most divergent parts have to be zero, as a consequence of electric charge conservation. This means, however, that the subtraction procedure does not follow the simple pattern I have been using, and a very different approach would have to be presented. The end result is that the infinite constants either are forced to be identified as zero on physical grounds or else get absorbed in the scale factor Z_3, which we are still free to choose.

The final step in the renormalization program is to show that the S matrix is finite and does not acquire a scaling factor. I have to confess now that there is one more type of rescaling going on that I have not told you about, namely rescaling of the wave functions u, v, and w that correspond to the external legs of the Feynman graphs (see Figs. 3.2 and 3.4). What causes this rescaling is the occurrence of self-energy subgraphs in these external legs, as illustrated in Fig. 3.10. This again complicates the discussion, which I am always hoping to keep simple; the end result of a careful analysis is simply a scale factor $\sqrt{Z_1}$ for each electron or positron leg, and a factor $\sqrt{Z_3}$ for each photon leg. The functional dependence of the wave functions does not get changed, except that they get reevaluated in terms of the physical electron mass m_R rather than the bare mass m_0. The reason is basically that the 4-momenta associated with the external legs are always on the mass shell, where $p^2 = m_R^2$ and $k^2 = 0$;

since any extra functional dependence would basically involve only the invariants p^2 or k^2, there is no room for anything but an extra constant factor. If you look at the scale factors associated with the lowest-order graph for Compton scattering but with vertex functions and dressed electron propagator, as in Fig. 3.10, you get the schematic form

$$S_{fi} \approx e_0^2 \int w^* \bar{u} \Gamma S_F' \Gamma u w \tag{75}$$

$$= (Z_3^{-1/2} e_R)^2 \int (Z_3^{1/2} w^*)(Z_1^{1/2} u)$$

$$\times (Z_1^{-1} \Gamma^R)(Z_1 S_F^R)(Z_1^{-1} \Gamma^R)(Z_1^{1/2} u)(Z_3^{1/2} w) \tag{76}$$

$$= e_R^2 \int w^* \bar{u} \Gamma^R S_F^R \Gamma^R u w. \tag{77}$$

As discussed earlier, you can construct more complicated graphs by inserting photon lines into the simplest graphs and such insertions do not in fact alter the overall scale factor, and so it works out quite generally that the S matrix does not get rescaled, just as we wished.

3.8. Discussion

I hope you understand that I do not pretend to have given you a proof of renormalizability, but only a sketch of the ideas involved, how the problems arise, and maybe a feeling for how we are able to handle the infinities and still have some confidence in the final calculations. In this section I want to remind you of some of the major points that I have tried to make, and tell you a few of the things I have not even begun to deal with.

First, the points I would like you to remember:

1. The Feynman graph expansion is the perturbation expansion for a system of particles, reduced to single-particle components.
2. The infinities we encounter reflect our ignorance of how to deal with the wide range of possible virtual processes at very high energy.
3. A renormalizable theory is one in which physical results at any given energy are insensitive to virtual processes at very high energy.
4. The renormalization of such a theory involves a small number of

infinite constants that have no effect on measurable quantities, and that can be identified as scale factors and renormalizations of masses and coupling constants.

Next, a partial list of things I have not dealt with:

1. Proof that higher-order graphs have no hidden divergences.
2. Regularization: the machinery for cutting off divergent integrals to allow the cancellation of infinite constants to be done unambiguously.
3. The requirements of Lorentz and gauge invariance, and the role these play in making regularization possible.
4. The complications that arise with non-Abelian gauge theories.
5. The additional ferocious complications that come with spontaneous symmetry breaking and the induced mass of gauge quanta.
6. Problems with "anomalies": contradictions between the classical symmetries of a theory and the renormalization process that arise in theories involving axial vector currents, as in the Weinberg–Glashow–Salam theory of the electroweak interactions.
7. The renormalization group: the mathematical group of finite rescalings of a renormalized field theory, a powerful technique that yields information about the content of the theory at widely different energy scales.

New Philosophy of Renormalization: From the Renormalization Group Equations to Effective Field Theories

Tian Yu Cao

The conceptual foundations of renormalization theory has undergone radical transformations during the last four decades. These changes are the result both of attempts to solve conceptual anomalies within the theory itself, and of fruitful interactions between quantum field theory (QFT) and statistical physics. Implicit assumptions concerning such concepts as regularization, cutoff, dimensionality, symmetry, and renormalizability have been clarified, and the original understanding of these concepts is being transformed. New concepts involve symmetry breaking, either spontaneous or anomalous, renormalization group transformations, decoupling of high-energy processes from low-energy phenomena, sensible nonrenormalizable theories, and effective field theories. These have been developed, drawing heavily on dramatic progress in statistical physics. The purpose of this essay is to examine these foundational transformations (Sec. 4.2), and to show that these advances have led to a new understanding of renormalization, a clarification of the theoretical structure of QFT and its ontological basis, and most importantly, a radical shift of outlook in fundamental physics (Sec. 4.3). For this purpose, however, a clarification of the conceptual background is indispensable (Sec. 4.1).

4.1. Conceptual Background

The renormalization theory is a complicated conceptual system whose content can be understood from various perspectives. First, the renormalization procedure can be viewed as a technical device that gets rid of infinite results occurring in the QFT calculations.[1] Second, the concept of renormalization helps to clarify the conceptual basis of QFT and to establish its consistency. Third, the concept of renormalizability can also be elevated to the status of a regulative principle, guiding the theory building and theory selection within the general framework of QFT. Historically, the emergence of the renormalization theory in the late 1940s was a response to the divergence difficulty of QFT, technical and conservative in character. It was technical because it involved a series of steps for matching the experimental results obtained by, e.g., Lamb (1947) and Rabi (see Nafe 1947); it was conservative because it took the QFT framework for granted, without any attempt to alter its foundations. Realizing these characteristics of the renormalization theory is crucial for

understanding its various ramifications. Thus a brief introduction to the conceptual framework of QFT is in order.

QFT is a system consisting of local operator fields, obeying equations of motion and canonical commutation or anticommutation relations, and a Hilbert space of state vectors, obtained by successive application of the field operators to the unique vacuum state. Three assumptions involved here need to be elaborated.

4.1.1. The Locality Assumption

The locality assumption means a point model of particles and of interactions among them. At first glance, it seems to be merely a statement of rejecting the principle of action at a distance, and of keeping it in accord with special relativity. Yet an examination of the point model of the electron reveals that its creation was a particular kind of response to a paradox in Lorentz's theory of the electron (1904a, b). According to J. J. Thomson (1881), the energy contained in the field of a spherical charge of radius **a** was proportional to $e^2/2\mathbf{a}$. If the radius went to zero, the energy would diverge linearly like $1/\mathbf{a}$. But if the electron had a finite radius, then the Coulomb repulsive force in the sphere of the electron was inconsistent with the stable existence of the electron. Poincaré's response (1906) to the paradox was a suggestion that there might exist a nonelectromagnetic cohesive force inside the electron to cancel the Coulomb force, so that the electron would not be fragmented. Two of Poincaré's ideas in this suggestion have exercised a great influence upon later generations:

i. the electron mass, at least partly, has a nonelectromagnetic origin;
ii. the nonelectromagnetic compensative interaction, combining with the electromagnetic interaction, would lead to the observable mass of the electron.

For example, Stueckelberg (1938), Bopp (1940), Pais (1945), Sakata (1947a, b), and many others obtained their inspiration from Poincaré's ideas in their study of the problem of electron self-energy.

As first pointed out by Fermi in 1922 (cf. Rohrlich 1973), the Poincaré equilibrium turned out not to be stable against deformations. Then came another kind of response to the paradox, first made by Frenkel (1925). Frenkel argued, within the classical framework, that the inner equilib-

rium of an extended electron is a meaningless problem since the electron is elementary and has no parts. By adopting the point model, Frenkel cancelled the "self-interaction" between the parts of an electron, and thereby avoided the stability problem. He could not, however, cancel the self-interaction between the point electron and the electromagnetic field it produces without abandoning Maxwell's theory. The problem Frenkel left open became more acute when QFT came into being.

Frenkel's idea of the point electron was quickly accepted by physicists and became a conceptual principle of QFT. Looking for a structure of the electron was given up because, as Dirac argued in 1938, "the electron is too simple a thing for the question of the laws governing its structure to arise." It is clear, therefore, that what is hidden in the locality assumption is an acknowledgement of our ignorance of the structure of the electron or other "elementary" particles described by QFT, and an appreciation of the point model as a good approximation at the energy available in present experiments, which is too low to explore the inner structure of the particles.

4.1.2. The Operator Field Assumption

When Jordan in 1925 (see Born 1926), and especially Dirac (in 1927a, b) extended the methods of quantum mechanics to electromagnetism, the electromagnetic field was promoted from a classical quantity to a quantum mechanical operator. The same procedure can also be applied to other fields describing fermions. These local operator fields have direct physical interpretation in terms of emission and absorption and the creation and annihilation of the quanta associated with the particles. Creation of a particle is realized by a localized excitation of the vacuum. According to the uncertainty principle, a localized excitation implies that arbitrary amounts of energy and momentum are available for the creation of particles. Thus the result of applying a Heisenberg field operator to the vacuum is not the creation of a single particle, but rather of a superposition of all multiparticle states which are only constrained by the conservation of relevant quantum numbers. It is clear, therefore, that an operator field is defined by the totality of its matrix elements, and the overwhelming proportion of these refer to energies and momenta that are far outside experimental experience.

4.1.3. The Plenum Assumption of the Vacuum

This seems not to be an accepted assumption, especially so when we recall the objections raised by Furry and Oppenheimer (1934), Pauli and Weisskopf (1934), Wentzel (1943), and others to Dirac's idea of a filled vacuum (1930). The strongest argument explicitly adopted by some physicists against the plenum assumption is this. According to special relativity, the vacuum must be a Lorentz invariant state of zero energy, zero momentum, zero angular momentum, zero charge, zero whatever, i.e., a state of nothingness. However, when these physicists seriously study various phenomena which are supposed to be caused by the vacuum fluctuations, they tacitly take the vacuum as the scene of wild activity, as a polarizable medium, as something substantial, or as an underlying substratum; namely, they do actually adopt the plenum assumption.

4.1.4. Renormalization and the Consistency of QFT

The local excitation of the vacuum by an operator field and the local coupling among quanta imply that in the QFT calculations we have to consider all the virtual processes involving arbitrarily high energy, for which we have no empirical evidence to test the correctness of the theory. Mathematically, the inclusion of these virtual processes at arbitrarily high energy results in infinite integrals. Thus the divergence difficulties are by no means external. Rather, they are internal to the very nature of QFT. In this sense the occurrence of the divergences clearly indicated a deep inconsistency in the conceptual structure of QFT.

To this inconsistency there emerged two main responses, in addition to other proposals for radically altering the foundations of QFT. The one first developed by Pais (1945) and Sakata (1947a, b), in line with Poincare's solution to the stability problem of the Lorentzian electron, was based upon the compensation idea: The fields of unknown particles were introduced in such a way as to cancel the divergences produced by the known interactions. The other was the renormalization program which is the central subject of this essay.

A vague idea of renormalization, in terms of subtractions, had already been expressed as early as the 1930s by Dirac (1933), Heisenberg (1934), Weisskopf (1936), Kramers (1938), and others. Yet the further elaboration of this idea was stimulated by experimental findings immediately after the Second World War: Lamb and Retherford's measurements of the fine

structure splitting of the 2s and 2p states of hydrogen, and Rabi's results on the hyperfine structure of hydrogen and deuterium. The challenge for physicists was to explain these accurate and reliable data. In attempting this task, they developed algorithms to calculate the experimental results, and ideas for suggesting and justifying the algorithms.

The ideas and algorithms developed by Kramers (1947), Bethe (1947), Lewis (1948), Schwinger (1948a, b), and Tomonaga (1946) can be summarized as follows.

i. The results of Lamb and Rabi are explainable within the framework of QED.
ii. The divergent terms that occur in the unrenormalized QED calculations are identifiable in a Lorentz and gauge invariant manner, and can be interpreted as modifying the mass and charge parameters that occurred in the original Lagrangian.
iii. By expressing the modified, or renormalized, parameters in terms of physically observable masses and charges of physical particles, all the divergences are absorbed into the mass and charge renormalization factors, and finite results are obtained in good agreement with experiments.

A crucial assumption underlying the whole renormalization program was expressed most clearly by Lewis:

The electromagnetic mass of the electron is a small effect and that its apparent divergence arises from a failure of present day quantum electrodynamics above certain frequencies (1948).

It is clear that only when a divergent quantity, improperly calculated in QFT, is actually a finite and small quantity, can its separation and amalgamation into the bare quantity be regarded as mathematically justifiable. The failure of QFT at ultra-relativistic energies, indicated by the apparent divergencies, implies that the region in which the existing framework of QFT is valid should be separated from the region in which it is invalid; in the latter region, new physics (new particles and new types of interactions) may enter the scene. It was impossible for physicists of the late 1940s to determine where the boundary was, and no one knew what theory could be used to calculate the small effect which was incalculable in QFT. However, this separation of the knowable from the unknowable, which was realized mathematically by the introduction of a

cutoff, could be schematized by using the phenomenological parameters, which must include these small effects.

No explicit use of the cutoff was made by Lewis, Schwinger, and Tomonaga, who directly identified the divergent terms with corrections in mass and charge, and removed them from the expressions for real processes by redefining the masses and charges. By contrast, Feynman's efficient algorithm (1948b, c) was decisively based on explicit use of a relativistic cutoff. The latter consisted of a set of rules for regularization, which enable the quantities that we have to calculate, but fail to be able to do so in the existing framework, not to diverge. This artifice transforms essentially purely formal manipulations of divergent quantities, i.e., the redefinition of parameters, into quasi-respectable mathematical operations. If after the redefinition of mass and charge, other processes are insensitive to the value of the cutoff, then a renormalized theory can be defined by letting the cutoff go to infinity. A theory is called renormalizable if a finite number of parameters are sufficient to define it as a renormalized one.

Physically, Feynman's relativistic cutoff is equivalent to introducing an auxiliary particle to cancel the infinite contributions by real particles. Different from realistic theories of regularization or compensation, in which the auxiliary particles with finite masses and positive energy are assumed to be observable in principle and described by observables entering the Hamiltonian explicitly, Feynman's theory of cutoff is formalistic in the sense in which (i) the auxiliary masses are used merely as mathematical parameters which finally tend to infinity and are non-observable in principle; and (ii) the coupling constant associated with the auxiliary particle would be imaginary. The representatives of realists were Rayski (1948), Sakata (1947a, b; 1950a, b), Umezawa (1948; 1949a, b), and other Japanese physicists; among formalists we can find, in addition to Feynman, Rivier and Stueckelberg (1948) and Pauli and Villars (1949).

It was Dyson (1949a, b) who, as a synthesizer, showed that Feynman's results and insights were derivable from Tomonaga's and Schwinger's formulation of QED. According to Dyson, renormalization is essentially associated with averaging out the large fluctuations of quantum fields, which is equivalent to blurring the exact point model. Furthermore, Dyson was able to outline a proof of the renormalizability of QED as a whole; that mass and charge renormalization removed all the divergences

from the S matrix of QED in any order of perturbation theory. He also suggested that renormalized QED itself, as well as its perturbation expansion, might well be a consistent quantum field theory.

Empirically, the renormalized version of QED has enjoyed a great success because of its astonishing predictive power, whether in calculating the Lamb shift and the anomalous magnetic moment of the electron, or in estimating results in high-energy electron–electron scattering, etc. It was hoped at the time, that by successfully circumventing the divergence difficulties, a consistent framework of QFT could be constructed, and a general theory of mass and charge, as Pauli required, would be obtainable. This expectation turned out to be too high, although some advances toward a rigorous proof of the renormalizability of QED were made. The most crucial among these advances were:

i. the solutions to the overlapping divergence problem given by Salam (1951a, b), Ward (1950, 1951), and Mills and Yang (1966); and
ii. the convergence theorem of Weinberg (1960), which is necessary for the proof that in renormalized theories all the ultraviolet divergences cancel to all orders of perturbation, despite the existence of complicated divergent subgraphs.

The next developments were first stimulated by advances in solid state physics. The study by Anderson, Bogoliubov, and Nambu of the theory of superconductivity in the late 1950s soon led to the rediscovery by Heisenberg, Nambu, and Goldstone of spontaneous symmetry breaking (SSB) within the framework of QFT, and a mechanism, first suggested by Anderson, but now known as the Higgs mechanism, by which gauge bosons can acquire masses.[2] In the late 1960s, Weinberg (1967) and Salam (1968), among others, adopted this mechanism, within the general framework suggested by Yang and Mills (1954a, b), in constructing their models for the electroweak interactions, and conjectured that the models would be renormalizable. In the late 1960s and early 1970s, Veltman (1968a, b; 1969a, b; 1970) and 't Hooft (1971a, b; 1972a, b, c) published a series of papers which paved the way for proving the renormalizability of the Yang–Mills theory in general, and of the Weinberg–Salam model and quantum chromodynamics (QCD) in particular, using dimensional regularization which preserved the gauge and Poincaré invariances. The work of Veltman and 't Hooft was improved by Becchi, Rouet, and Stora in (1974), with all sorts of tantalizing complications which I shall not

review here. Their proof is convincing at the one-loop level. At the two-loop level, however, some people feel that the result is less convincing. As for the higher loop levels, it seems to be a virgin soil remaining to be cultivated.[3] Anyhow, these works certainly constitute an extension of Dyson's original program into a new area.

Conceptually, however, it was still quite unclear why the renormalization program actually works in QED even though renormalizability had already been accepted as a property of QED. This question can be divided into two parts:

i. Why do the apparent divergences arising from a failure of unrenormalized QED above certain frequencies actually give rise to small effects?
ii. Why are the descriptions of nature by renormalizable theories stable and insensitive to whatever happens at very high energy?

While some progress towards an answer to the second part of the question has been made during the last two decades, (which progress we shall discuss in the next section), no effort has been made even to attack the first question during the more than four decades since Lewis first made his smallness assumption. Yet a more fundamental question about renormalization theory is whether all fundamental interactions in nature are renormalizable.

Negative answers to the question occurred immediately after Dyson's classic papers on renormalization appeared. For example, Feldman (1949) observed that the electromagnetic interactions of the vector meson are nonrenormalizable. In 1951, Kamefuchi pointed out that the four-fermion direct interactions are also nonrenormalizable. To this Peterman and Stueckelberg (1951) added the magnetic moment interaction (the Pauli term). Thus an unavoidable question arises: Should nature be described only by renormalizable theories? For physicists, such as Schweber, Bethe, and Hoffman (1955), who had elevated the renormalizability from a property of QED to a regulative principle guiding the theory selection, the answer was positive. They justified their position in terms of predictive power. Since the aim of fundamental physics was to formulate theories that possessed considerable predictive power, they argued "fundamental laws" must contain only a finite number of parameters. Only renormalizable theories were consistent with this requirement, while the divergences of nonrenormalizable theories could possibly be eliminated

by absorbing them into an infinite number of parameters in terms of which the theories would be specified.

According to the renormalizability principle, the Pauli moment term in the interaction Lagrangian had to be rejected. Also excluded was the pseudovector coupling of the pion to the nucleon. By the same reasoning, Fermi's theory of weak interaction lost its status as a fundamental theory. More interesting was the case of the Yang–Mills theory. Physicists were interested in the original Yang–Mills theory in part because it was conjectured to be renormalizable, although the massless gauge bosons required by the gauge invariance could not be responsible for short-range nuclear forces. The massive version of Yang–Mills theory was unacceptable, because the massive bosons ruined the gauge invariance and the renormalizability as well. Gell-Mann was attracted by the theory and tried to find a "soft- mass" mechanism which would allow the renormalizability of the massless theory to persist in the presence of gauge boson masses, but he did not succeed (cf. Gell-Mann 1987, 1989). Where Gell-Mann failed, Weinberg and Salam succeeded with the help of the Higgs mechanism. After the apparent proof by Veltman and 't Hooft of the renormalizability of the Yang–Mills theory, the Yang–Mills theory became a paradigm case of QFT. The rejection of the pseudoscalar coupling of the pion to the nucleon in the strong interaction— which paved the way for the prevalence of a dispersion relation approach and S matrix theory that rejected the whole framework of QFT (cf. Cushing 1990; Cao 1991)—was a more complicated application of the renormalization constraint. Formally, the pseudoscalar coupling was renormalizable. Yet its renormalizability is not realizable because the radiation corrections it produces are too large to use the perturbation theory, which is the only framework within which the usual renormalization procedure works.

It would not be too exaggerated to claim that the most substantial advances in QFT achieved in the last four decades have been guided and constrained by the renormalizability principle. The most convincing case in point is Weinberg's unified theory of electroweak interactions. As Weinberg remarked in his Nobel lecture (1980a), weak interactions in his theory would have received contributions from $SU(2) \times U(1)$ invariant four-fermion couplings (which were known to be nonrenormalizable), as well as from vector boson exchange (which were believed, though not proven until a few years later by Veltman and 't Hooft, to be renor-

malizable), if he had not been guided by the principle of renormaliz-ability, and the theory would have lost most of its predictive power. It is true that in a sense the renormalization theory saved QFT, made it manipulable and calculable, and thus revived people's faith in QFT. Be that as it may, no unanimous consensus has ever been reached as to whether renormalizability is an essential characteristic of QFT, or even a universal principle constraining all the possible descriptions of nature. As a matter of fact, serious arguments challenging the consistency of the renormalization theory and shedding doubts on the very founda-tions of QFT have been published since 1950. The argumentation has led to a deeper understanding of the physics and philosophy of renormaliza-tion, and helps to clarify the foundations of QFT. Perhaps this can be viewed as another way in which the renormalization theory has advanced QFT into a new phase.

An unrenormalized theory is certainly inconsistent because of the ul-traviolet divergences, and also because of the infinities resulting from the infinite volume of space-time. The latter has to be disentangled from the former and excludes the Fock representation as a candidate for the Weyl form of canonical commutation relations. The occurrence of these two kinds of infinities makes it impossible to define a Hamiltonian operator, and the whole scheme of canonical quantization of QFT collapses.

The consistency problem in renormalized theory takes quite a different look from that of the unrenormalized one. The ultraviolet divergences are supposed to be circumventable by the renormalization procedure. The remaining difficulty associated with the infinite volume of space-time is also claimed to be solved mathematically by axiomatic field theorists with the help of distribution theory (cf. Wightman 1976). Yet new prob-lems created by the renormalization theory had invited serious criticisms, which were waged on three different levels.

On the logico-mathematical level, Dirac (1969) criticized the renor-malization theory of neglecting the infinities (and not infinitesimals) which is radically contrary to the typical custom in mathematics. Lewis' small-ness assumption seems to anticipate and invalidate Dirac's criticism, but the assumption itself has to be justified in the first place.

On the physical level, Heitler (1961) observed that the mass differences of those particles which were identical except for charge, as the pions and nucleons, lay outside of the range of the renormalization theory. It is not difficult to see that if the mass differences are of electromagnetic origin,

then the divergent electromagnetic self-energy will lead to infinite mass differences. This difficulty has clearly indicated that the renormalization theory is far from living up to Pauli's expectation of providing a general theory of mass. In addition, the renormalization theory is criticized as too narrow a framework to accommodate descriptions of such important interactions existing in nature as the CP-violating weak interaction and gravity. But its graver defect is that it is in direct and irreconcilable conflict with the chiral and trace anomalies that happen in high orders of QFT—this defect being recognized around 1970.

On the fundamental level, the internal consistency of the renormalization theory was seriously challenged by Dyson (1952), Källen,[4] Landau (1954a, b, c, d; 1955a, b; 1956), and others, whose arguments were expressed in terms of the breakdown of perturbation theory. As is well known, Dyson's renormalization theory works only within the framework of perturbation theory. The output of perturbative renormalization theory is a set of well-defined formal power series of the S matrix elements of a field theory. However, it was soon realized that this series was most likely divergent. Thus physicists were thrown into a state of confusion as to the sense in which the perturbative series of a field theory defines a solution. Interestingly enough, the first physicist who felt disillusion with the perturbative renormalization theory was Dyson himself. In 1952, Dyson gave an ingenious and suggestive argument that all the power series expansions were divergent after renormalization. The subsequent discussions by Hurst (1952), Thirring (1953), Peterman (1953a, b), and Jaffe (1965) and other axiomatic and constructive field theorists have convinced people that the renormalized perturbative series of most field theories diverge, even though there is still no complete proof of this assertion in most cases.

A divergent perturbative series for a Green's function may still be an asymptotic solution of the theory. The existence of solutions for some field theoretical models established by constructive field theorists in the mid-1970s seems have verified a posteriori that the solution is uniquely determined from its perturbation expansion. (See Wightman 1976.) Yet these models exist only in unrealistic two- or three-dimensional space-time. As for realistic four-dimensional QED, Hurst suggested in 1952 that the excellent agreement of QED with experiments would indicate that the series is an asymptotic expansion. However, the study of the high-energy behavior of QED by Källen, Landau, and especially by

Gell-Mann and Low (1954), shows that the perturbative theory in QED breaks down unavoidably, as a consequence, ironically, of the necessity of charge renormalization. Landau and his collaborators (1954a, b, c, d) further argued that sticking to the perturbative framework would lead either to a trivial case (zero charge), which is controversial (see Weinberg 1983; Gell-Mann 1987), or to the apparently inconsistent case, namely the occurrence of ghost states (Landau 1955a, b). Both cases have indicated the inapplicability of perturbative theory in renormalized QED. After the discovery of asymptotic freedom in a wide class of nonabelian gauge theories, especially in QCD, a hope was raised that perturbative QCD would get rid of the Landau ghost and thus eliminate most doubts as to the consistency of QFT. However, the illusion did not last long. It was soon realized that the ghost that disappears at high energy reappears at low energy (cf. Collins 1984), indicating persistently the limit of application of perturbative theory, and leaving the consistency problem of QFT in general, and perturbative renormalization theory in particular, in a state of uncertainty.

Physicists' attitudes towards this issue are dramatically divergent. For most practicing physicists, it is just a pedantic problem. As pragmatists, they are only guided by their scientific experiences and without serious interest in speculating about the ultimate consistency of a theory. For Dirac (1963; 1969; 1973a, b; 1983), however, the existing renormalization theory was simply illogical and quite nonsensical physically. What were required, in his opinion, were new forms of interactions and new mathematics, indefinite metric (1942) or nonassociative algebra (1973a) or something else. More radical was the attitude adopted by Landau and Chew. What they rejected was not merely some wrong form of interaction or any perturbative version of QFT, but the general framework of QFT itself. For them the very concept of a local operator field, and of any detailed mechanism for interactions in a microscopic space-time region were totally unacceptable, because these are too speculative to be observable even in principle. (See Cao 1991.) This position is supported by the presence of divergences in QFT and the lack of a proof of the consistency of the renormalization theory, although Landau's arguments for the inconsistency of renormalized QED cannot claim to be conclusive.

The most positive attitude is taken by axiomatic and constructive field theorists.[5] In the tradition of Hilbert they try to settle the internal consistency of QFT via axiomatization, and take this as the only way to

give clear answers to conceptual problems. While Hilbert tried to establish the existence of mathematical entities with a proof of the consistency of a formal system consisting of these entities, the axiomatic field theorists go the other way around. They try to prove the internal consistency of QFT by the construction of nontrivial examples whose existence is a consequence of the axioms alone. Without radically altering the foundations of QFT, they try to overcome the apparent difficulties of its consistency step by step. Although many important problems remain open, nowhere do they find any indication of basic inconsistencies of QFT. One of their achievements is to define the fields as operator-valued distributions, choosing test functions that are infinitely differentiable and have rapid decrease at infinity, or have compact support. Essentially, it is a mathematical expression of the physical idea of modifying the exact point model. Yet, a theory so defined may still be nonrenormalizable in the sense of perturbation. The failure of constructing a solvable four-dimensional field theory, despite intensive efforts lasting four decades, shows that the axiomatic or constructive field theorists are far from justifying their optimism concerning the consistency problem of QFT, in Hilbert's sense.

More optimistic than the axiomatic field theorists are the finitists, including Salam (1970, 1973) and various advocates of supergravity (e.g., Hawking 1980) and superstrings (e.g., Green 1985a, b; 1987). The basic idea is that with the introduction of gravity, one way or another, into the existing formulations of QFT systems, it is possible to construct a finite theory without the necessity of renormalization. They cancelled, but did not solve, the consistency problem of the renormalization theory. Hopes come and go, yet all of them are short-lived.

Two other opposing views on renormalization, held respectively by Sakata and Schwinger, were expressed in terms of their concerns about the structures of the elementary particles. For Sakata (1950a, b; 1952; 1956), the renormalization theory was only an abstract formalism, behind which the concrete structures of elementary particles lie hidden. Thus, whenever the renormalization theory had any defect, it would become necessary to look for the structure of elementary particles. Under Sakata's influence, model building about the constituents of elementary particles in Japan overtook the analysis of the theoretical structure of QFT, and as a result, the renormalization theory as a conceptually essential ingredient of QFT was finally ignored. (See Takabayasi 1983; Aramaki 1989.)

Schwinger's point of view on renormalization is of particular interest, not only because he was one of the founders of the renormalization theory, but also because he is an incisive analyst and critic of the philosophy of the renormalization theory. According to Schwinger (1970; 1973; 1983) the unrenormalized description, taking the local operator field as its conceptual basis, contains speculative assumption of the dynamic structure of the physical particles, which is sensitive to details at high energy where we have no reason to believe in the correctness of the theory. In accordance with Kramers' idea, which has been accepted by Schwinger as a guiding principle, that QFT should have a structure-independent character, the renormalization procedure established mainly by Schwinger has removed the reference to very high energy and the related inner structure assumptions, thus transferring attention from the hypothetical world of localized excitations and interactions to the observed world of physical particles. Schwinger has felt it unacceptable to proceed in this tortuous manner of introducing physically extraneous structural assumptions, only to delete them at the end in order to obtain physically meaningful results. This is a rejection of the philosophy of renormalization. But renormalization is essential and unavoidable in a local operator field theory if the latter is to make any sense. Carrying his criticism to its logical conclusion, Schwinger has introduced numerical sources and numerical fields to replace the operator fields. As the action principle succinctly expresses, these sources symbolize the interventions that constitute measurement of the physical system. Furthermore, all the matrix elements of the associated field, field equations, and the commutation relations can be expressed in terms of the sources. According to Schwinger, his source theory takes finite quantities as primary, and is thus free from infinities; this theory is also flexible enough to incorporate experimental results, and extrapolate them in a reasonable manner without falling into the trap of the wholesale extrapolation that infringes on unexplored areas where new unknown physics is sure to await.

Thus the ultimate fate of the renormalization theory in Schwinger's hands is to be excluded from the description of nature, together with a radical alteration of the foundations of QFT, an abandonment of the concept of a local operator field. The radical character of Schwinger's approach, which had its origin in 1951, and was elaborated in the 1960s and 1970s, and its significance for developing a new understanding of renormalization, of QFT, of scientific theory in general, was not recogniz-

able until the mid-1970s when the renormalizability principle began to be challenged, interest in nonrenormalizable theories began to rise, and the effective field theory approach began to gain popularity. In a changed conceptual situation, the most perspicacious theorists (e.g., Weinberg 1979, 1980b) began to realize that Schwinger's ideas are essential to the radical shift of outlook in fundamental physics.

4.2. Foundational Transformations

The fundamentality of the renormalizability principle has been challenged since the mid-1970s, as physicists' knowledge of the foundations of renormalization theory undergoes radical transformation; a result of fruitful interactions between QFT and statistical physics during the two decades. At the heart of the transformation is the emergence of the new concept of "broken scale invariance" and the related renormalization group approach. It was Weinberg (1978) who first assimilated the physical insights, mainly developed by K. G. Wilson in the context of critical phenomena, such as the existence of fixed point solutions of renormalization group equations and the conditions for trajectories in coupling-constant space passing through fixed points, in order to explain or even replace the renormalizability principle by a more fundamental guiding principle called "asymptotic safety." Yet this program was soon overshadowed by another program of "effective field theory" (EFT), also started by Weinberg. Initially, EFT was less ambitious than asymptotically safe theories because it still took renormalizability as its conceptual basis. Eventually, however, it led to a radical change of outlook, together with an examination of the very concept of renormalizability and a clarification of the ontological basis of QFT.

4.2.1. Cutoff

The renormalization procedure, as we noted in the last section, consists essentially of two steps. First, unambiguously separating knowable low-energy processes from unknowable (in terms of existing theory) high-energy processes, which are describable only by new theories. Second, incorporating the impact of the latter upon the former by redefining a finite number of parameters of the theory; the redefined parameters

are not calculable by the theory, but are determinable by experiments (Schwinger 1948). The implicit requirements for the redefinition to be possible will be examined in Sec. 4.2.2. Here our focus is on the separation.

For Schwinger and Tomonaga, who directly separate the finite terms from the divergent integrals by contact transformations, the unknowables (knowables) are simply represented by the divergent (finite) terms. With regard to the boundary line separating the knowable energy region from the unknowable region, however, there is no clue whatsoever in their formulations. It is buried somewhere in the divergent integral. Thus the redefinition can only be viewed as purely formalistic manipulations of divergent quantities, with extremely tenuous logical justification. (See Dirac's criticism, 1969.)

Feynman, Pauli, Villars, and many other physicists differ from Schwinger and Tomonaga; they take an indirect way to extract the finite parts from the divergent integrals, with the help of a regularization procedure, a way of temporarily modifying the theory so as to make the integrals finite. In the momentum-cutoff regularization scheme introduced by Feynman (1948c) and Pauli and Villars (1949), the boundary line separating the knowable region from the unknowable one is clearly indicated by the momentum cutoff introduced.[6] Far below the cutoff, the theory is supposed to be trustworthy, and the integrals for higher order corrections are justifiably manipulated and calculable. The unknowable high-energy processes above the cutoff are excluded from consideration, as they have to be. Up to this point, Feynman's scheme seems better than Schwinger's in implementing the basic idea of renormalization, which was first clearly expressed in print by Schwinger (1948). Logico-mathematically, it also seems to be more respectable.

However, a difficult question encountered by various regularization schemes is how to take into account the effect of the excluded high-energy processes upon the low-energy phenomena. This question is peculiar to the local field theory, and unavoidable within this framework. Feynman's solution to this question, which has become the orthodoxy since then, is taking the cutoff to infinity at the end of calculation. In this way, all the high-energy processes are taken into consideration, and their effects upon low-energy phenomena can be incorporated by redefining the theory's parameters in Schwinger's manner. The price for this achievement is that we can no longer take the cutoff as the threshold energy at

which the theory stops being valid and unknown new theories are required for the physical description. Otherwise we would face a serious conceptual anomaly: Taking the cutoff to infinity would mean that the theory is trustworthy everywhere and no high-energy processes are unknowable. This is in direct contradiction with the basic idea of renormalization, and the divergent integrals resulting from this step also clearly indicates that this is not the case.[7]

The implications of taking the cutoff to infinity are quite significant. It has changed the status of the cutoff from a tentative, and also tantalizing, threshold energy to a purely formalistic device, and thus has definitely reduced the whole scheme to Schwinger's original formalistic one, with the boundary line separating the knowable from the unknowable buried. Physically, we can view momentum-cutoff regularization as another more efficient algorithm for manipulating the divergent quantities, to replace Schwinger's canonical transformations. Or, we may equivalently view Schwinger's direct identification of the divergent integrals as merging Feynmen's two steps of introducing a finite cutoff, followed by taking it to infinity. More significantly, taking the cutoff to infinity also reinforces a prevailing claim that physics should be cutoff-independent and that all explicit reference to the cutoff should be removed by redefining parameters. The claim seems compelling because the step deprives the cutoff-dependent quantities of any physical meaning. Conversely, this claim in turn allows physicists to make a merely formalistic interpretation of the cutoff, and forces them to expel it from real physics.

What if the cutoff is taken seriously and interpreted realistically as the threshold energy for new physics? Then the orthodox formalistic scheme will collapse and the whole perspective will change: The cutoff cannot be taken to infinity and, as the other side of the coin, physics cannot be claimed to be cutoff-independent. Actually, great advances achieved since the mid-1970s in understanding the physics and philosophy of renormalization do come from this realist interpretation. (See Polchinski 1984; Lepage 1989.) There are several intertwined strands of physical reasoning leading to this foundational change, which is, in turn, reinforced by philosophical and practical considerations. The rest of this section is devoted to disentangling these strands of physical reasoning, leaving other considerations to be examined in a separate essay (Cao and Schweber, 1993).

To begin with, let us examine (in the rest of this subsection) the reason

why it is possible to take such a realist position on the cutoff. As we have noticed above, the motivation for taking the cutoff to infinity is to take into account the effects upon low-energy phenemena of high-energy processes, which are excluded by introducing the finite cutoff. If we can find other ways to retain these effects while keeping the cutoff finite, then there is no compelling reason for taking the cutoff to infinity. The realist position is gaining popularity because physicists have gradually realized since the late 1970s, with the help of detailed power-counting and dimensional analysis, that these effects can be retained without taking the cutoff to infinity. This objective can be achieved by adding a finite number of new, local, nonrenormalizable interactions which have the same symmetries as the original Lagrangian, combined with redefining the parameters of the theory. (See Wilson 1983; Symanzik 1983; Polchinski 1984; especially Lepage 1989.) Notice that the introduction of nonrenormalizable interactions causes no difficulty because the theory has a finite cutoff.

Two prices have to be paid for taking this realist position. First, the formalism becomes more complicated by adding the new compensating interactions. This price is not very high since the new interactions added are subject to various constraints and thus have only a finite number. Besides, the price is also compensated because this position is conceptually simpler than the formalistic one. Second, the realist formalism is valid only up to the cutoff energy. However, considering the fact that any experiment can only probe a limited range of energies, the limit in accuracy in the realist formalism has actually caused no real loss in accuracy, and the price is thus nonexistent.

The next question is how to articulate the physical realization of the cutoff so that ways can be found to determine its energy scale. The cutoff in realist theory is no longer a formalistic device or an arbitrary parameter, but acquires physical significance as an embodiment of the hierarchical structure of QFT, a boundary line separating energy regions which are separately describable by different sets of parameters and different physical laws (interactions) with different symmetries. The discovery of spontaneous symmetry breaking and of the decoupling theorem, to be discussed below, suggest that the value of the cutoff is connected with the masses of heavy bosons which are associated with the spontaneous symmetry breaking. Since the symmetry breaking makes the otherwise negligible nonrenormalizable interactions (which simulate

the low-energy evidence of new high-energy dynamics and are thus suppressed by a power of experimental energy divided by the mass of the heavy boson) detectable due to the absence of all other interactions which are forbidden by the symmetry, the energy scale of the cutoff can be established by measuring the strength of the nonrenormalizable interactions in a theory.

The above discussion has preliminarily shown that a realist conception of the cutoff is not an untenable one. However, a convincing proof of its viability is possible only when this conception is integrated into a network which provides a new foundation for understanding renormalizability, nonrenormalizable interactions, and QFT in general. Now let us turn to other strands in this network.

4.2.2. Symmetry and Symmetry Breaking

One of the motivations for a renormalization procedure is the necessity of dealing with the divergences occurring in the solutions of a quantum field theory. In the traditional (formalistic) procedure, after separating the invalid (divergent) part from the valid (finite) part of the solutions, the effects of the unknowable high-energy processes upon knowable low-energy phenomena are absorbed by modifying the theory's parameters. For this amalgamation to be possible, however, the structure of the amplitudes which simulate the unknowable high-energy dynamics has to be same as the structure of the amplitudes responsible for the low-energy processes. Otherwise the multiplicative renormalization would be impossible. For guaranteeing the structural similarity required, a crucial assumption about the unknowable high-energy dynamics has to be made and is actually implicitly built into the very scheme of multiplicative renormalization. That is the assumption that the high-energy dynamics is constrained by the same symmetries as those that constrain the low-energy dynamics. Since the solutions of a theory constitute a representation of the symmetry group under which the theory is invariant, if different pieces of dynamics display different symmetries in different energy regions, implying different group-theoretical constraints, then the renormalizability of the theory is definitely spoiled.

In the case of QED, the renormalizability is guaranteed by the somewhat mysterious universality of the $U(1)$ gauge symmetry. However, with the discovery of symmetry breaking—first came the spontaneous

symmetry breaking (SSB) in the early 1960s, which was followed by the anomalous symmetry breaking (ASB) in the later 1960s[8]—the situation became more and more complicated, and the above general consideration about the relationship between symmetry and renormalizability needs to be reconsidered.

Consider SSB first, a kind of phenomenon first noticed a long time ago, and rediscovered in the 1950s in the research of superconductivity. It was explained and integrated into the theoretical structure of QFT by Heisenberg, Nambu, Goldstone, Anderson, Higgs, and others in the early 1960s (cf. Brown and Cao 1991). In statistical physics, SSB is a statement about the property of the solutions of a system; namely, some less symmetrical configurations are energetically more stable than more symmetrical ones. Essentially, it concerns the low-energy behavior of the solutions and asserts that some low-energy solutions of a system of equations are less symmetrical than the system itself, while others possess the full symmetry of the system. Traced to its very root, SSB is an inherent property of the system itself, because the existence and determination of the asymmetrical solutions are completely controlled by the parameters of the system, and connected with the hierarchical structure of the solutions, which, in statistical physics, is manifested in the phenomena of continuous phase transitions.

In QFT, so far as the continuous symmetries are concerned, SSB makes physical sense only in gauge theories. Otherwise, one of its mathematical predictions, namely the massless Goldstone bosons, contradicts physical observations. Within the framework of the gauge theories, however, all the assertions concerning SSB listed in the previous paragraph are valid. In addition to these, there is another very important assertion which is most relevant to our discussion. That is, with the help of SSB, diverse low-energy phenomena can be accomodated into a hierarchy in a gauge theory, as in the case of the electroweak theory, without, contrary to the case of explicit symmetry breaking, spoiling the renormalizability of the theory. The reason for this mystery is that SSB affects the structure of physics only at an energy lower than the scale at which the symmetry is broken; thus it has no impact on the renormalizability of a theory, which is essentially a statement about the high-energy behavior of the theory. Deep understanding of these implications of SSB has provided a strong impetus to searching for an ultimate unified description of nature, in which natural laws with different invariance properties, symmetrical laws, and asymmetrical physical states all emerge from the highest sym-

metry which characterizes physics under the conditions present at the early universe, passing through a sequence of phase transitions as the temperature decreases while the universe expands until we reach the state described by the electroweak theory and QCD.

Such an enterprise has to meet several stringent constraints. One of them is placed by the occurrence of ASB. Generally speaking, ASB is the breakdown of a classical symmetry caused by quantum mechanical loop corrections, and is related to the absence of an invariant regulator. If the symmetries concerned are local, such as gauge symmetries and general covariance, then the occurrence of ASB, which is unavoidable in any chiral theories as shown by Adler (1969) and Bell and Jackiw (1969), is fatal because the renormalizability of the theory is spoiled and its unitarity is violated.[9] Since any realistic models must contain some chiral sector(s), there is no way to avoid the presence of ASB. The only way out then is to make some ad hoc arrangements to cancel the anomalies. This requirement leads to severe restrictions on the choice of fermions (as in the Weinberg model; see Gross and Jackiw 1972) or on the choice of space-time dimensions (10 or 26) and of symmetry groups [SO(32) or $E8 \times E8$] (as in the case of superstring theories; see Green 1987). Whether such restrictions are a great success or a crushing defeat is a subject for debate, but that the investigation of ASB occupies a central place in the fundamental research of physics is beyond doubt.

If the symmetries concerned are global, then the occurance of ASB is harmless or even desirable, as in the case of global γ_5 invariance for explaining pion $\rightarrow 2\gamma$ decay, and of scale invariance in QCD with massless quarks for obtaining massive hadrons as bound states. But the implications of the anomalous breakdown of scale invariance are so profound that they demand separate discussions.

4.2.3. Scale Invariance and Renormalization Group Approach

Historically, within the framework of QFT, the idea of scale dependence appeared earlier than the idea of scale invariance, and can be traced back to Dyson's work on the smoothed interaction representation (1951). In this representation, the low-frequency part of the interaction can be treated separately from the high-frequency part, which was thought to be ineffective, except in producing renormalization effects. To this end Dyson defined, following the tradition of the adiabatic hypothesis, a smoothly varying charge of the electron and a smoothly varying interac-

tion, with the help of a smoothly varying parameter g. Dyson argued that when g varied, some modification had to be made in the definition of the g-dependent interaction, in order to compensate the effect caused by the change of the g-dependent charge. These insightful ideas were met with total silence in the 1950s. Twenty years later, however, when Wilson was developing his renormalization group approach to the strong interactions, he acknowledged that "a rather similar approach was suggested many years ago by F. J. Dyson" (1971).

In line with Dyson's idea, Landau and his collaborators developed, in a series of influential papers published in 1954, a similar concept of smeared out interaction. In accord with this concept, the magnitude of the interaction should be regarded as a function of the radius of interaction and not as a constant, and must fall rapidly when the momentum exceeds a critical value $\mathbf{p} \propto 1/\mathbf{a}$, where \mathbf{a} is the range of interaction. As \mathbf{a} decreases, all the physical results tend to finite limits. Correspondingly, the electron's charge must be regarded as an as-yet unknown function of the radius of interaction. With the help of this concept Landau studied the short distance behavior of QED and obtained some significant results. These results were shown by Symmanzik to be equivalent to those obtained by the renormalization group approach in 1970, when he was extending Wilson's work on that approach.

Both Dyson and Landau had the idea that electron's charge as a parameter was scale-dependent. In addition, Dyson also suggested, though only implicitly, an idea that the physics of QED should be scale-independent, and Landau also suggested, more explicitly, an idea that the interaction of QED might be asymptotically scale invariant.

The term "renormalization group" made its first appearence in a paper by Stueckelberg and Petermann (1953). In that paper they noticed that while the infinite part of counterterms introduced in the renormalization procedure was determined by the requirement of canceling out the divergences, the finite part was changeable, depending on arbitrary choice of subtraction point. This arbitrariness, however, is physically irrelevant because different choice only leads to a different parameterization of the theory. They observed that a transformation group could be defined which related different parameterizations of the theory, and they called it renormalization group. They also pointed out the possibility of introducing infinitesimal operators and of constructing a differential equation.

One year later, Gell-Mann and Low (1954), in studying the short

distance behavior of QED, exploited the renormalization group invariance more fruitfully. First, they emphasized that the measured charge e was a property of the very low momentum behavior of QED, and that e can be replaced by any one of a family of parameters e_λ, which was related to the behavior of QED at an arbitrary momentum scale λ. When $\lambda \to 0$, e_λ became the measured charge e, and when $\lambda \to \infty$, e_λ became the bare charge e_0. Second, they found that by virtue of renormalizability, e_λ^2 obeyed an equation: $\lambda^2 d(e_\lambda^2)/d(\lambda^2) = \psi(e_\lambda^2, m^2/\lambda^2)$. When $\lambda \to \infty$, the renormalization group function ψ became a function of e_λ^2 alone, thus establishing a scaling law for e_λ^2. Third, they argued that as a result of the equation, the bare charge e_0 must have a fixed value independent of the value of the measured charge e, this is the so-called Gell-Mann–Low eigenvalue condition for the bare charge.

In the works of Stueckelberg and Petermann and of Gell-Mann and Low, Dyson's varying parameter g and Landau's range of interaction **a** were further specified as the sliding renormalization scale, or subtraction point; the scale-dependent character of parameters and the connection between parameters at different renormalization scales were elaborated in terms of renormalization group transformations; and the scale-independent character of the physics was embodied in the renormalization group equations. Although Landau, Bogoliubov, and other Russian physicists paid some attention to Gell-Mann and Low's work, there was no proper appreciation of these elaborations until much later, in the later 1960s and early 1970s, when the conceptual situation in theoretical physics changed radically due to a series of significant developments, centered around the concept of the anomalous breakdown of scale invariance, and when a deep understanding of the ideas of scale invariance and renormalization group equations was fully developed, as a result of fruitful interactions between QFT and statistical physics, mainly by K. G. Wilson.

The idea of scale invariance of a theory is much more complicated and quite different than the idea of scale independence of physics, as vaguely suggested by Dyson, or the idea of renormalization scale independence of physics as expressed by renormalization group equations. The scale invariance of a theory is the invariance under the group of scale transformations which are defined only for dynamical variables (the fields) but not for the dimensional parameters, such as masses, since otherwise one would not work on the same physical theory. While the

physics should be independent of the choice of the renormalization scale, a theory may not be scale invariant if there is any dimensional parameter.

In Gell-Mann and Low's treatment of the short distance behavior of QED, the theory is not scale invariant when the electric charge was renormalized at very large distances. The scale invariance would be expected, because the electron mass could be neglected in this case and there seemed to be no other dimensional parameter appearing in the theory. The reason for the unexpected failure of scale invariance is that there is a singularity when the electron mass goes to zero, that is entirely due to the necessity of charge renormalization. (See Weinberg 1981.) However, when the electric charge is renormalized at a relevant energy scale by introducing a sliding renormalization scale to effectively suppress irrelevant low-energy degrees of freedom, there occurs an asymptotic scale invariance, which is expressed by Gell-Mann and Low in terms of a scaling law for effective charge and of the eigenvalue condition for the bare charge; that is, there is a "fixed" value for the bare charge, independent of the value of the measured charge.[10]

Although as early as 1961 there was a suggestion by Johnson that the Thirring model might be scale invariant (1961), the real advance in understanding the nature of scale invariance obtained its first impetus in the mid-1960s from the developments in statistical physics, and was further promoted by the discovery of field-theoretical anomalies in the study of current algebra and of short distance expansion for products of quantum field operators (OPE). Here I want to emphasize that an interaction between QFT and statistical mechanics, which was reflected in the shaping of Wilson's idea, played an important role in the development. Conceptually, it is very interesting but also complicated. In 1965, Widom (1965a, b) proposed a scaling law for the equation of state near the critical point, which generalized the earlier results obtained by Essam and Fisher (1963) and by Fisher (1964) about the relations among critical exponents, but puzzled Wilson because of the absence of any theoretical basis. Wilson was familiar with Gell-Mann and Low's work and had just found a natural basis for renormalization group analysis while working on developing a lattice field theory: namely, the solution and elimination of one momentum scale for the problem (1965). Wilson realized that there should be applications of Gell-Mann and Low's idea to critical phenomena. One year later, Kadanoff (1966) derived Widom's scaling law from an idea—essentially embodying the renormalization group

transformation—that the critical point becomes a fixed point of transformations on the scale-dependent parameters. Wilson quickly assimilated Kadanoff's idea and amalgamated his thinking about field theories and critical phenomena, exploiting the concept of broken scale invariance.[11]

Wilson did some pioneer work in 1964 (unpublished) on operator product expansion (OPE) but failed in the strong coupling domain. After thinking about the implications of the scaling theory of Fisher, Widom, and Kadanoff for QFT, along with the scale invariance of the Thirring model suggested by Johnson (1961), and of strong interactions at short distances by Mack (1968), Wilson redid his theory of OPE, based on the new idea of scale invariance (1969). This new theory of OPE soon became a powerful tool for studying the short distance behavior of strong interactions, more powerful than the equal-time commutators since the short distance singularity structure of the operator product in Wilson's theory was isolated and had its manifestation only in the expansion coefficients, whose momentum dependence can be studied by the renormalization group equations (1969). With his theory of OPE Wilson found that QFT might be scale invariant at short distances if the scale dimensions of the field operators, which are defined by the requirement that the canonical commutation relations are scale invariant, were treated as new degrees of freedom,[12] so that they can be changed by the interactions between the fields and acquire anomalous values,[13] which correspond mathematically to the nontrivial exponents in critical phenomena.

The most important implications of the radical advancement in statistical physics that Wilson used to transform the foundations of QFT can be summarized in two concepts: (i) The statistical continuum limit in a local theory and (ii) the fixed points of renormalization group transformations.

i. Wilson found that systems described by statistical physics and by QFT embodied various scales. If functions of a continuous variable, such as the electric field defined on space-time, are themselves independent variables and assumed to form a continuum, so that functional integrals and derivatives can be defined, then we can define a statistical continuum limit which is characterized by the absence of a characteristic scale. This means that fluctuations at all scales are coupled to each other and make equal contributions to a process. In QED calculations

this coupling typically leads to logarithmic divergences. Thus renormalization is necessary for these systems. That this concept of statistical continuum limit occupies a central position in Wilson's thinking on QFT in general, and on renormalization in particular, is reflected in his claim that "the worst feature of the standard renormalization procedure is that it gives no insight into the physics of the statistical continuum limit" (1975).

ii. Various parameters characterizing the physics at various renormalization scales reflect the scale dependence of the renormalization effects. These parameters are related to each other by the renormalization group transformations and describable by the renormalization group equations.

The scale invariance of any quantum field theory was gradually, since the later 1960s, recognized to be unavoidably broken anomalously because of the necessity of regularization. A prelude to this recognition was the discovery of the anomalous dimension of quantum fields, and the idea of ASB. A more convincing argument was based on the concept of dimensional transmutation. The scale invariance of a theory is equivalent to the conservation of the scale current in the theory. For defining the scale current a renormalization procedure is required, because as a product of two operators at the same space-time point, the scale current implicitly contains an ultraviolet singularity. However, when renormalizing, even in a theory without any dimensional parameter, it is still necessary to introduce a dimensional parameter as a subtraction point, to avoid the infrared divergence and to define the coupling constant. This breaks the scale invariance of the theory. The necessity of introducing a dimensional parameter was called by Coleman and E. Weinberg (1973) "dimensional transmutation." Precisely because of this dimensional transmutation, the scale invariance in a renormalized theory is unavoidably broken anomalously, though the effects of this breakdown can be taken care of by the renormalization group equations.

In statistical physics, the renormalization group approach is powerful in establishing connections between physics at different scale levels, achieving conceptual unification of various complicated systems, such as those of elementary excitations (quasiparticles) and collective ones (phonons, plasmons, spin-waves), understanding the universality of various types of critical behavior, and calculating order parameters and

critical components, by scaling out the irrelevant short-range correlations and finding a stable infrared fixed point. In QFT, the same approach can be used to suppress the irrelevant low-energy degrees of freedom, and to discover a stable ultraviolet fixed point. In both cases, the essence of the approach, as Weinberg once put it (1983), is to concentrate on the relevant degrees of freedom for a particular problem,[14] and the goal is to find fixed point solutions of the renormalization group equations.

According to Wilson, the fixed point in QFT is just a generalization of Gell-Mann and Low's eigenvalue condition for the bare charge in QED. At the fixed point a scaling law, either in Gell-Mann–Low's, Wilson's, or Bjorken's sense, holds and the theory is asymptotically scale invariant. The scale invariance is broken at nonfixed points, and the breakdown can be traced out by the renormalization group equations. Wilson (1969) further generalized Gell-Mann and Low's result by introducing a generalized mass vertex which breaks the scale invariance of the theory. Callen (1970) and Symanzik (1970) elaborated Wilson's generalization and obtained a nonhomogeneous equation so that the renormalization group function ψ is exact rather than asymptotic as in the case of Gell-Mann and Low. When the nonhomogeneous term is neglected, the Gell-Mann–Low equation is recovered. Thus, with the more sophisticated scale argument, the implication of Gell-Mann and Low's original idea becomes clearer. That is, the renormalization group equations can be used to study properties of a field theory at various energy scales, especially at very-high-energy scale, by following the variation of the effective parameters of the theory with changes in energy scale, arising from the anomalous breakdown of scale invariance, in a quantitative way rather than qualitatively, as suggested earlier by Dyson (1951) or Landau (1954a, b, c, d).[15]

If a field theory's renormalization group equations possess a stable ultraviolet fixed point solution, then its high-energy behavior causes no trouble, and thus it can be called, according to Weinberg (1978), an "asymptotically safe theory." An asymptotically safe theory may be a renormalizable theory if the fixed point it possesses is the Gaussian fixed point.[16] However, Weinberg argued, and supported his argumentation with a concrete example of five-dimensional scalar theory, that the concept of "asymptotic safety" is more general than, and thus can explain, and even replace, the concept of renormalizability: There may be cases in

which theories are asymptotically safe but not renormalizable in the usual sense if they are associated with the Wilson–Fisher fixed point. (See Weinberg 1978.)

The conceptual developments described in this subsection can be summarized as follows: In systems, such as those described by QFT, with many scales that are coupled to each other and without a single characteristic scale, the scale invariance is always anomalously broken due to the necessity of renormalization. This breakdown manifests itself in the anomalous scale dimensions of fields in the framework of OPE, or in the variation of parameters at different renormalization scales, which can be followed by the renormalization group equations. If these equations have no fixed point solution, then they are not asymptotically scale invariant and the theory is, rigorously speaking nonrenormalizable[17]; if they possess a fixed point solution, then they are asymptotically scale invariant and asymptotically safe. If the fixed point is Gaussian then the theory is renormalizable. But there may be some asymptotically safe theories which are nonrenormalizable if the fixed point they possess are the Wilson–Fisher fixed point. With the occurrence of the more fundamental guiding principle of asymptotic safety, which is one of the consequences of the renormalization group approach, the fundamentality of the renormalizability principle began to be seriously challenged.

4.2.4. Decoupling Theorem and Effective Field Theories

According to the renormalization group approach, different renormalization prescriptions lead only to different parameterizations of a theory. An application of this freedom in choosing a convenient renormalization prescription led to the discovery of the decoupling theorem, first formulated by Symanzik (1973) and Appelquist and Carazzone (1975). The theorem states that in a renormalizable theory, with some fields having much larger masses compared with the others, a renormalization prescription can be found such that the heavy particles can be shown, by a power-counting argument, to decouple from the low-energy physics, except for producing renormalization effects and corrections suppressed by a power of the experimental momentum divided by a heavy mass.

The theorem was claimed to be applicable to any renormalizable theory with different mass scales. An important corollary of this theorem is that low-energy physics is describable by an effective field theory (EFT),

which incorporates only those particles that are actually important at the energy being studied, without solving a complete theory describing all light and heavy particles. (See Georgi 1989b.) EFT can be obtained by deleting all heavy fields from the complete renormalizable theory and suitably redefining the coupling constants, masses, and the scale of the Green's functions using the renormalization group equations. Clearly, a description of physics by EFT is context-dependent. It is delimited by the experimental energy available, and thus able to keep close track of the experimental situation. This context dependence of EFT is embodied in an effective cutoff which is represented by a heavy mass associated with SSB. Thus, with the decoupling theorem and the concept of EFT emerges a hierarchical picture of nature offered by QFT, which justifies why the description at any one level is so stable, not being disturbed by whatever happens at higher energy levels.

There seems to be an apparent contradiction between the idea underlying the renormalization group approach and the idea underlying EFT. While the former is the absence of a characteristic scale in a system under consideration, the latter is to take seriously the mass scale of heavy particles, which plays the role of a physical cutoff or a characteristic scale in the low-energy physics involving only light particles. The contradiction disappears immediately, however, if we remember that the heavy particles still make contributions to the renormalization effects in EFT. Thus the mass scale of heavy particles in EFT actually plays only a role of a quasi-, but not genuine, characteristic scale. The existence of such quasicharacteristic scales reflects a hierarchical ordering of couplings between different energy scales but does not change the essential feature of the system described by QFT, namely the absence of a characteristic scale and the coupling between fluctuations at various energy scales. While some couplings between fluctuations at high- and low-energy scales exist universally and manifest themselves in the renormalization effects in low-energy physics, others are suppressed and give no observable clue in low-energy physics.

The above assertion that the decoupling is not absolute has been reinforced by an important observation that the effects of heavy particles in some circumstances are even directly detectable in low-energy physics: If there are processes (e.g., those of weak interactions) that are exactly forbidden by symmetries (e.g., parity, strangeness conservation, etc.) in the absence of the heavy particles (e.g., W and Z bosons) which are

involved in symmetry-breaking (e.g., weak) interactions leading to these processes, then the effects of the heavy particles on the low-energy phenomena are observable, though, due to the decoupling theorem, suppressed by a power of energy E divided by the heavy mass M. Typically, these effects can be described by an effective nonrenormalizable theory (e.g., Fermi's theory of weak interactions), which, as a low-energy approximation to a renormalizable theory (e.g., the electroweak theory), possesses a physical cutoff or characteristic energy scale set by the heavy particles (e.g., 300 GeV for Fermi's theory). When the experimental energy approaches the cutoff energy, the nonrenormalizable theory becomes inapplicable, new physics appears and demands a renormalizable theory, *or a new effective theory with a higher cutoff energy*. The first choice is the orthodoxy. The second choice presents a serious challenge to the fundamentarity of the renormalizability principle, and is gaining momentum and popularity at the present time.

4.3. New Philosophy

The concept of EFT clarifies how QFT at different scales takes different forms, and permits two ways of looking at the situation. First, if a renormalizable theory at high energy is available, then the effective theory at any lower energy is obtainable in a totally systematic way by integrating out the heavy fields of the theory. In this way, the renormalizable electroweak theory and QCD can be understood as effective theories at low energy of some grand unified theory, thus losing their supposed status of fundamental theory. Another possibility, also compatible with this way of looking at the situation, is that a tower of effective theories contains nonrenormalizable interactions, each with fewer particles and more small nonrenormalizable interactions than the last. When the physical cutoff (heavy particle of mass M) is much larger than the experimental energy E, the effective theory is approximately renormalizable, the nonrenormalizable terms are suppressed by a power of E/M.

The second way corresponds more closely to what high-energy theorists actually do in studying physics. Since nobody knows what the renormalizable theory at the highest energy is, or even whether it exists at all, we have to probe the low energy first, and stretch our theory to higher energies only when it becomes relevant to our understanding of physics,

thus obtaining an endless tower of theories, in which each theory is a particular response to a particular experimental situation, and none can ultimately be regarded as the fundamental theory. In this approach, the requirement of renormalizability can be replaced by a condition on the nonrenormalizable interactions in the effective theories as follows: All the nonrenormalizable interactions in an effective theory describing physics at a scale m must be produced by heavy particles with a mass scale M, and thus are suppressed by powers of m/M; and in the renormalizable effective theory including the heavy particles with mass M, these nonrenormalizable interactions must disappear.

These clarifications, together with the renormalization group equations, have helped physicists to come to a new understanding of renormalization. As David Gross once put it, "renormalization is an expression of the variation of the structure of physical interactions with changes in the scale of the phenomena being probed" (1985). Notice that this new understanding, different from the old one which focuses exclusively on the high-energy behavior and ways of circumventing divergences, shows a more general concern on the variation of various physical interactions with change of energy scale, thus provides enough space for considering nonrenormalizable interactions.

A significant change in physicists' attitude towards what should be taken as a guiding principle in theory construction is taking place in recent years in the context of the development of EFT. For many years since Dyson's classic work was published, renormalizability has been taken as a necessary requirement. Now, considering the fact that experiments can probe only a limited range of energies, it seems natural to take EFT as a general framework for analyzing experimental results. Since nonrenormalizable interactions are present quite naturally in this framework, there seems no a priori reason for excluding them in constructing theoretical models for currently accessible physics.

In addition to the compatibility with the new understanding of renormalization as well as with Weinberg's idea of asymptotic safety, taking nonrenormalizable interactions seriously is also supported by some other arguments. First, nonrenormalizable theories are flexible enough to accommodate experiments and observations, especially in the area of gravity. Second, they possess enough predictive power and are able to improve this power by taking higher and higher cutoffs. Third, because of their phenomenological nature, conceptually they are simpler than the

renormalizable theories, which, as in Schwinger's criticism, involve physically extraneous speculations about the dynamic structure of the physical particles. The fourth supportive argument comes from constructive theorists. Since the mid-1970s, there have appeared major efforts in constructive field theories to understand the structure of nonrenormalizable theories, and to discover conditions in which a nonrenormalizable theory can make sense. One of the striking results of this effort is that some nonperturbative solutions of nonrenormalizable theories are found to have only a finite number of arbitrary parameters, contrary to the descriptions of these theories in terms of the perturbative series. A speculation is that an infinite number of parameters to be renormalized may come from the illegitimate expansion of a function. (For a review of the progress in this direction, see Wightman 1986.) Certainly this effort has exhibited some degree of openness and flexible frame of mind among the axiomatic and constructive theorists, who are supposed to be the most dogmatic field theorists. A traditional argument against nonrenormalizable theories is that they lack consistency and are inapplicable at any energy higher than their physical cutoff. More discussion on consistency will be given in a separate essay (Cao and Schweber, 1993). Let us focus on the high-energy behavior of the nonrenormalizable interactions, which has been regarded by many physicists as the most fundamental question in QFT.

As we noticed above, within the original framework of EFT, which takes renormalizability as its conceptual basis, the nonrenormalizable theories, as low-energy approximations to renormalizable ones, acquire only the status of auxiliary devices. With the experimental energy approaching their cutoffs and new physics appearing, they become incorrect and have to be replaced by renormalizable theories. Within the framework of Weinberg's asymptotically safe theories, the nonrenormalizable theories have acquired a more fundamental status. Nevertheless, this framework still shares a common feature with EFT, namely all the discussions are based on taking the cutoff to infinity, thus falling into the category of formalistic interpretation of the cutoff.

However, if we take the idea underlying EFT to its logical conclusion, then a radical change in outlook takes place, a new perspective appears, a new intepretation of QFT can be developed, and a new theoretical structure of QFT waits to be explored. A thoroughgoing advocate of EFT, such as Georgi (1989b) and Lepage (1989), would argue that when

experimental energy approaches the cutoff of a nonrenormalizable effective theory, we can always replace it by another nonrenormalizable effective theory with much higher cutoff. In this way, the high-energy behavior of the nonrenormalizable interaction above the cutoff will be properly taken care of by

i. the variation of renormalization effects, caused by the change of the cutoff and calculable by the renormalization group equations; and
ii. additional nonrenormalizable counterterms.

(See Lepage 1989.) Thus, in any stage of development, the cutoff is always finite and can be given a realist interpretation as we argued in Sec. 4.2.1. In addition to the finite cutoff, we also find two more new ingredients which have been absent or forbidden in the traditional structure of QFT but are legitimate and indispensible in the theoretical structure of the new formulation of QFT. These are (i) the variations of renormalization effects with specified changes of cutoff and (ii) the nonrenormalizable counterterms which are legitimized by the introduction of finite cutoffs.

The recent advances in theoretical thinking of fundamental physics also help to clarify the ontological basis of QFT. The picture of the domain under investigation provided by the framework based on the decoupling theorem and EFT possesses a more discernible and better defined hierarchical structure. The hierarchy is delimited by mass scales associated with a chain of SSB and justified by the decoupling theorem. Examining the hierarchical structure from a metaphysical perspective we find two implications worth noticing, seemingly in the opposite directions. On the one hand, the hierarchical structure seems to lend support to the potential of interpreting physical phenomena in a reductionist or even reconstructionist way, at least to the extent SSB works. Most of the efforts made by the mainstream high-energy physics community in the last two decades, from the standard model to superstring theories, can be seen as a pursuit of exploring this potential. On the other hand, taking the decoupling theorem and EFT seriously would finally lead to rejecting the reductionist pursuit as an illusion, and accepting a pluralist view of theoretical ontology.

What the decoupling theorem rejects is not the general idea of the connections between different hierarchical levels, which are assumed to exist and be describable by the renormalization group equations, and thus are built into the very conceptual basis of the theorem. Rather, it is

the universal and direct relevance of the connections to scientific inquiry that is to be rejected, the possibility, that is to be rejected, of inferring the complexity and novelty that emerge on lower energy level, from the simplicity on a higher energy level, simply via this kind of connection, without any empirical imput. The requirement, by the decoupling theorem and EFT, of the empirical imput in theoretical ontology on the lower energy level, to which the ontologies on the higher levels have no direct relevance in scientific investigations, provides a special picture of the physical world, which could be considered as layered into quasiautonomous domains, each layer having its own ontology and associated "fundamental" laws. This hierarchical pluralisn in theoretical ontology does not mean to reject the connections between ontologies on different levels, so in a weak sense it still falls into the category of atomism; but merely rejects the possibility of deducing various entities from some basic ontology.

In a sense, these foundational transformations in the renormalization theory, partly stemming from internal conceptual evolution and partly inspired by the radical progress in statistical physics, have provided fertile soil for the acceptance and further development of Schwinger's insightful ideas. These ideas were expressed in his criticism of renormalization and operator field formulation of QFT, and in his own formulation of source theory. They strongly influenced Weinberg, as early as the mid-1960s, in his work on the phenomenological Lagrangian approach to chiral dynamics, and also in his later work on EFT. We can easily find three common features shared by Schwinger's source theory and the new formulation of QFT:

 i. The denial of fundamental theory;
 ii. the flexibility of incorporating new particles and new interactions into existing schemes; and
iii. the possibility of considering nonrenormalizable interactions.

The difference between the two approaches, however, are numerous. Here I only want to emphasize the most fundamental one concerning the adoption of the notion of a local operator field. A system described by local operator fields is characterized by the absence of a characteristic scale, thus the contributions from fluctuations at arbitrarily high energy have to be considered. However, the behavior of local couplings among local fields at various momentum scales can be traced by the renormali-

zation group equations, which often, though not always, possess a fixed point. If this is the case, the local field theory is calculable, and is able to make explanations and effective predictions. Thus for the new formulation of QFT, the notion of such an effective local operator field is acceptable, while in Schwinger's theory the notion is totally rejected. His is a thoroughly phenomenological theory, in which a numerical field, different from a local operator field, is responsible for the one-particle excitation at low energy. There is, therefore, no question of renormalization at all in Schwinger's theory, while in the new formulation of QFT, the renormalization takes on a more and more sophisticated form, and enjoys more and more calculability and predictive power.

In conclusion, some difficulties with the new understanding of renormalization should be mentioned. First, the point of departure for all the new developments is the assumption that the renormalization group equations have fixed point solutions. However, there is no guarantee that such fixed points exist in general. So the ground for the whole edifice seems to be insufficiently sound. Second, EFT is justified by the decoupling theorem, which, however, encounters a number of complicated difficulties when symmetry breaking, whether spontaneous or anomalous, gets involved, as is certainly the case in contemporary field theories. There are extensive discussions on this topic. (See, for example, Veltman 1977 and Collins, Wilczeck, and Zee 1978.) The main argument is this. The nonrenormalizable effects arising from heavy particles will be detectable if there is a process that is forbidden in the absence of the heavy particles. Third, the decoupling argument has not addressed the smallness assumption, namely that the divergences incorporated in the renormalization effects, which also exist in the case of decoupling, are actually small effects. Finally, the long standing difficulty of local field theories, first raised by Landau, namely the zero charge argument, remains to be addressed.

Acknowledgments. I am grateful to Silvan S. Schweber for extensive discussions. I would also like to thank S. Adler, W. Bardeen, S. Coleman, M. Fisher, H. Georgi, S. Glashow, D. Gross, R. Jackiw, K. Johnson, L. Kadanoff, E. Lieb, F. Low, D. Nelson, J. Polchinski, G. 't Hooft, H. Schnitzer, M. Veltman, S. Weinberg, F. Wilczek, K. Wilson, and Y. Yao for helpful conversations. This work is supported in part by the research fellowship, Trinity College, University of Cambridge, England, in part by

a grant from the National Science Foundation [Grant DIR-No. 9014412 (4-59070)].

Notes

1. Note that this statement, although quite popular, is by no means exact: In some cases, finite theories would also require renormalization. I thank Professor Laurie Brown for bringing this point to my attention. An illuminating example is Landau's quasiparticle picture of Fermi liquids. In this picture, liquid ^3He can be described at low temperatures by a dilute gas of quasiparticle exitations near a spherical Fermi surface; and the quasiparticles can be viewed as "dressed" versions of the constituent ^3He fermions, with altered masses and interactions. The basic idea here, the same as that adopted by field theorists, is to replace a complicated interacting system by a simpler one in which the effects of interactions are absorbed into redefinitions of masses and coupling constants.
2. For a historical review and conceptual analysis of the subject, see Brown and Cao (1991).
3. A remark made to me by T. T. Wu in a private conversation (Nov. 1989).
4. In 1953, Källen claimed to be able to show that at least one of the renormalization constants in QED must be infinite, even though we started by assuming that all renormalization constants were finite. This contradictory result had been accepted by most physicists for several years as an evidence for the inconsistency of QED. Yet, as pointed out later by some critics (e.g., Gasiorowicz 1959), this result is heavily dependent upon some notoriously unreliable arguments involving a number of interchanges of orders of integration and summations over an infinite number of states, and was thus highly inconclusive. Källen himself also acknowledged this in 1966.
5. Wightman (1978) takes constructive QFT as an offspring of axiomatic field theory, with some differences between them. While the concern of axiomatic field theory is the general theory of quantum fields, constructive QFT starts from specific Lagrangian models and constructs solutions satisfying the requirements of the former. For early developments of axiomatic QFT, see Jost (1965) and Streater (1964); for constructive QFT, cf. Velo (1973).
6. As to other regularization schemes, the same claim can be made to the essentially equivalent lattice cutoff scheme, but not to the dimensional regularization, which is more formalistic and irrelevant to the point discussed here.
7. Lepage (1989) asserts without explanation that "it now appears likely that this last step (taking the cutoff to infinity) is also a wrong step in the nonperturbative analysis of many theories, including QED."
8. Explicit symmetry breaking, for example, adding non-gauge-invariant mass terms to a pure Yang–Mills theory, is irrelevant to out discussion here.

9. Unitarity can be saved, as pointed out by Steven Weinberg in a private correspondence (Sept. 1991), if we are willing to use a definition of the measure in path integrals that spoils Lorentz invariance.

10. There has been no proof for the existence of fixed points in the renormalization group transformations of coupling constant space of QED. Thus, the asymptotic scale invariance of QED remains only a conjecture.

11. Wilson in his Nobel lecture (1983) vividly described how the progress in statistical physics in the mid-1960s, especially the works by Fisher, Widom, and Kadanoff, had influenced his thinking in theoretical physics.

12. (a) Wilson further substantiated his dynamic view of the scale dimension of field operators with his analysis of the Thirring model (1970a) and $\lambda\varphi^4$ theory (1970b). (b) Even the dimensions of space-time were also becoming new degrees of freedom since then, at least in an instrumentalist sense. In statistical physics, there occurred the ε-expansion technique (Wilson and Fisher 1972); in QFT there occurred dimensional regularization ('t Hooft 1972). Both techniques are based on this new conception of space-time dimensions. While realistic field-theoretical models ultimately have to be four-dimensional, and only toy models can be two-dimensional, in statistical physics, however, two-dimensional models are quite realizable in the real world.

13. It is worth noting that there is an important difference between Wilson's idea of the asymptotic scale invariance of QFT at short distances and that of Bjorken. Bjorken's scaling hypothesis (1969) about the form factors of the deep inelastic lepton–hadron scattering triggered off a great enthusiasm for studying the quark–parton model and the light-cone current algebra of free fields, that was intertwined with the study of Wilson's theory of OPE. While Bjorken's scaling hypothesis suggests that the strong interactions seem to turn off at very short distances, Wilson's formulation of OPE reestablishes the scale invariance only after absorbing the effects of interactions into the anomalous dimensions of the fields, which is just another way of expressing logarithmic corrections of the scale invariance of the theory. Thus, Bjorken's ideas was soon fitted into the framework of nonabelian gauge theory (QCD) and reexpressed as asymptotic freedom, while Wilson's idea has found its applications in other areas.

14. Weinberg (1983) also notices that sometimes the relevance problem is more complicated than simply choosing appropriate energy scale, and involves turning on collective degrees of freedom (e.g., hadrons) and turning off the elementary ones (e.g., quarks and gluons).

15. The most widely known applications of the renormalization group equations are (i) the observation of asymptotic freedom in QCD, which provides a basis for a perturbative QCD that is renormalizable (Politzer 1973; Gross and Wilczeck 1973) and (ii) the calculations of the coupling constants in the strong and electroweak interactions, which lend a support to the suggestion of grand unified theories (Georgi, Quinn, and Weinberg 1974).

16. The Gaussian fixed point coorresponds to a free massless field theory for which the field distributions are Gaussian.
17. QED is regarded as perturbatively renormalizable only because the breakdown of perturbation at extremely high energy, as pointed out by Gell-Mann and Low, is practically ignored.

References

Adler, S. L. (1969), "Axial-vector vertex in spinor electrodynamics," *Phys. Rev.* **177**, pp. 24226–2438.

Aramaki, S. (1989), "Development of the renormalization theory in quantum electrodynamics. II," *Historia Sci.* **37**, pp. 91–113.

Appelquist, T. and J. Carazzone (1975), "Infrared singularities and massive fields," *Phys. Rev. D* **11**, pp. 2856–2861.

Becchi, C., A. Rouet, and R. Stora (1974), "The Abelian Higgs–Kibble model, unitarity of the S operator," *Phys. Lett. B* **52**, pp. 344–346.

Bell, J. S. and R. Jackiw (1969), "A PCAC puzzle: $\pi^0 \to \gamma\gamma$ in the σ model," *Nuovo Cimento B* **60**, pp. 47–61.

Bethe, H. A. (1947), "The electromagnetic shift of energy levels," *Phys. Rev.* **72**, pp. 339–341.

Bjorken, J. D. (1969), "Asymptotic sum rules at infinite momentum," *Phys. Rev.* **179**, pp. 1547–1553.

Bopp, F. (1940), "Eine lineare theorie des elektrons," *Ann. Phys.* **38**, pp. 345–384.

Born, M., W. Heisenberg, and P. Jordan (1926a), "Zur quantemmechnik. II," *Z. Phys.* **35**, pp. 557–615.

Brown, L. M. and T. Y. Cao (1991), "Spontaneous breakdown of symmetry: Its rediscovery and integration into quantum field theory," *Historical Stud. Phys. Biol. Sci.* **21**, pp. 211–235.

Callan, C. G., Jr. (1970), "Bjorken scale invariance in scalar field theory," *Phys. Rev. D* **2**, pp. 1541–1547.

Cao, T. Y. (1991), "The Reggeizaqtion program 1962–1982: Attempts at reconciling quantum field theory with S-matrix theory," *Arch. History Exact Sci.* **41**, pp. 239–283.

Cao, T. Y. and S. S. Schweber (1993), "The conceptual foundations and philosophical aspects of renormalization theory." *Synthese* (forthcoming: vol. 97, no. 1, Oct. 1993).

Coleman, S. and E. Weinberg (1973), "Radiative corrections as the origin of spontaneous symmetry breaking," *Phys. Rev. D* **7**, pp. 1888–1910.

Collins, J. C. (1984), *Renormalization*, Cambridge: Cambridge University Press.

Cushing, J. T. (1990), *Theory Construction and Selection in Modern Physics: The S-Matrix Theory*, Cambridge: Cambridge University Press.

Dirac, P. A. M. (1927a), "The quantum theory of emission and absorbtion of radiation," *Proc. R. Soc. London Ser. A* **114**, pp. 243–265.

Dirac, P. A. M. (1927b), "The quantum theory of dispersion," *Proc. R. Soc. London Ser. A* **114**, pp. 716–728.

Dirac, P. A. M. (1930), "A theory of electrons and protons," *Proc. R. Soc. London Ser. A* **126**, pp. 360–365.

Dirac, P. A. M. (1933), "Theorie du positron," in *Rapport du 7e Conseil Solvay de Physique, Structure et Proprietes des noyaux Atomiques* (22–29, Oct. 1933), Paris: Gauthier-Villars, pp. 203–212.

Dirac, P. A. M. (1938), "Classical theory of radiating electrons," *Proc. R. Soc. London Ser. A* **167**, pp. 148–169.

Dirac, P. A. M. (1942), "The physical interpretation of quantum mechanics," *Proc. R. Soc. London Ser. A* **180**, pp. 1–40.

Dirac, P. A. M. (1963), "The evolution of the physicist's picture of nature," *Sci. Am.* **208**, pp. 45–53.

Dirac, P. A. M. (1969), "Methods in theoretical physics," in *Special Suppl. of IAEA Bulletin*, Vienna: IAEA, pp. 21–28.

Dirac, P. A. M. (1973a), "Relativity and quantum mechanics," in *The Past Decades in Particle Theory*, C. G. Sudarshan and Y. Neéman, eds., New York: Gordon and Breach, pp. 741–772.

Dirac, P. A. M. (1973b), "Development of the physicist's conception of nature," in *The Physicist's Conception of Nature*, J. Mehra, ed., Dordrecht: D. Reidel, pp. 1–14.

Dirac, P. A. M. (1983), "The origin of quantum field theory," in *The Birth of Particle Physics* L. M. Brown and L. Hoddeson, eds., Cambridge: Cambridge University Press, pp. 39–55.

Dyson, F. J. (1949), "The radiation theories of Tomonaga, Schwinger, and Feynman," *Phys. Rev.* **75**, pp. 486–502.

Dyson, F. J. (1949), "The S matrix in quantum electrodynamics," *Phys. Rev.* **75**, pp. 1736–1755.

Dyson, F. J. (1951), "The renormalization method in quantum electrodynamics," *Proc. R. Soc. London Ser. A* **207**, pp. 395–401.

Dyson, F. J. (1952), "Divergence of perturbation theory in quantum electrodynamics," *Phys. Rev.* **85**, pp. 631–632.

Essam, J. W. and M. E. Fisher (1963), "Padé approximant studies of the lattice gas and Ising ferromagnet below the critical point," *J. Chem. Phys.* **38**, pp. 802–812.

Feldman, D. (1949), "On realistic field theories and the polarization of the vacuum," *Phys. Rev.* **76**, pp. 1369–1375.

Feynman, R. P. (1948a), "Space-time approach to nonrelativistic quantum mechanics," *Rev. Mod. Phys.* **20**, pp. 367–387.

Feynman, R. P. (1948b), "A relativistic cutoff for classical electrodynamics," *Phys. Rev.* **74**, pp. 939–946.

Feynman, R. P. (1948c), "Relativistic cutoff for quantum electrodynamics," *Phys. Rev.* **74**, pp. 1430–1438.

Fisher, M. E. (1964), "Correlation functions and the critical region of simple fluids," *J. Math. Phys.* **5**, pp. 944–962.

Frenkel, J. (1925), "Zur elektrodynamik punktfoermiger elektronen," *Z. Phys.* **32**, pp. 518–534.

Furry, W. H. and J. R. Oppenheimer (1934), "On the theory of the electron and positron," *Phys. Rev.* **45**, pp. 245–262.

Gasiorowicz, S. G., P. R. Yennie, and H. Suura (1959), "Magnitude of renormalization constants," *Phys. Rev. Lett.* **2**, pp. 513–516.

Gell-Mann, M. (1987), "Particle theory from *S* matrix to quark," in *Symmetries in Physics* (1600–1980), M. G. Doncel, A. Hermann, L. Michel, and A. Pais, eds., Barcelona: Bellaterra, pp. 474–497.

Gell-Mann, M. (1989), "Progress in elementary particle theory, 1950–1964," in *Pions to Quarks*, L. M. Brown, M. Dresdon, and L. Hoddeson, eds., Cambridge: Cambridge University Press, pp. 694–711.

Gell-Mann, M. and F. E. Low (1954), "Quantum electrodynamics at small distances," *Phys. Rev.* **95**, pp. 1300–1312.

Georgi, H., H. Quinn, and S. Weinberg (1974), "Hierarchy of interactions in unified gauge theories," *Phys. Rev. Lett.* **33**, pp. 451–454.

Georgi, H. (1989b), "Effective quantum field theories," in *The New Physics*, Paul Davies, ed., Cambridge: Cambridge University Press, pp. 4446–4457.

Green, M. B. and J. H. Schwarz (1984), "Anomaly cancellations in sypersymmetric $D = 10$ gauge theory and superstring theory," *Phys. Lett.* B **149**, pp. 117–122.

Green, M. B. (1985), "Unification of forces and particles in superstring theories," *Nature* **314**, pp. 409–414.

Green, M. B., J. H. Schwarz, and E. Witten (1987), *Superstring Theory*, Cambridge: Cambridge University Press.

Gross, D. and R. Jackiw (1972), "Effect of anomalies on quasi-renormalizable theories," *Phys. Rev. D* **6**, pp. 477–493.

Gross, D. and F. Wilczek (1973), "Ultraviolet behavior of non-abelian gauge theories," *Phys. Rev. Lett.* **30**, pp. 1343–1346.

Gross, D. (1985), "Beyond quantum field theory," in *Recent Developments in Quantum Field Theory*, J. Ambjorn, B. J. Durhuus, and J. L. Petersen, eds., Amsterdam: Elsevier, pp. 151–168.

Hawking, S. (1980), *Is the End in Sight for Theoretical Physics?* Cambridge: Cambridge University Press.

Heisenberg, W. (1934), "Remerkung zur Diracschen theorie des positrons," *Z. Phys.* **90**, pp. 209–231.

Heitler, W. (1961), in *The Quantum Theory of Fields*, R. Stoops, ed., New York: Interscience, p. 37.

Hurst, C. A. (1952), "The enumeration of graphs in the Feynman–Dyson technique," *Proc. R. Soc. London Ser. A* **214**, pp. 44–61.

Jaffe, A. (1965), "Divergence of perturbation theory for bosons," *Commun. Math. Phys.* **1**, pp. 127–149.

Johnson, K. (1961), "Solution of the equations for the Green's functions of a two-dimensional relativistic field theory," *Nuovo Cimento* **20**, pp. 773–790.

Jost, R. (1965), *The General Theory of Quantum Fields*, Providence: American Mathematical Society.

Kadanoff, L. P. (1966), "Scaling laws for Ising models near T_c," *Physics* **2**, pp. 263–272.

Källen, G. (1953), "On the magnitude of the renormalization constants in quantum electrodynamics," *Dan. Mat.-Fys. Medd.* **27**, pp. 1–18.

Källen, G. (1966), "Review of consistency problems in quantum electrodynamics," *Acta Phys. Austr. Suppl.* **II**, pp. 133–161.

Kamefuchi, S. (1951), "Note on the direct interaction between spinor fields," *Progr. Theor. Phys.* **6**, pp. 175–181.

Kramers, H. (1938), *Quantentheorie des Elektrons und der Strahlung*, Leipzig: Akad. Verlag, trans. D. ter Haar, Amsterdam: North-Holland, 1957.

Kramers, H. (1947), A review talk at the Shelter Island Conference (June 1947), Unpublished. For its content and significance in the development of renormalization theory, cf. S. S. Schweber: "A short history of Shelter Island I," in *Shelter Island II*, R. Jackiw, N. N. Khuri, S. Weinberg, and E. Witten, eds., Cambridge MA: MIT Press, 1985.

Lamb, W. E., Jr. and R. C. Retherford (1947), "Fine structure of the hydrogen atom by a microwave method," *Phys. Rev.* **72**, pp. 241–143.

Landau, L. D., A. A. Abrikosov, and I. M. Khalatnikov (1954a), "The removal of infinities in quantum electrodynamics," *Dokl. Akad. Nauka* **95**, pp. 497–499.

Landau, L. D., A. A. Abrikosov, and I. M. Khalatnikov (1954b), "An asymptotic expression for the electro Green function in quantum electrodynamics," *Dokl. Akad. Nauka* **95**, pp. 773–776.

Landau, L. D., A. A. Abrikosov, and I. M. Khalatnikov (1954c), "An asymptotic expression for the photon Green function in quantum electrodynamics," *Dokl. Akad. Nauka* **95**, pp. 1117–1120.

Landau, L. D., A. A. Abrikosov, and I. M. Khalatnikov (1954d), "The electron mass in quantum electrodynamics," *Dokl. Akad. Nauka* **96**, pp. 261–263.

Landau, L. D. (1955a), "On the quantum theory of fields," in *Niels Bohr and the Development of Physics*, W. Pauli, ed., London: Pergamon, pp. 52–69.

Landau, L. D. and I. Pomeranchuck (1955b), "On point interactions in quantum electrodynamics," *Dokl. Akad. Nauka* **102**, pp. 489–491.

Landau, L. D., A. A. Abrikosov, and I. M. Kalatnikov (1956), "On the quantum theory of fields," *Nuovo Cimento Suppl.* **3**, pp. 80–104.

Lepage, G. P. (1989), "What is renormalization?" preprint, CLNS, 89/970. Newman Lab. of Nuclear Studies, Cornell University.

Lewis, H. W. (1948), "On the reactive terms in quantum electrodynamics," *Phys. Rev.* **73**, pp. 173–176.

Lorentz, H. A. (1904a), "Maxwell's elektromagnetische theorie," in *Encyc. Mat. Wiss.* Vol. V/2, pp. 63–144.

Lorentz, H. A. (1904b), "Weeiterbildung der Maxwellschen theorie: elektronentheorie," in *Encyc. Mat. Wiss.* Vol. V/2, pp. 145–280.

Mack, G. (1968), "Partially conserved dilatation current," *Nucl. Phys. B* **5**, pp. 499–507.

Mills, R. L. and C. N. Yang (1966), "Treatment of overlapping divergences in the photon self-energy function," *Suppl. Progr. Theor. Phys.* **37–38**, pp. 507–511.

Nafe, J. E., E. B. Nelson, and I. I. Rabi (1947), "The hyperfine structure of atomic hydrogen and deuterium," *Phys. Rev.* **71**, pp. 914–915.

Pais, A. (1945), "On the theory of the electron and of the nucleon," *Phys. Rev.* **68**, pp. 227–228.

Pauli, W. and F. Villars (1949), "On the invariant regularization in relativistic quantum theory," *Rev. Mod. Phys.* **21**, pp. 434–444.

Pauli, W. and V. Weisskopf (1934), "Uber die quantisierung der skalaren relativistischen wellengleichung," *Helv. Phys. Acta* **7**, pp. 709–731.

Peterman, A. and E. C. G. Stueckelberg (1951), "Restriction of possible interactions in quantum electrodynamics," *Phys. Rev.* **82**, 548–549.

Peterman, A. (1953), "Divergence of perturbation expression," *Phys. Rev.* **89**, pp. 1160–1161.

Peterman, A. (1953), "Renormalisation dans les séries divergentes," *Helv. Phys. Acta* **26**, pp. 291–299.

Poincaré, H. (1906), "Sur la dynamique de l'électron," *Read. Circ. Mat. Palermo* **21**, pp. 129–175.

Polchinski, J. (1984), "Renormalization and effective Lagrangians," *Nucl. Phys. B* **231**, pp. 269–295.

Politzer, H. (1973), "Reliable perturbative results for strong interactions?" *Phys. Rev. Lett.* **30**, pp. 1346–1349.

Rayski, J. (1948), "On simultaneous interaction of several fields and the self-energy problem," *Acta Phys. Polonica* **9**, pp. 129–140.

Rivier, D. and E. C. G. Stueckelberg (1948), "A convergent expression for the magnetic moment of the neutron," *Phys. Rev.* **74**, p. 218.

Rohrlich, F. (1973), "The electron: Development of the first elementary particle theory," in *Physicist's Conception of Nature*, J. Mehra, ed., Dordrecht: Reidel, pp. 331–369.

Sakata, S. and O. Hara (1947a), "The self-energy of the electron and the mass difference of nucleons," *Progr. Theor. Phys.* **2**, pp. 30–31.

Sakata, S. (1947b), "The theory of the interaction of elementary particles," *Progr. Theor. Phys.* **2**, pp. 145–147.

Sakata, S. (1950a), "On the direction of the theory of elementary particles" (English trans. in *Suppl. Progr. Theor. Phys.* **50** (1971): 155–158.

Sakata, S. and H. Umezawa (1950b), "On the applicability of the method of mixed fields in the theory of the elementary particles," *Progr. Theor. Phys.* **5**, pp. 682–691.

Sakata, S., H. Umezawa, and S. Kamefuchi (1952), "On the structure of the interaction of the elementary particles," *Progr. Theor. Phys.* **7**, pp. 377–390.

Sakata, S. (1956), "On a composite model for the new particles," *Progr. Theor. Phys.* **16**, pp. 686–688.

Salam, A. (1951a), "Overlapping divergences and the S matrix," *Phys. Rev.* **82**, pp. 217–227.

Salam, A. (1951b), "Divergent integrals in renormalizable field theories," *Phys. Rev.* **84**, pp. 426–431.

Salam, A. (1968), "Weak and electromagnetic interactions," in *Proceedings of Nobel Conference VIII*, pp. 367–377.

Salam, A. and J. Strathdee (1970), "Quantum gravity and infinities in quantum electrodynamics," *Lett Nuovo Cimento.* **4**, pp. 101–108.

Salam, A. (1973), "Progress in renormalization theory since 1949," in *The Physicist's Conception of Nature*, J. Mehra, ed., Dordrecht: Reidel, pp. 430–446.

Schweber, S. S., H. A. Bethe, and F. de Hoffmann (1955), *Mesons and Fields*, Vol. I, Row, Peterson, and Co.

Schwinger, J. (1948a), "On quantum electrodynamics and the megnetic moment of the electron," *Phys. Rev.* **73**, pp. 416–417.

Schwinger, J. (1948b), "Quantum electrodynamics. I. A covariant formulation," *Phys. Rev.* **74**, pp. 1439–1461.

Schwinger, J. (1951), "On the Green's functions of quantized field. I," *Proc. Natl. Acad. Sci. U.S.A.* **37**, pp. 452–459.

Schwinger, J. (1970), *Particles, Sources, and Fields*, Reading MA: Addison-Wesley, Vol. I.

Schwinger, J. (1973), "A report on quantum electrodynamics," in *The Physicist's Conception of Nature*, (J. Meyra, ed., Dordrecht: Reidel, pp. 413–429.

Schwinger, J. (1983), "Renormalization theory of quantum electrodynamics: An individual view," in *The Birth of Particle Physics*, L. M. Brown and L. Hoddeson, eds., Cambridge: Cambridge University Press, pp. 329–353.

Streater, R. F. and A. S. Wightman (1964), *PTC, Spin and Statistics, and All That*, Reading, MA: Benjamin.

Stueckelberg, E. C. G. (1938), "Die wechselwirkungskrafte in der elektrodynamik und in der feldtheorie der Kernkrafte," *Helv. Phys. Acta* **11**, pp. 225–244; 299–329.

Stueckelberg, E. C. G. and A. Peeterman (1953), "La normalisation des constantes dans la theorie des quanta," *Helv. Phys. Acta* **26**, pp. 499–520.

Symanzik, K. (1970), "Small distance behavior in field theory and power counting," *Commun. Math. Phys.* **18**, 227–246.

Symanzik, K. (1973), "Infrared singularities and small-distance behavior analysis," *Commun. Math. Phys.* **34**, pp. 7–36.

Symanzik, K. (1983), "Continuum limit and improved action in lattice theories," *Nucl. Phys. B* **226**, pp. 187–227.

Takabayasi, T. (1983), "Some characteristic aspects of early elementary particle theory in Japan," in *The Birth of Particle Physics*, L. M. Brown and L. Hoddeson, eds., Cambridge: Cambridge University Press, pp. 294–303.

Thirring, W. (1953), "On the divergence of perturbation theory for quantum fields," *Helv. Phys. Acta* **26**, pp. 33–52.

Thompson, J. J. (1881), "On the electric and magnetic effects produced by the motion of electrified bodies," *Philos. Mag.* **11**, pp. 227–249.

't Hooft, G. (1971a) "Renormalization of massless Yang–Mills fields," *Nucl. Phys. B* **33**, pp. 173–99.

't Hooft, G. (1971b) "Renormalizable Lagrangians for massive Yang–Mils fields," *Nucl. Phys. B* **35**, pp. 167–188.

't Hooft and M. Veltman (1972a), "Renormalization and regularization of gauge fields," *Nucl. Phys. B* **44**, pp. 189–213.

't Hooft and M. Veltman (1972b), "A Combinatorics of gauge fields," *Nucl. Phys. B* **50**, pp. 318–353.

't Hooft and M. Veltman (1972c), "Example of Gauge field theory," *Proc. Marseille Conf.* June 1972, C. Korthals-Altes, ed.

Tomonaga, S. (1946), "On a relativistically invariant formulation of the quantum theory of wave fields," *Progr. Theor. Phys.* **1**, pp. 27–42.

Tomonaga, S. (1965), "Development of quantum electrodynamics," in *Noble Lectures (Physics)*: 1963–1970, Amsterdam: Elsevier, pp. 126–136.

Umezawa, H., J. Yukawa, and E. Yamada (1948), "The problem of vacuum polarization," *Progr. Theor. Phys.* **3**, pp. 317–318.

Umezawa, H. and R. Kawabe (1949a), "Some general formulae relating to vacuum polarization," *Progr. Theor. Phys.* **4**, pp. 423–442.

Umezawa, H. and R. Kawabe (1949b), "Vacuum polarization due to various charged particles," *Progr. Theor. Phys.* **4**, pp. 443–460.

Velo, G. and A. Wightman (eds.) (1973), *Constructive Quantum Field Theory*, Berlin: Springer-Verlag.

Veltman, M. (1968a), "Relation between the practical results of current algebra techniques and the originating quark model," Copenhagen lectures, July 1968. Reprinted in *Gauge Theory—Past and Future*, R. Akhoury, B. De Wit, P. van Nieuwenhuizen, and H. Veltman, eds., Singapore, World Scientific, 1992.

Veltman, M. (1968b), "Perturbation theory of massive Yang–Mills fields," *Nucl. Phys. B* **7**, pp. 637–650.

Veltman, M. (1969a), Proc. Topical Conf. on Weak Interactions, CERN, Geneva, 14–17 Jan. 1969. *CERN Yellow Report*, 69-7, p. 391.

Veltman, M. (with J. Reiff) (1969b), "Massive Yang–Mills fields," *Nucl. Phys. B* **13**, pp. 545–564.

Veltman, M. (1970), "Generalized Ward identities and Yang–Mills fields," *Nucl. Phys. B* **21**, pp. 288–302.

Veltman, M. (1977), "Large Higgs mass and μ–e universality," *Phys. Lett. B* **70**, pp. 253–254.

Waller, I. (1930), "Bemerküngen über die Rolle der Eigenenergie des Elektrons in der Quantentheorie der Strahlung," *Z. Phys.* **62**, pp. 673–676.

Ward, J. C. (1950), "An identity in quantum eleectrodynamics," *Phys. Rev.* **78**, p. 182.

Ward, J. C. (1951), "On the renormalization of quantum electrodynamics," *Proc. Soc. (London) Ser. A* **64**, pp. 54–56.

Weinberg, S. (1960), "High energy behavior in quantum field theory," *Phys. Rev.* **118**, pp. 838–849.

Weinberg, S. (1967), "A model of leptons," *Phys. Rev. Lett.* **19**, pp. 1264–1266.

Weinberg, S. (1978), "Critical phenomena for field theorists," in *Understanding the Fundamental Constituents of Matter*, A. Zichichi, ed. New York: Plenum, pp. 1–52.

Weinberg, S. (1979), "Phenomenological Lagrangian," *Physica A* **96**, pp. 327–340.

Weinberg, S. (1980a), "Conceptual foundations of the unified theory of weak and electromagnetic interactions," *Rev. Mod. Phys.* **52**, pp. 515–523.

Weinberg, S. (1980b), "Effective gauge theories," *Phys. Lett. B* **91**, pp. 51–55.

Weinberg, S. (1983), "Why the renormalization group is a good thing," in *Asymptotic Realms of Physics*: *Essays in Honor of Francis. E. Low*, A. H. Guth, K. Huang, and R. L. Jaffee, eds., Cambridge, MA: MIT Press.

Weisskopf, V. F. (1936), "Über die elektrodynamic des vakuums auf grund der quantentheorie des elektrons," *K. Danske Vidensk. Selsk., Math.-Fys. Medd.* **14**, pp. 1–39.

Wentzel, G. (1943), *Quantum Field Theory* (English trans., New York: Interscience, 1949).

Widom, B. (1965a), "Surface tension and molecular correlations near the critical point," *J. Chem. Phys.* **43**, pp. 3892–3897.

Widom, B. (1965b), "Equation of state in the neighborhood of the critical point," *J. Chem. Phys.* **43**, pp. 3898–3905.

Wightman, A. S. (1976), "Hilbert's sixth problem: Mathematical treatment of the axioms of physics," in *Mathematical Developments Arising from Hilbert Problems*, F. E. Browder, ed. pp. 147–240.

Wightman, A. S. (1978), "Field theory, Axiomatic," in the *Encyclopedia of Physics*, New York: McGraw-Hill, pp. 318–321.

Wightman, A. S. (1986), "Some lessons of renoormalization theory," in *The Lesson of Quantum Theory*, J. de Boer, E. Dal, and D. Ulfbeck, eds., Amsterdam: Elsevier, pp. 201–225.

Wilson, K. G. (1965), "Model Hamiltonians for local quantum field theory," *Phys. Rev. B* **140**, pp. 445–457.

Wilson, K. G. (1969), "Non-Lagrangian models of current algebra," *Phys. Rev.* **179**, pp. 1499–1512.

Wilson, K. G. (1970a), "Operator-product expansions and anomalous dimensions in the Thirring model," *Phys. Rev. D* **2**, pp. 1473–1477.

Wilson, K. G. (1970b), "Anomalous dimmensions and the breakdown of scale invariance in perturbation theory," *Phys. Rev. D* **2**, pp. 1478–1493.

Wilson, K. G. (1971), "Renormalization group and strong interactions," *Phys. Rev. D* **3**, pp. 1818–1846.

Wilson, K. G. and M. E. Fisher (1972), "Critical exponents in 3.99 dimensions," *Phys. Rev. Lett.* **28**, pp. 240–243.

Wilson, K. G. (1975), "The renormalization group: Critical phenomena and the Kondo problem," *Rev. Mod. Phys.* **47**, pp. 773–840.

Wilson, K. G. (1983), "The renormalization group and critical phenomena," *Rev. Mod. Phys.* **55**, pp. 583–600.

Yang, C. N. and R. L. Mills (1954a), "Isotopic spin conservation and a generalized gauge invariance," *Phys. Rev.* **95**, p. 631.

Yang, C. N. and R. L. Mills (1954b), "Conservation of isotopic spin and isotopic gauge invariance," *Phys. Rev.* **96**, pp. 191–195.

Changing Conceptualization of Renormalization Theory

Silvan S. Schweber

5.1. Introduction

Quantum field theory (QFT) was developed during the late 1920s to describe the interaction of charged particles with the electromagnetic field. During the 1930s the formalism was extended by Fermi to model β-decay phenomena and by Yukawa to explain nuclear forces. All these field theories have one feature in common: the interaction between the fields takes place at a single point in space-time. Such local quantum field theories seem to be the most efficient way to obtain a synthesis of quantum mechanics and special relativity consistent with the principle of causality. However, local quantum field theories are flawed: their perturbative solutions are divergent, the infinities that are encountered being a consequence of the locality of the interaction. Stimulated by important experimental advances after World War II (the measurement of the Lamb shift and of the hyperfine structure of hydrogen), renormalization theory was formulated to circumvent the divergence difficulties encountered in higher order calculations in quantum electrodynamics (QED). In this approach QED is defined by a limiting procedure. A cutoff is introduced into the theory so that the physics at momenta higher than some momentum—or equivalently the physics at distances shorter than some cut-off length—is altered and all calculated quantities thereby rendered finite but cut-off dependent. The parameters of the cut-off theory are then expressed in terms of physically measurable quantities (such as the mass and charge of the particles which are described by the theory). Renormalized QED is the theory which is obtained by letting the cut-off length go to zero. Dyson (1949a, b) was able to show that a "charge renormalization" and a "mass renormalization" were sufficient to absorb all the divergences in QED. More generally Dyson demonstrated that only for certain kinds of quantum field theories is it possible to absorb *all* the infinities by a redefinition of a *finite* number of parameters. He called such theories renormalizable. Renormalizability thereafter became a criterion for theory selection.

During the past 15 years our understanding of quantum field theories and of renormalization has changed dramatically. What has emerged from the new insights—mainly due to the work of K. Wilson and S. Weinberg—is a more limited view that accepts the notion that all theoretical representations of phenomena are only partial descriptions, and incorporates the fact that the most effective description of particle inter-

actions in a quantum field theoretic formalism depends on the energy at which the interactions are being analyzed. The new description is in terms of "effective field theories" which include only those particles which are actually important at the energy being studied. An effective field theory is useful only in a prescribed range of energies, and changes as the energy under consideration is varied. Quantum electrodynamics is now understood to be the effective field theory corresponding to the Weinberg–Salam electroweak theory at long distances. It has also become clear why QED works so well even though so many other complicating factors are operating.

In my paper I address some of the philosophical issues which arise from the blurring of the distinction between "fundamental" and "phenomenological" which the effective field theory point of view entails. This approach implies a hierarchical ordering of the physical world. I will discuss some of its implications for reductionism.

5.2. The History of Quantum Mechanics and QFT

The revolutionary achievements in physics during the period from 1925 to 1927 stemmed from the confluence of a theoretical understanding, the representation of the dynamics of microscopic particles by quantum mechanics, and the apperception of an approximately stable ontology, electrons and nuclei. Approximately stable meant that these particles (electrons, nuclei), the building blocks of the entities—atoms, molecules, simple solids—that populated the domain that was being carved out could be treated as *ahistoric* objects, whose physical characteristics were seemingly independent of their mode of production and whose lifetimes could be considered as essentially infinite. These entities could be assumed to be "elementary" point-like objects, that were specified by their mass, spin, and statistics (whether bosons or fermions), and electromagnetic properties such as their charge and magnetic moment.

Quantum mechanics reasserted that *the physical world presented itself hierarchically*. The world was not carved up into terrestrial, planetary, and celestial spheres, but layered by virtue of certain constants of nature.[1] As Dirac emphasized in the first edition of *Principles of Quantum Mechanics* (Dirac 1930b), Planck's constant allows the world to be parsed into microscopic and macroscopic realms. It is to be stressed that it is

constants of nature—Planck's constant, the velocity of light, the masses of elementary particles—that demarcate the domains. There are of course other domains of nature delineated by physical constants (usually with the dimension of a length), but in these cases the constants are usually characteristics of the *particular* experimental or physical situation. For example, in the case of fluid flow on a macroscopic scale, it is the density, viscosity, and temperature of the fluid, the size of the channel in which the flow takes place—all adjustable parameters—that determine the domain and the valid description, i.e., whether by hydrodynamical equations or by Boltzmann-like equations (Wilson 1979; Dresden 1985).

In the initial flush of success, quantum mechanics was believed to explain most of physics and all of chemistry. All that remained to be done was "fitting of the theory with relativity ideas." The famous assertion by Dirac (1929) that:

The general theory of quantum mechanics is now almost complete, the imperfections that still remain being in connection with the fitting of the theory with relativity ideas. These give rise to difficulties only when high-speed particles are involved, and are therefore of no importance in the consideration of atomic and molecular structure and ordinary chemical reactions.... The underlying physical laws necessary for the mathematical theory of a large part of physics and the whole of chemistry are thus completely known, and the difficulty is only that the exact application of these laws lead to equations much too complicated to be soluble ...

reflected the confidence and hubris of the community. However, fitting the theory with relativity ideas proved to be a much more difficult problem than had been anticipated. How to synthesize the quantum theory with the theory of special relativity was—and has remained—the basic problem confronting elementary particle theorists since 1925–1927.

By the early 1930s it became clear that particle creation and annihilation was the genuinely novel feature emerging from that synthesis. It should be recalled that the theoretical apparatus for the description of microscopic phenomena up to that time had been predicated on a metaphysics that assumed conservation of "particles." Dirac's quantum electrodynamics (Dirac 1927a, b) was the first step in the elimination of that preconception (Bromberg 1976, 1977). Dirac's hole theory (Dirac 1930a) was the first instance of a relativistic quantum theory in which the creation and annihilation of matter was an intrinsic feature. Hole theory was

the first insight into what was entailed by a quantum mechanical description of particles that conformed with the requirements of special relativity. In both his quantum electrodynamics as well as in his positron theory Dirac considered particles the fundamental entities.

It was Jordan who championed the field point of view. Already in the Dreimännerarbeit (Born 1926) Jordan had indicated that the quantization rule $[q, p] = ih/2\pi$, that effected the transition from the classical to the quantum description also applied to systems with an infinite number of degrees of freedom, that is, to fields. His view was that Dirac's quantum electrodynamics was to be understood as "quantizing" the classical electromagnetic field. In practice, what this meant was to exhibit the electromagnetic field as a superposition of harmonic oscillators, whose dynamical variables were then required to satisfy the quantum rules:

$$[q_m, p_n] = i(h/2\pi)\,\delta_{mn}.$$

Jordan was committed to a unitary view of nature in which both matter and radiation were described by wave fields. The quantization of these wave fields exhibited the particle nature of the quanta. It ended the mystery of the particle-wave duality. One of the further dividends of his approach was an answer to the question: Why are all particles in a given species (as characterized by their mass and spin) indistinguishable from one another. The field quantization rules made them automatically indistinguishable.

Steven Weinberg has observed (1977, 1986b) that the history of elementary particle physics can be analyzed in terms of oscillations between two viewpoints. One of them takes fields as fundamental, and in this view particles are manifestations of the fields; they are localized excitations of the fields. And the other takes particles as fundamental, and in that view fields are useful mathematical adjuncts to formalize the properties of particles, and are in special cases coherent superpositions of particle states.

Although the equivalence of the two approaches could be demonstrated in certain simple models (such as the case of free fields and noninteracting particles), as noted by Feynman (1966):

Theories of the known, which are described by different physical ideas, may be equivalent in all their predictions and hence scientifically indistinguishable. However, they are not psychologically identical when trying to move from that base into the unknown. For different views suggest different kinds of modifications

which might be made and hence are not equivalent in the hypotheses one generates from them in one's attempt to understand what is not yet understood.

That the quantum field theoretic approach was richer in potentialities and possibilities is made evident by the field theoretic developments of the 1930s. All these advances took as their point of departure insights gained from the quantum theory of the electromagnetic field, and in particular from the centrality of the concept of emission and absorption of quanta.

Fermi's theory of beta decay was an important landmark in the field theoretic developments of the 1930s. It marked a change in the way of thinking about elementary processes. In the introduction to his paper Fermi (1934) noted:

The simplest way for the construction of a theory which permits a quantitative discussion of the phenomena involving nuclear electrons, seems then to examine the hypothesis that the electrons do not exist as such in the nucleus before the beta emission occurs, but that they, so to say, acquire their existence at the very moment when they are emitted; in the same manner as a quantum of light, emitted by an atom in a quantum jump, can in no way be considered as preexisting in the atom prior to the emission process. In this theory, then, the total number of the electrons and of the neutrinos (like the total number of light quanta in the theory of radiation) will not necessarily be constant, since there might be processes of creation or destruction of these light particles.

Fermi's theory made clear the power of a quantum field theoretical description. Fields were considered the fundamental objects and they have pride of place in the description of the phenomenon. Fermi's theory also formalized the conception of an elementary particle: an elementary particle is one whose field appears in the Lagragian of the theory.

Fermi's theory of beta decay and Yukawa's theory of nuclear forces established the model upon which all subsequent developments were based. [Brown (1981, 1985); Darrigol (1988)]. The model postulated (i) new "impermanent" particles to account for interactions. This has led to a description of nature in terms of a sequence of families of elementary constituents of matter with fewer and fewer members. (ii) The model is committed to quantum field theory as the natural framework in which to attempt the representation of high-energy phenomena.

By the late 1930s, the formalism of quantum field theory was fairly well understood. Pauli reviewed the state of affairs in the *Reviews of Modern Physics* in 1941. But it was Wentzel's *Einführung in der Quantentheorie der*

Wellenfelder (Wentzel 1943), in which a full account of relativistic quantum field theories was presented, that disseminated this approach to a wide audience after World War II. In particular, Wentzel in his book made clear how to quantize the Dirac field in such a way that all reference to the "sea" had disappeared. As a result of his exposition it became standard to regard the quantized Dirac field as describing electrons and positrons, with the "bare" vacuum taken to be the state with no electrons and no positrons present.

In many ways hole theory was equally successful. Most of the predictions of quantum electrodynamics during the 1930s—such as the cross sections for pair production and annihilation, Bremsstrahlung, Compton scattering—as well as the verification of the validity of the theory up to energies of the order of $137 \, mc^2$ and even greater, were based on hole-theoretic QED calculations. Incidentally, it was confidence in this theory that was responsible for the discovery of a new particle in the cosmic radiation, the "mesotron," the particle now identified as the muon (Cassidy 1981; Galison 1983). In 1936 Heitler summarized the hole-theoretic approach in his *The Quantum Theory of Radiation*, with a slightly revised edition appearing in 1944. Heitler's book was the primary and standard source for learning how to "calculate" quantum electrodynamic processes.

But both approaches—field theory and hole-theoretic QED—were beset by overwhelming divergence difficulties that manifested themselves in perturbative calculations beyond the lowest order (Weinberg 1977; Pais 1986). These difficulties impeded progress and gave rise to a deep pessimism about the formalism at hand. Numerous proposals to overcome the problems of the divergences were advanced.

Almost all the proposals to eliminate the divergences that were made during the 1930s ended in failure. The pessimism of the leaders of the discipline—Bohr, Pauli, Heisenberg, Dirac—was partly responsible for the lack of progress. They had witnessed the overthrow of the classical concepts of space-time and were responsible for the ejection of the classical concept of determinism in the description of atomic phenomena. They had brought about the quantum mechanical revolution and they were convinced that only further conceptual revolutions would solve the divergence problem in quantum field theory. In 1938 Heisenberg noted that the revolutions of special relativity and quantum mechanics were associated with fundamental *dimensional* parameters: the speed of light c and

Planck's constant h. These delineated the domain of classical physics. He proposed that the next revolution be associated with the introduction of a fundamental unit of length, which would delineate the domain in which the concept of fields and local interactions would be applicable. The S-matrix theory which he developed in the early 1940s was an attempt to make this approach concrete.

5.3. The Post-World War II Developments

In the period immediately after World War II important methods were developed to bypass the difficulties that had beset all relativistic quantum field theories since their initial formulation in the late 1920s. These advances were stimulated by empirical findings: Lamb and Retherford's measurements of the fine structure of hydrogen (Lamb 1947), and the results of Nafe, Nelson, and Rabi on the hyperfine structure of hydrogen (Nafe 1947) and deuterium. Lamb's experiment was of fundamental importance. All the theoretical developments after the Shelter Island Conference have, as their point of departure, the attempt to account for the numbers that had been generated by the Columbia experiments (Schweber 1986a, b). Incidentally, it was an attitude towards numbers and the meaning of numbers that differentiated the Europeans theorists working on fundamental problems—in particular Pauli, Dirac, Heisenberg, Peierls—from their American counterparts. Given the accurate and reliable data that had been reported by Lamb and Rabi, the challenge for the Americans was to explain them. For the American theorists physics was about numbers and theories were algorithms to obtain and thereby to explain numbers.

The resolution to the divergence problems in the 1945–1950 period was the work of a handful of individuals—principally Kramers, Bethe, Lewis, Schwinger, Tomonaga, Feynman, and Dyson—and the solution advanced was conservative and technical. It asked to take seriously the received dogma of quantum field theory and of special relativity and to explore the limits of that synthesis. Renormalization theory—the technical name for the proposed solution of the 1947–1950 period—revived the faith in quantum field theory. The history of the post-World War II developments can be told in a form that highlights the dichotomy between the field and the particle approach: Tomonaga, Schwinger, and

Dyson were all field theorists; for Feynman, on the other hand, particles were the fundamental building blocks (Schweber 1992; see also Weinberg 1977; Pals 1986).

By exhibiting a formalism that eliminated the divergences in low orders of perturbation theory in a relativistically and gauge invariant fashion, Schwinger (1948a, b) firmly established the validity of relativistic quantum field theories. In Schwinger's work, the elimination of the divergences was accomplished by identifying in a gauge and Lorentz invariant manner the divergent terms that occurred in the calculation, and by noting that these terms could be interpreted as modifying the mass and charge parameters that appeared in the original Lagrangian. Most importantly, the formalism could make predictions about observable phenomena (e.g., the magnetic moment of the electron, the Lamb shift, the scattering of electrons by nuclei). Feynman's genius was such that his idiosyncratic approach (stemming from his work with Wheeler on an action-at-a-distance formulation of classical electrodynamics from which all reference to the electromagnetic field had been eliminated!) resulted in a readily visualizable and highly effective computational scheme (Feynman 1949a, b). Feynman diagrams visualize the fundamental processes in terms of space-time trajectories of particles. Dyson (1949a, b) then showed that Feynman's results and insights were derivable from Schwinger's and Tomonaga's formulation of QED. Dyson was furthermore able to outline a proof that mass and charge renormalization removed all the divergences from the S matrix of QED to all orders of perturbation theory and suggested that renormalized QED might well be a consistent quantum field theory. To construct a rigorous proof of the renormalizability of QED in perturbation theory proved to be a difficult task: this was only accomplished in the early 1960s with the work of Weinberg, Mills, and Yang, Bogoliubov, Parasiuk, Hepp, and others.

Perhaps the most important theoretical accomplishment of the 1947–1952 period was the establishment of local quantum field theory as the best suited framework for the unification of quantum theory and special relativity. The most perspicacious theorists, e.g., Gell-Mann, also noted the ease with which symmetries—both space-time and internal symmetries—could be incorporated into the framework of local quantum field theory. Furthermore, with the new formalism of Feynman and Dyson, insights that had only been intuited previously became readily provable assertions; for example, the fact that a relativistically invariant quantum

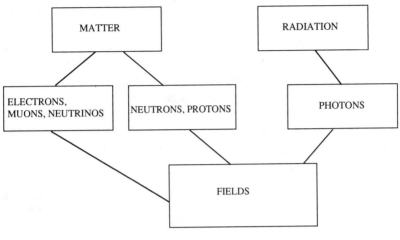

FIGURE 5.1

field theory of charged particles automatically contained in its description the oppositely charged particles, what Dirac had originally called "antiparticles." These field-theoretic ideas could readily be incorporated in the description of the weak and nuclear interactions. The buildup of matter, as perceived in the early 1950s, can be summarized in the manner indicated in Fig. 5.1. The underlying fields, those of the photons, pions, nucleons, electrons, muons, and neutrinos, were assumed to be local fields and the elementary particles—nucleons, mesons, ...—corresponded to localized excitations of the fundamental fields.

A local quantum field theory is a system with an infinity of degrees of freedom in which the interactions between fields take place at single space-time points. Stated more technically, in a Lorentz invariant relativistic local field theory the energy density at the point x is the sum of various product of fields quantities and of derivatives of field quantities at x. This assumption has two consequences that are difficult to reconcile. On the one hand, it makes the theory "causal," meaning that no interactions propagate outside the light cone. On the other hand, it is precisely the locality assumption that introduces divergences in relativistic quantum field theories in four-dimensional space-time.

At the time it was argued that these divergences were a consequence of the fact that a space-time point is not a physical object: it is an abstraction introduced to simplify the mathematical description. In special

relativistic quantum field theories space-time is a rigid frame that is unaffected by the interactions that take place on that stage. General relativity had taught that space-time must be dynamicized. The divergences were a reflection of an inappropriate description of events at smaller and smaller distances—or equivalently at higher and higher energies—where other processes and their effect on the geometry of space-time need to be taken into account. Lewis (1948), in his important paper that corrected an earlier mistake by Dancoff and initiated the relativistic version of the renormalization program, noted that the crucial assumption underlying the renormalization program is that

The electromagnetic mass of the electron is a small effect and ... its apparent divergence arises from a failure of present-day quantum electrodynamics above certain frequencies.

Similarly Schwinger (1948a), in his first paper on the new QED, emphasized that

Electrodynamics unquestionably requires revision at ultrarelativistic energies, but it is presumably accurate at moderate relativistic energies. It would be desirable, therefore, to isolate those aspects of the current theory that essentially involve high energies, and are subject to modification by a more satisfactory theory, from aspects that involve only moderate energies and are thus moderately trustworthy.

Renormalization was the implementation of that view. The way renormalization works is as follows. All relativistic quantum field theories containing interactions are ill-defined. One must define the theory by a limiting procedure so that all processes at energies higher than some cut-off energy Λ_0 (or equivalently, at distances smaller than some cut-off length $1/\Lambda_0$) give rise to finite contributions. "Regularization" is the technical name for the procedure whereby a cutoff is introduced into the integral that is associated with a given Feynman diagram. With regularization any ultraviolet divergence appears only as the cut-off parameter tends to some limiting value. This artifice transforms essentially purely formal manipulations of divergent quantities into quasirespectable mathematical operations. The parameters in terms of which the original theory had been formulated—the masses of the quanta of the fields and the coupling constants associated with the elementary scattering processes described by the interaction terms in the Lagrangian—are then expressed in terms of physically measurable, observable quantities, such as

the masses and the charges of the physical particles, and the cross sections for certain simple processes. The renormalized theory is then defined by letting the cutoff go to infinity. In this limit, the physics proper must not depend on the cutoff, although the description may. In other words any dependence on the cutoff must be associated with some parameter in the theory. However, only certain special kinds of theory have the property that a *finite number* of parameters are sufficient to define the renormalized theory. Such theories were called renormalizable. Renormalizability is the translation of the statement that processes at very small distances (or equivalently very-high-energy interactions) play a negligible role except for effects on the parameters of the theory.

The fundamental result of renormalization theory is the statement that to all orders in perturbation theory the ultraviolet divergences of a relativistically invariant local quantum field theory may be formally absorbed into the parameters defining the theory, while locality, unitarity, and Lorentz invariance are maintained. Since the aim of foundational physics is to formulate theories that possess considerable predictive power, "fundamental laws" must contain only a finite number of parameters. Only renormalizable theories are consistent with this requirement. Note that the concept of renormalization and that of renormalizability are distinct: the divergences of nonrenormalizable theories could possibly be eliminated by absorbing them into an *infinite* number of parameters in terms of which the theory would be specified. It turns out that in four-dimensional space-time the class of renormalizable quantum field theories is composed of those in which the local interaction parameters have zero or positive energy dimension; in these theories the interaction terms between the fields are characterized by dimensionless coupling constants.

Renormalizability became a criterion for theory selection (Dyson 1949b). Only renormalizable local relativistic quantum field theories were adopted for the representation of the interactions of what were then thought to be the elementary particles. Note the cunning of reason at work: the divergences that had previously been considered a disastrous liability now became a valuable asset. However, the question as to why nature should be described by renormalizable theories was not addressed. Such theories were simply the only ones in which calculations could be done.

The impressive advances of the late 1960s and early 1970s that culminated with the standard model were a triumph of renormalization

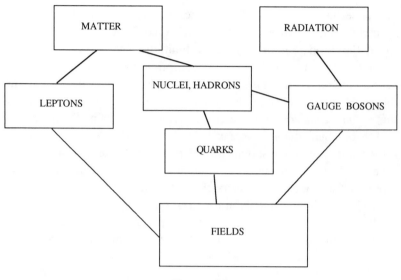

FIGURE 5.2

theory.[2] In 1976, Steven Weinberg, one of the principal architects of the unified theory of weak and electromagnetic interactions, declared that the fact there existed a limited class of theories that were renormalizable was for him "the most exciting thing" about quantum field theory. In the lecture he delivered in 1979 in Stockholm when he received the Nobel prize in physics, he indicated (Weinberg 1980a) that

To a remarkable degree, our present detailed theories of elementary particles interactions can be understood deductively, as consequences of symmetry principles and of the principle of renormalizability which is invoked to deal with the infinities.

The "deductive" understanding was predicated on a conceptualization that is a refinement of the formulation of the early 1950s. It is illustrated in Fig. 5.2. Relativistic local fields are again the "fundamental" entities; but now gauge symmetry and renormalizability (together with insights derived from dynamically broken symmetries) are the guiding principles.

In that same speech Weinberg (1980a) recalled that

I learned about renormalization as a graduate student, mostly by reading Dyson's papers. From the beginning it seemed to me to be a wonderful thing that very few quantum field theories are renormalizable. Limitations of this sort are, after all what we most *want*; not mathematical methods which can make sense

out of an infinite variety of physically irrelevant theories, but methods which carry constraints, because constraint may point the way towards the one true theory.... [At the time] I thought that renormalizability might be the key criterion, which also in a more general context would impose a precise kind of simplicity on our theories and help us pick out the one true physical theory out of the infinite variety of conceivable quantum theories.... I would say this a bit differently today, but I am more convinced than ever that the use of renormalizability as a constraint on our theories of the observed interactions is a good strategy.

Renormalization theory was first worked out in the context of QED. The fact that in that theory the renormalized coupling constant e^2/hc is a small number $= 1/137$, implied that perturbative calculations could be made, and led to truly amazing agreement between theory and experiment for

a. the Lamb shift and hyperfine structure of hydrogen and singly ionized helium,
b. the anomalous magnetic moment of electron and muon, and
c. the spectrum and decay properties of positronium (Kinoshita 1990).

The advances in our understanding of QED during the period from 1947 to the present chronicles the way "normal" science progresses and offers a valuable insight into the interaction between theorists and experimenters. Greater experimental precision led to more powerful calculational techniques, and conversely, refinements in calculations stimulated more precise measurements. In turn, the theoretical advances were intimately linked to a deeper understanding of renormalization and were connected with better methods to incorporate the demands of renormalization in calculations, and in particular computer-based calculations. Indeed, renormalization had become the operating "paradigm."

The very success of the renormalization program in QED posed another question that could only be answered much later. Why is the notion of a local field so effective? "Who would have expected that this concept, which originated in Faraday's attempt to visualize macroscopic magnetic fields, would be so fruitful?" [Gross (1985a)]. To put the matter in perspective: With the establishment during the 1970s of gauge theories to describe the electroweak and the strong interactions physicists now believe that they are able to account for all physical phenomena "from the macroscopic structure of the universe down to the structure of matter at distances of at least 10^{-15} cm" (Gross 1985a). In fact the only place they

express doubt about the adequacy of local quantum field theories is in the description of physics at the Planck scale of 10^{-33} cm.

5.4. The Changing Conceptualization of Renormalization. Effective Field Theories

When renormalization was first developed it was regarded as a technical device to get rid of the divergences in perturbation theory, and seemed to be a remarkably effective way of sweeping the problems under the rug. In the early 1950s Stückelberg and Peterman [Stückelberg (1953)], and Gell-Mann and Low (Gell-Mann 1954) made a fundamental observation whose importance was not realized by the community until much later. In the early 1970s, the implications of Gell-Mann and Low's work were made manifest by the work of Kenneth Wilson, who had received important insights from the work of condensed matter physicists attempting to explain phase transitions—in particular the work of Onsager, Widom, Kadanoff, and Fischer. Wilson's work made clear that renormalization was not a technical device to eliminate the divergences, "but rather is an expression of the variation of the structure of physical interactions with changes in the scale of the phenomena being probed" (Gross 1985b).

To understand the role played by the cutoff in defining the theory, consider QED (Lepage 1989). That theory is defined by the Lagrangian

$$\mathscr{L} = \bar{\psi}(i\gamma \cdot \partial - e_0 \gamma \cdot A - m_0)\psi - \tfrac{1}{2}F_{\mu\nu}F^{\mu\nu}$$

and by a regularization procedure with a cutoff Λ_0. What is the effect of removing from this theory all states having energies or momenta greater than some $\Lambda < \Lambda_0$—states in an energy region that are inaccessible to us and of whose properties we are ignorant? If we restrict ourselves to processes at energies much lower than Λ the answer is as follows: The removal of the states having energy above the cutoff Λ can be compensated by the addition to the Lagrangian of the following *local* terms:

$$\delta\mathscr{L} = -e_0 c_0\left(\frac{\Lambda}{\Lambda_0}\right)\bar{\psi}\gamma \cdot A\psi - m_0\tilde{c}_0\left(\frac{\Lambda}{\Lambda_0}\right)\bar{\psi}\psi,$$

where c_0 and \tilde{c}_0 are dimensionless "constants" which, to lowest order, can be computed from the vertex diagram and the electron self-energy diagram, respectively. They both depend logarithmically on Λ/Λ_0.

The theory with Lagrangian

$$\mathscr{L} + \delta\mathscr{L} = \bar{\psi}(i\gamma \cdot \partial - e_\Lambda \gamma \cdot A - m_\Lambda)\psi - \tfrac{1}{2}F_{\mu\nu}F^{\mu\nu} + \frac{e_\Lambda m_\Lambda c_1(\Lambda)}{2\Lambda^2}\bar{\psi}\sigma_{\mu\nu}F^{\mu\nu}\psi,$$

cutoff Λ and coupling parameters

$$e_\Lambda = e_0\left[1 + c_0\left(\frac{\Lambda}{\Lambda_0}\right)\right],$$

$$m_\Lambda = m_0\left[1 + \tilde{c}_0\left(\frac{\Lambda}{\Lambda_0}\right)\right]$$

gives the same results as the original theory with cutoff Λ_0 up to correction of order $1/\Lambda^2$. Note further that the $1/\Lambda^2$ term corresponds to a nonrenormalizable interaction.

Thus a change in the cutoff can be compensated by changing the bare coupling and mass in the Lagrangian, and this can be done in such a way that the low-energy physics of the theory is essentially unaffected. The parameters e_Λ and m_Λ vary as the cutoff is varied. The coupling is said to "run" as more or fewer of the states are included in the cutoff theory. The equations

$$\Lambda\frac{de_\Lambda}{d\Lambda} = \beta(e_\Lambda),$$

$$\Lambda\frac{dm_\Lambda}{d\Lambda} = m_\Lambda\gamma_m(e_\Lambda)$$

governing the change are called the renormalization group equations.

The cut-off theory is accurate only up to corrections of order p^2/Λ^2 where p is typical of the external momenta. In practice such errors may be negligible, but if one wishes to remove them there are two options. The traditional one is to let Λ go to infinity. The second is to keep Λ finite and to add further terms to the Lagrangian to compensate for them. Power counting and dimensional analysis indicate that only a few processes are affected to this order and therefore only a finite number of terms need be added to the Lagrangian. These (nonrenormalizable) terms appear with a coefficient of $(1/\Lambda)^{\text{power}}$, and will therefore be negligible, if only low-energy processes are considered.[3]

No theory that one is likely to study will actually be renormalizable because basically no theory is likely to be complete. However, the physics

that is observed at accessible energies (of order E) can to a very good approximation [i.e., by neglecting terms of $O[(E/\Lambda)^2]$ described by a renormalizable effective field theory, in which the interaction terms are finite in number and limited in complexity. In the effective field theory— the one that essentially any theory reduces to at sufficiently low energies —the nonrenormalizable interaction terms are all suppressed by powers of one over the cutoff. "Thus the only interactions that we can detect at ordinary energies are those that are renormalizable in the usual sense, plus any nonrenormalizable interactions that produce effects which although tiny, are somehow exotic enough to be seen" [Weinberg (1980b)]. It should be emphasized that an effective theory description is an approximate one, valid to some degree of approximation. Note also that a representation of physics by effective field theories is one that keeps close track of the experimental situation and is delimited by it.

Once one accepts nonrenormalizable interactions the key issue in addressing a theory like quantum electrodynamics "is not whether it is or is not renormalizable, but rather how renormalizable is it?" How large are the nonrenormalizable interactions in the theory? What range of energy scales are well described by the degrees of freedom that one keeps in the theory? Renormalizability has to do with the range in energy over which theory is valid [Lepage (1989)].

Old fashioned QED is a low-energy approximation to some high-energy "supertheory." Consequently there will be some large energy scale beyond which QED is insufficient to describe nature. What that "correct" theory is not known. The unknown physics is excluded by introducing a cutoff equal to the scale at which the new physics enters. The correct theory does affect low-energy phenomena, but it does so only through the value of the coupling constants that appear in the cut-off Lagrangian.

Note that the coupling constants cannot be calculated until the correct theory valid at energies of the order Λ is discovered; the coupling constants must be experimentally determined.

The above mode of description and explanation is in fact characteristic of most of physics. A physical system generally has a number of length scales, with each length scale described by a different set of laws (e.g., for liquids hydrodynamics at the macroscopic level, quantum mechanics at the atomic level, and so forth) (Wilson 1979). To each separate length scale belongs a separate set of parameters needed to describe the physics —e.g., the density and Reynolds' number for hydrodynamics, the electric

charges and masses of electrons and nuclei for the atomic scale. The parameters needed for a description at a given length scale are determined from the parameters for the next smaller length. Moreover, one need not know all the parameters governing yet smaller lengths. (For example, the effects of the nuclear and subnuclear levels are already contained in the parameters of that used at the atomic level). As Wilson has noted: "In general, events distinguished by a great disparity in size have little influence on one another; they do not communicate, and so the phenomena associated with each scale can be treated independently.... The success of almost all practical theories in physics depends on isolating some limited range of length scale" (Wilson 1979). But there exists a class of phenomena, e.g., the behavior of a simple substance near its critical point and a class of representations, e.g., local field theories with dimensionless coupling constants, where events at many scales of length make contributions of equal weight. Wilson's important and seminal work on the renormalization group (see in particular Wilson 1979, 1983) has clarified why the field theoretical "representation" of the physical world in hierarchical levels works.

The concept of effective field theory also clarifies how a quantum theory can assume different forms at different scales. "Old fashioned" QED is an effective field theory that is approximately valid at long distances. At distances of the order of the electron Compton wavelength, the only particles that need be taken into account are the electron and the photon. All other charged particles are heavier. When one is probing distances of the order of the Compton wavelength of the electron, there is not enough energy to produce these heavier particles and one therefore does not have to consider them. The neutrino and the graviton—the other particles that could enter into the description—are so weakly coupled at these energies that they too can be neglected. Of course, this description is only valid to some degree of approximation. If experiments of sufficiently high precision were performed one would find, even at low energies, the effect of the μ meson.

If one accepts the approach of effective field theories in its most extreme version, one can associate each elementary particle Compton wavelength with a boundary between two effective theories. For distances greater than its Compton wavelength the particle is omitted from the theory, while for shorter distances it is included. The connection between the parameters in the two effective theories on either side is

determined so that the description of the physics just below the boundary (where no heavy particles can be produced) is the same in the two effective theories. These matching conditions are calculated with the renormalization scale equal to the mass of the boundary particle in order to eliminate large logs (Georgi 1989).

These results allow one to look at the situation in two ways. The first takes the viewpoint that quantum field theory will ultimately yield a fundamental theory. If a complete renormalizable theory at infinitely short distances were available, one would be able to work one's way up to the effective theory at any larger distance in a totally systematic way by integrating out the heavy fields of the theory (Appelquist and Carazzone 1975; Ovrut and Schnitzer 1980, 1981; Weinberg 1980). One would in this way obtain a tower of nonrenormalizable interactions, each with fewer particles and more small nonrenormalizable interactions than the last. When the heavy particle masses are large, the effective theory is approximately renormalizable; the nonrenormalizable terms are of order $(m/M)^2$; m the mass of the light particle described by the effective theory and M that of the heavy particle.

The second way of looking at the situation corresponds more closely to what high-energy theorists actually do in practice. The long distance scales that are probed first and each member of the tower is built up only as it becomes relevant to the understanding of the physics. On this view, the renormalizable theory at short distances is not assumed known; in fact, whether it exists at all is not relevant. In this approach, the requirement of renormalizability is replaced by the requirement that the nonrenormalizable interactions in the effective theories be suppressed by appropriate powers of (E/Λ). In the extreme version of this viewpoint there is nothing fundamental about quantum field theory. Quantum field theory by itself has no content: it is merely a very efficient and effective formalism that allows one to calculate the most general scattering amplitudes that obey the axioms of S-matrix theory. Those committed to this viewpoint justify their position by quoting a folk theorem[4] that claims that "any theory that satisfies the axiom of S-matrix theory, and contains only a finite number of particles with mass below some M, will at energy below M look like a quantum field theory involving just those particles" (Weinberg 1986a).

Irrespective of the viewpoint adopted, or how one's metaphysics polarizes the answer to such questions as: Is the tower endless? Does the

effective quantum field theory eventually break down? The insights of the effective field theory approach have greatly clarified why the description at any one level is so stable. Moreover, as Georgi has stressed, the beauty of effective field theory language is that "whatever happens at short distances, it does not affect what we actually do to study the theory at distances we can probe" (Georgi 1989). Finally, the renormalization group methods have shown that the renormalizable couplings vary only logarithmically with distance. It is therefore not so strange that the concept of the local field, originally discovered in macroscopic phenomena, should continue to apply to distances smaller by 30 orders of magnitude. But for the methods to apply, it is important that the divergences removed by the renormalization procedures be at most logarithmically divergent. Only gauge theories whose bosons are initially massless and acquire mass through a spontaneously broken symmetry have this property.

5.5. The Ebb and Flow of Reductionism

The successes of the standard model of the electroweak and strong interactions has been very impressive. These theories, when interpreted as effective field theories, have lent support to a positivistic and antireductionist viewpoint. The physical world could be considered as layered into quasiautonomous domains, each layer having its ontology and associated laws. A considerable number of high-energy physicists have adopted such a stance, thus rejecting Einstein's vision that

The supreme test of the physicist is to arrive at those universal elementary laws from which the cosmos can be built up by pure deduction.

Einstein was advocating a radical form of theory reductionism. In his "Autobiographical Notes," Einstein was even more explicit (Einstein 1949):

I would like to state a principle, which cannot be based upon anything more than a faith in the simplicity, i.e., intelligibility, of nature; that is to say, nature is so constituted that it is possible logically to lay down such strongly determined laws that within these laws only rationally, completely determined constants occur (not constants, therefore, whose numerical values could be changed without destroying the theory).

Although the majority of elementary particle physicists probably held similar views until the mid-1970s, this was not the case for "many-body"

physicists. Philip Anderson, one of the foremost condensed matter physicists, asserted (Anderson 1972) that

the reductionist hypothesis does not by any means imply a "constructionist" one: The ability to reduce everything to simple fundamental laws does not imply the ability to start from those laws and reconstruct the universe. In fact, the more the elementary particle physicists tell us about the nature of the fundamental laws, the less relevance they seem to have to the very real problems of the rest of science, much less to those of society. The constructionist hypothesis breaks down when confronted with the twin difficulties of scale and complexity.

Anderson believes in emergent laws. He holds the view that each level has its own "fundamental" laws and its own ontology. But it is not enough to know the fundamental laws at a given level. It is the solutions to equations, not the equations themselves that provide a mathematical description of the physical phenomena. Emergence refers to properties of the solutions. Translated into the language of particle physicists, Anderson would say each level has its effective Lagrangian and its sets of particles. Although there are suggestive indications of how to relate one level to another, there is no way to infer from this the complexity and novelty that can emerge through composition. The properties of solutions are not readily apparent from the equations. The formulation of the strong interactions as a nonabelian gauge theory can be considered a fundamental description. But to go from that description to an effective chiral Lagrangian to describe low-energy pion–nucleon scattering, or to deduce from it the binding energy of the deuteron and explain why it is so small presents enormous difficulties, that reflect the fact that ascertaining the properties of the solutions of the fundamental equations—to say nothing of obtaining actual solutions—is a very difficult mathematical task involving delicate limiting procedures (judging from some of the exact results obtained for phase transitions in various dimensions).

Anderson, and similarly inclined positivists among the particle physicists, e.g., Georgi, would say that in each level the effective Lagrangians are the best we can do. When particle theorists explore the consequences of the $SU_3 \times SU_2 \times U_1$ standard model their work is not more fundamental than what Anderson does exploring the consequences of the Schrödinger theory for condensed matter physics. Note: positivism leads to intellectual democracy.

There are, of course, reductionists left among particle physicists.[5] In 1984 David Gross explicitly embraced Einstein's views regarding the

possibility of ascertaining and formulating unique laws of nature (Gross 1985b):

This (Einstein's) is a marvelous statement of the ultimate goal of fundamental physics—the motivating force behind the bootstrap and unified theory alike.

He added: "It is a rather arrogant goal and a recent one in the history of physics," and indicated that he found support for this view from the uniqueness of QCD, referring "not to the fact that it seems to be uniquely singled out by experiment but rather to the fact that it contains essentially no adjustable parameters."

At the present time those physicists who share Einstein views can be identified by their commitment to string theory. Here is the recently stated credo of Gell-Mann (1985):

I'm delighted that, during the last decade or more, an old prediction of mine has been confirmed; that particle physics and cosmology would essentially merge into one field, the field of fundamental physics, which underlies all of natural science. In our attempts to understand the basic structure of the universe, we theorists of fundamental physics, even though our day-to-day labors are often frustrating and petty like everyone else's, are engaged in a magnificent quest, along with our experimental friends, for a kind of Holy Grail; a universal theory. Will it prove as elusive as the Holy Grail? Will there be a Lancelot who almost grasps it? A Galahad to whom it is fully revealed? Whether or not we achieve the quest, each time we slay a dragon or rescue a maiden along the way, each splendid adventure is an accomplishment in itself; like the writing of a poem or a symphony, part of the soaring of the human spirit.[6]

Perhaps the most thoughtful and measured statement regarding reductionism in the light of the recent advances comes from Steve Weinberg (1987):

In all branches of science we try to discover generalizations about nature, and having discovered them we always ask why are they true. I don't mean why we believe they are true, but why are they true. Why is nature that way? When we answer this question the answer is always found partly in contingencies, that is, partly in just the nature of the problem that we pose, but partly in other generalizations. And so there is a sense of direction in science, that some generalizations are explained by others....

... There are arrows of scientific explanation, that thread through the space of all scientific generalizations. Having discovered many of these arrows, we can now look at the pattern that has emerged, and we notice a remarkable thing: perhaps the greatest scientific discovery of all. These arrows seem to converge to a common source! Start anywhere in science and, like an unpleasant child, keep asking "why?" You will eventually get down to the level of the very small.

In testimony before Congress in support of the SSC, Weinberg stated:

There is reason to believe that in elementary particle physics we are learning
something about the logical structure of the universe at a very very deep level.
The reason I say this is because as we have been going to higher and higher
energies and as we have been studying structures that are smaller and smaller we
have found that the laws, the physical principles become simpler and simpler. I
am not saying that the mathematics gets easier, Lord knows it doesn't. I am not
saying that we always find fewer and fewer particles in our list of elementary
particles. What I am saying is that the rules that we have discovered become
increasingly coherent and universal. We are beginning to suspect that this isn't
an accident of the particular problems that we have chosen to study at this
moment in the history of physics but there is a simplicity, a beauty that we are
finding in the rules that govern matter that mirrors something that is built into
the logical structure of the universe at a very deep level. I think this kind of
discovery is something that is going on in our present civilization at which future
men and women and not just physicists will look back with respect.

Weinberg's view is what has been called constitutive reductionism.
There is no explicit claim at being able to reconstruct the world. How-
ever, one commitment all theorists share—whether they be extreme re-
ductionists like Gross or more positivistically inclined like Georgi or
Anderson—is that they all believe in constitutive reductionism.

In some sense, I believe that we have witnessed a severe blow being
delivered to (crude) reductionism. The only camp holding on to their
belief in complete reductionism, and of physics as the search for a funda-
mental equation from which the world can be *deduced*, are the theorists
who believe that salvation lies in strings and superstrings (see, e.g., Sch-
wartz 1987).[7] Rarely, in the recent past has overt metaphysics so obvi-
ously driven research programs. It may of course be the case that the
"strong" form of reductionism will regain favor in the future. For the time
being the challenge for the historian is to try to understand the role
played by context, culture, politics, and by the day-to-day necessities of
life in altering the views of a community that previously considered an
extreme form of reductionism so integral to its metaphysics.[8]

The role of the culture is difficult to ascertain and I will not comment
on it. But one last observation is appropriate. The tug of war going on
between condensed matter physicists like Anderson and high-energy
physicists like Gross within the physics community is for its soul. On the
one side are those like the late Leon Van Hove, the former head of the
theoretical physics division at CERN, who believed "that the elucidation

of the fundamental laws remains the most essential task of physics" and who believe that physicists must not allow this endeavor, the mainstream of physics, to be diverted, despite the ever-increasing cost of the instruments that are required to accomplish the task.

"Fundamental laws" may mean something different to Van Hove, Gross, and Georgi but they are all in agreement about what the mainstream of physics ought to be. John Ziman gave the most succinct statement of the other side (Ziman 1974):

> In the education of a physicist, we recount the bold voyages of the great explorers —Newton and Einstein, Faraday and Bohr—in search of new laws of nature. They found and charted the continents on which we have built our cities of the mind and of art. Does anyone really suppose that similar vast and fertile territories are still waiting to be discovered and colonized?... The unaccustomed rules that govern black holes and quasars in the cosmic deeps affect our lives no more than the icy crabs of the Himalayas or the conjunction of the planets....
>
> ... Think of physics simply as the fundamental science and it is oversubscribed almost to bankruptcy. But define it as the science whose aim is to describe natural phenomena in the most mathematical or numerical language, and you will understand its past and have confidence in its future.... The task of the modern physicist is to determine the mathematically comprehensible characteristics of the natural world and of human artifacts.

Notes

1. Thus nonrelativistic quantum mechanics came to be seen as correctly describing that domain of nature delineated by Planck's constant h: Any system whose characteristic length (l), mass (m) and time (t) were such that the product ml^2/t was of the order of h, and such that $1/t$ was much smaller than c, the velocity of light, was quantum mechanical and was to be described by the new nonrelativistic quantum mechanics.

2. It is interesting to note the parallel between the field-theoretic advances of the post-World War II period with those of the late 1960s. At the end of the 1950s the failure of field-theoretic approaches to give quantitative accounts of the strong interactions, the nonrenromalizability of the Fermi theory of the weak interactions, and the proliferation of the number of "elementary particles" (each requiring its own field) had given rise to pessimism and led to the rejection of quantum field theory. Dispersion relations and Chew's S-matrix program were born out of this disillusionment with quantum field theory. But S-matrix theory proved too intractable and could not make much contact with experiments, except for the initial successes of forward dispersion relations and those of Regge pole phenomenology (Cushing 1982, 1990; Weinberg 1985a; Cao 1991).

In the early 1970s progress was once again due to a handful of individuals: Wilson, Weinberg, Veltman, 't Hooft, Benjamin Lee, Callan, Symanzik, and a few others, and again the advances were technical and conservative. First, 't Hooft proved that Weinberg's earlier conjecture that a spontaneously broken gauge theory of electroweak interactions was renormalizable was indeed correct. At the same time t'Hooft, Gross, Politzer, and Wilczeck unravelled the short distance behavior of Yang–Mills gauge theories, thus laying the foundations for a field theoretical description of the strong interactions in terms of gluons and quarks. With these works came an understanding of the physics of renormalization that greatly clarified the structure of quantum field theory and elucidated the nature of field theoretic descriptions.

The divergences of quantum electrodynamics are logarithmic, of the form $\log \Lambda_0/m$, where Λ_0 is the large momentum at which the theory is cut off and m the mass of the electron. Now

$$\log \Lambda_0/m = \log \Lambda_0/\mu + \log \mu/m,$$

where μ is a dimensional parameter. When the logarithmic divergence is absorbed by the redefinition of one of the parameters in the theory, the rest of the logarithm remains. Renormalization introduces a dimensional parameter that sets the scale of the logarithm. In the initial formulation of the renormalization program (Dyson 1949a, b) μ was set equal to m. In fact its value can be adjusted arbitrarily. Although arbitrary in principle some renormalization scales will be more convenient than others because of the presence of $\log \mu/m$ or $\log q/m$ terms, where q is a characteristic momentum for the process under consideration. The choice of μ is usually determined by the masses and momenta in the process under consideration; μ is so chosen as to minimize the $\log \mu/m$ and $\log q/m$ terms and thereby improve the behavior of the perturbation theory.

S. Coleman and E. Weinberg (1973) realized that because the renormalization scale μ has been introduced, the physics of massless QED is determined by a dimensional parameter. Moreover, since the dimensionless coupling constant is a function of the renormalization point, it must be of the form

$$e^2_{\text{eff}}(\mu) = f(\mu/\mu_0)$$

with μ_0 a fixed dimensional parameter. The dependence of $e^2_{\text{eff}}(\mu)$ on μ is determined by the theory, so that f is some computable function. The trading of the dimensionless parameter that occurs in the original Lagrangian for a dimensional one was called dimensional transmutation by Coleman and Weinberg. [In their preprint the phenomenon was called dimensional transvestism. The editor of *Physical Review* objected and it was renamed dimensional transmutation.] In QED the effective coupling constant is of the form

$$e^2_{\text{eff}}(\mu) = d/\log(\mu/\mu_0).$$

The sign of d is a crucial quantity. In QED, d is negative. Since $e^2_{\text{eff}} > 0$, QED makes sense only for $\mu_0 > \mu$: it is the small distance behavior that is bad. In

QCD (which is a Yang–Mills gauge theory in which the gluons interact with themselves)

$$e_{\text{eff}}^2(\mu) = b/\log(\mu/\mu_0)$$

with b positive. The theory therefore only makes sense for $\mu > \mu_0$: at small distances the theory is a free field theory (asymptotic freedom). Asymptotically free theories may in fact contain no infinities. Their bare, or zero distance, coupling constants do not diverge but rather vanish. Only when one attempts to express physics at finite distances in terms of the parameters at zero distance do divergences occur.

3. The most elegant analysis has been given by Polchinski who has shown that at energies above Λ nothing much need be said about how the physics is represented: the theory could be another field theory, or even something as yet not specifiable. Just below the cutoff the theory is represented by a very general Lagrangian in which the various interaction terms have coefficients of the order Λ to the appropriate power to make the dimensions correct. Only some of these terms give rise to renormalizable interactions; most of the terms give rise to nonrenormalizable interactions, with coefficient of Λ to negative powers.

The following is then found when describing the physics at energy E far below Λ (Polchinski 1984):

The nonrenormalizable terms, those with coefficients of Λ to negative powers, typically give contributions that are suppressed by powers of Λ. This is true unless the nonrenormalizable term is embedded in a Feynman graph sufficiently divergent to make up for the small coefficient. Power counting shows that the only n-point functions sufficiently divergent are those which would be divergent even if they contained only renormalizable interactions.... However the latter divergences can be reabsorbed in redefinitions of the renormalizable couplings. Thus to accuracy E/Λ the entire effect of the nonrenormalizable terms can be absorbed in the initial values of the renormalizable ones, and all quantities can be calculated in the resulting effective field theory with renormalizable interactions only.

Taking the cutoff seriously also indicates why renormalization actually works. Wilson's insight was to consider what happens as the cutoff is smoothly lowered. As this is done the effective Lagrangian changes (Polchinski 1984):

The effective Lagrangian at lower scales is given in terms of its form at a given scale, and its change with scale is governed by a scaling or renormalization group equation. Typically, as [one] scales down to smaller momenta, the Lagragian converges toward a finite-dimensional submanifold in the space of possible Lagrangians. That is, the scaling transformation has only a finite number of nonnegative eigenvalues, with deviations in the orthogonal directions damped as [one] travels to low momenta. These orthogonal directions are therefore termed "irrelevant." In the zero coupling limit, the negative, irrelevant, eigenvalues correspond precisely to the nonrenormalizable interactions. Since there is nothing discontinuous about the scaling transformation as the couplings are changed, those eigenvalues which were negative at zero coupling should remain negative at sufficiently small coupling. This is equivalent to renormalizability.

4. A folk theorem, according to Wightman, is one which is generally known to be true although it has not been proved (Weinberg 1986b).
5. See in particular the Dirac Memorial lecture that Steve Weinberg delivered in 1986. Weinberg (1986b).
6. The rhetoric and the particular metaphors used by Gell-Mann will not escape the careful reader.
7. Part of the reason for the opposition to string theory by the more empirically inclined theorists is that the new physics would probably only be seen at or near the Planck scale, which is some 18 orders of magnitude from anything measurable at present.
8. The adoption of the effective field point of view was given a strong boost when high-energy theorists were marshalling their arguments to justify the construction of the SSC and the need for the next generation of electron–positron collider. The standard model, regarded as an effective field theory, indicated that new physics connected with the Z and W masses must appear at energies of the order of a TeV. In any case, it is clear that you cannot justify the SSC if you believe that there is a desert with no new physics until you reach the Planck scale.

References

Anderson, P. W. (1972), "More is different," *Science* **177**, pp. 393–396.
Appelquist, T. and J. Carazzone (1975), "Infrared singularities and massive fields," *Phys. Rev. D* **11**, pp. 2856–2861.
Born, M., W. Heisenberg, and P. Jordan (1926), "Zur quantemmechnik. II," *Z. Phys.* **35**, pp. 557–615.
Bromberg, Joan (1976), "The concept of particle creation before and after quantum mechanics," *Hist. Stud. Phys. Sci.* **7**, pp. 161–191.
Bromberg, Joan (1977), "Dirac's quantum electrodynamics and the wave particle equivalence," in *History of Twentieth Century Physics. Proc. Int. School of Physics*, "Enrico Fermi" Course LVII, C. Weiner, ed., New York: Academic.
Brown, L. M. (1981), "Yukawa's prediction of the meson," *Centaurus* **25**, pp. 71–132.
Brown, L. M. (1985), "How Yukawa arrived at the meson theory," *Progr. Theor. Phys.* **85**, pp. 13–19.
Cao, T. Y. (1991), "The Reggeization program 1962–1982: Attempts at reconciling quantum field theory with S-matrix theory," *Arch. Hist. Exact Sci.* **41**, 239–283.
Cassidy, D. C., "Cosmic ray showers, high-energy physics, and quantum field theories," *Hist. Stud. Phys. Sci.* **12**, pp. 1–39.
Coleman, S. and E. Weinberg (1973), "Radiative corrections as the origin of symmetry breaking," *Phys. Rev. D* **7**, pp. 1888–1910.
Coleman, S. (1986), *Secret Symmetry*, Cambridge: Cambridge University Press.
Cushing, J. (1982), "Models and methodologies in current theoretical high-energy physics," *Synthèse* **50**, pp. 5–101.

Cushing, J. T. (1990), *Theory Construction and Selection in Modern Physics: The S-Matrix Theory*, Cambridge: Cambridge University Press.

Darrigol, O. (1988), "The quantum electrodynamical analogy in early nuclear theory or the roots of Yukawa's theory," *Rev. Hist. Sci.* **41**, pp. 226–297.

Dirac, P. A. M. (1927a), "The quantum theory of the emission and absorption of radiation," *Proc. R. Soc. London Ser. A* **114**, pp. 243–265.

Dirac, P. A. M. (1927b), "The quantum theory of dispersion," *Proc. R. Soc. London Ser. A* **114**, pp. 710–728.

Dirac, P. A. M. (1929), "Quantum mechanics of many-electron systems," *Proc. R. Soc. London Ser. A* **126**, pp. 714–723.

Dirac, P. A. M. (1930a), "A theory of electrons and protons," *Proc. R. Soc. London Ser. A* **126**, pp. 360–365.

Dirac, P. A. M. (1930b), *Quantum Mechanics*, 1st ed., (Oxford: Oxford University Press).

Dresden, M. (1985), "Reflections on 'Fundamentality and Complexity'," in *Physical Reality and Mathematical Description*, C. P. Enz and J. Mehra, eds., Dordrecht: Reidel, pp. 133–166.

Dyson, F. J. (1949a), "The radiation theories of Tomonaga, Schwinger, and Feynman," *Phys. Rev.* **75**, pp. 486–502.

Dyson, F. J. (1949b), "The S matrix in quantum electrodynamics," *Phys. Rev.* **75**, pp. 1736–1755.

Dyson, F. J. (1951), "The renormalization method in quantum electrodynamics," *Proc. R. Soc. London Ser. A* **207**, pp. 395–401.

Dyson, F. J. (1952), "Divergence of perturbation theory in quantum electrodynamics," *Phys. Rev.* **85**, pp. 631–632.

Einstein, A. (1949), "Autobiographical notes," in *Albert Einstein: Philosopher—Scientist*, P. A. Schilpp, ed., Evanston: The Library of Living Philosophers.

Fermi, E. (1934), "Versuch einer theorie der β-strahlen. I," *Z. Phys.* **88**, pp. 161–171.

Feynman, R. P. (1966), "The development of the space-time view of quantum mechanics. Nobel lecture, *Science* **1966**, pp. 699–708.

Feynman, R. P. (1948b), "A relativistic cutoff for classical electrodynamics," *Phys. Rev.* **74**, pp. 939–946.

Feynman, R. P. (1948c), "Relativistic cutoff for quantum electrodynamics," *Phys. Rev.* **74**, pp. 1430–1438.

Feynman, R. P. (1949a), "The theory of positrons," *Phys. Rev.* **76**, pp. 749–768.

Feynman, R. P. (1949b), "The space-time approach to quantum electrodynamics," *Phys. Rev.* **76**, pp. 769–789.

Feynman, R. P. (1966), "The development of the space-time view of quantum mechanics. Nobel lecture," *Science* **1966**, pp. 699–708.

Galison, P. (1983), "The discovery of the muon and the failed revolution against quantum electrodynamics," *Centaurus* **26**, pp. 262–316.

Gell-Mann, M. and F. Low (1954), "Quantum electrodynamics at small distances," *Phys. Rev.* **95**, pp. 1300–1312.

Gell-Mann, M. (1985), "From renormalizability to calculability?," in *Shelter*

Island II, R. Jackiw, N. N. Khuri, S. Weinberg, and E. Witten, eds., Cambridge, MA: MIT Press.

Georgi, H. (1989), "Effective quantum field theories," in *The New Physics*, Paul Davies, ed., Cambridge: Cambridge University Press, pp. 4446–4457.

Gross, D. (1985a), "Beyond quantum field theory," in *Recent Developments in Quantum Field Theory*, J. Ambjorn, B. J. Durhuus, and J. L. Petersen, eds., New York: Elsevier.

Gross, D. (1985b), "On the uniqueness of physical theories," in *A Passion for Physics*, C. DeTar, J. Finkelstein, and Chug-I. Tan, eds., Singapore: World Scientific.

Kinoshita, Toichiro (1990), *Quantum Electrodynamics*, Singapore: World Scientific.

Lamb, W. E. Jr. and R. C. Retherford (1947), "Fine structure of the hydrogen atom by a microwave method," *Phys. Rev.* **72**, pp. 241–243.

Lepage, G. Peter (1989), "What is renormalization?" preprint, CLNS, 89/970. Newman Laboratory of Nuclear Studies, Cornell University.

Lewis, H. W. (1948), "On the reactive terms in quantum electrodynamics," *Phys. Rev.* **73**, pp. 173–176.

Nafe, J. E., E. B. Nelson, and I. I. Rabi (1947), "The hyperfine structure of atomic hydrogen and deuterium," *Phys. Rev.* **71**, pp. 914–915.

Ovrut, B. and H. Schnitzer (1981a), "The decoupling theorem and minimal subtractions," *Phys. Lett. B* **100/5**, pp. 403–406.

Ovrut, B. (1981b), "Effective field theories and higher dimension operators," *Phys. Rev. D* **24**, pp. 1695–1698.

Pais, A. (1986), *Inward Bound*, New York: Oxford University Press.

Polchinski, P. (1984), "Renormalization and effective Lagrangian," *Nucl. Phys. B* **231**, pp. 269–295.

Schwartz, J. H. (1987), "Superstrings," *Physics Today* **40/11**, pp. 33–40.

Schweber, S. S. (1986a), "Shelter Island, Pocono, and Oldstone: The emergence of American quantum electrodynamics after World War II," *Osiris* (Second Series) **2**, pp. 265–302.

Schweber, S. S. (1986b), "Feynman and the visualization of space-time processes," *Rev. Mod. Phys.* **58**, pp. 449–508.

Schwinger, J. (1948a), "On quantum electrodynamics and the magnetic moment of the electron," *Phys. Rev.* **73**, pp. 416–417.

Schwinger, J. (1948b), "Quantum electrodynamics. I. A covariant formulation," *Phys. Rev.* **74**, pp. 1439–1461.

Schwinger, J. (1951), "On the Green's functions of quantized field. I," *Proc. Natl. Acad. Sci. U.S.A.* **37**, pp. 452–459.

Schwinger, J. (1973), "A report on quantum electrodynamics," in *The Physicist's Conception of Nature*, (J. Mehra, ed., Reidel, Dordrecht), pp. 413–429.

Schwinger, J. (1983), "Renormalization theory of quantum electrodynamics: An individual view," in *The Birth of Particle Physics*, L. M. Brown and L. Hoddeson, eds., Cambridge: Cambridge University Press, pp. 329–353.

Stückelberg, E. C. G. and A. Peterman (1953), "La normalisation des constantes dans la theorie des quanta," *Helv. Phys. Acta* **26**, pp. 499–520.

Symanzik, K. (1970), "Small distance behavior in field theory and power count-ing," *Commun. Math. Phys.* **18**, pp. 227–246.

Tomonaga, S. (1946), "On a relativistically invariant formulation of the quantum theory of wave fields," *Progr. Theor. Phys.* **1**, pp. 27–42.

Tomonaga, S. (1965), "Development of quantum electrodynamics," in *Nobel Lectures (Physics): 1963–1970*, Amsterdam: Elsevier, pp. 126–136.

Weinberg, S. (1960), "High energy behavior in quantum field theory," *Phys. Rev.* **118**, pp. 838–849.

Weinberg, S. (1967), "A model of leptons," *Phys. Rev. Lett.* **19**, pp. 1264–1266.

Weinberg, S. (1977), "The search for unity: Notes for a history of quantum field theory," *Deadalus*, Fall 1977, Vol. II of *Discoveries and Interpretations in Contemporary Scholarship*.

Weinberg, S. (1979), "Phenomenological Lagrangian," *Physica A* **96**, pp. 327–340.

Weinberg, S. (1980a), "Conceptual foundations of the unified theory of weak and electromagnetic interactions," *Rev. Mod. Phys.* **52**, pp. 515–524.

Weinberg, S. (1980b), "Effective gauge theories," *Phys. Lett. B* **91**, pp. 51–55.

Weinberg, Steven (1983), "Why the renormalization group is a good thing," in *Asymptotic Realms of Physics: Essays in Honor of Francis E. Low*, A. H. Guth, K. Huang, and R. L. Jaffe, eds., Cambridge, MA: MIT Press.

Weinberg, Steven (1985a), "The ultimate structure of matter," in *A Passion for Physics: Essays in Honor of Geoffrey Chew*, C. DeTar, J. Finkelstein, and C. I. Tan, eds., Singapore: World Scientific.

Weinberg, Steven (1985b), "Calculation of fine structure constants," in *Shelter Island II*, Cambridge, MA: MIT Press.

Weinberg, Steven (1986a), "Particle physics: Past and future," *Int. J. Mod. Phys. A* **1/1**, pp. 135–145.

Weinberg, Steven (1986b), "Towards the final laws of physics," in *Elementary Particles and the Laws of Physics. The 1986 Dirac Memorial Lectures*, Cambridge: Cambridge University Press.

Weinberg, Steven (1987), "Newtonianism, reductionism and the art of congressional testimony," Talk at the Tercentenary Celebration of Newton's *Principia*. University of Cambridge, 30 June 1987.

Wentzel, G. (1943), *Einführung in der Quantentheorie der Wellenfelder*, Wein: Franz Deuticke.

Wilson, K. G. (1965), "Model Hamiltonians for local quantum field theory," *Phys. Rev. B* **140**, pp. 445–457.

Wilson, K. G. (1969), "Non-Lagrangian models of current algebra," *Phys. Rev.* **179**, pp. 1499–1512.

Wilson, K. G. (1970a), "Operator-product expansions and anomalous dimensions in the Thirring model," *Phys. Rev. D* **2**, pp. 1473–1477.

Wilson, K. G. (1970b), "Anomalous dimensions and the breakdown of scale invariance in perturbation theory," *Phys. Rev. D* **2**, pp. 1478–1493.

Wilson, K. G. and J. Kogut (1974), "The renormalization group and the ε expansion," *Phys. Rep. C* **12**, p. 131.

Wilson, K. G. (1975), "The renormalization group: Critical phenomena and the Kondo problem," *Rev. Mod. Phys.* **47**, pp. 773–840.

Wilson, K. B. (1979), "Problems in physics with many scales of length," *Sci. Am.* **241**, pp. 158–179.

Wilson, K. G. (1983), "The renormalization group and critical phenomena," *Rev. Mod. Phys.* **55**, pp. 583–600.

Ziman, J. M. (1974), *Phys. Bull.* **25**, pp. 280–285.

Historical Remarks on the Renormalization Group

Dmitri V. Shirkov

To the memory of N. Bogoliubov

A.1. History of RG in Quantum Field Theory

A.1.1. Renormalization and Renormalization Invariance

As is known the systematic formalism for subtracting ultraviolet (UV) divergences in QFT was developed on the basis of covariant perturbation theory at the end of the 1940s. This achievement is connected with the names of Tomonaga, Feynman, Schwinger, and some others. In particular, Dyson and Salam performed a general analysis of the structure of divergences in arbitrarily high orders of perturbation theory. However, a number of subtle questions related to so-called overlapping divergences in the scattering matrix and boundary divergencies discovered by Stueckelberg[o1] in the Tomonaga–Schwinger equation remained unsolved for some time.

An important contribution, based on careful analysis of the mathematical origin of the UV divergences, was made by Bogoliubov. This was achieved with the help of a new branch of mathematics, the theory of *generalized functions* of Sobolev and Schwartz. The point is that in local QFT, propagators are generalized functions, like the Dirac delta function, and products of them are not, in general, well-defined. UV divergences are a direct counterpart of the ambiguities of such products for coincident space-time arguments.

On this basis, in the mid-1950s Bogoliubov and his disciples developed a technique of redefining products of Stueckelberg–Feynman propagators[o2] and proved the theorem[o3] that the scattering matrix is finite and (for renormalized theories) unique in arbitrary order of perturbation theory. The prescriptive part of this renormalization theorem, *Bogoliubov's R operation*, has served up to now as a practical means for obtaining finite, unique results in perturbative QFT calculations.

The method of *R* operation is the following. To get rid of UV divergencies, instead of introducing some regularization, e.g., a momentum cutoff, and manipulating infinite counterterms, it is sufficient to redefine divergent Feynman integrals by subtracting from them some polynomials in the external momenta, which in the simplest case reduce to the first few terms in the Taylor series expansion of the integral. Uniqueness of the calculations is ensured by imposing some conditions on the divergence-free, i.e., finite results of the calculations. These conditions contain some degrees of freedom[1] that can be used to regulate relations between the

Lagrangian parameters (masses, coupling constants) and the physical ones. That physical predictions do not depend on this arbitrariness, i.e., *renormalization invariance*, forms the conceptual base of the renormalization group.

The attractive feature of this approach is that it is free from unphysical auxiliary entities, like bare masses, couplings, and regularization parameters, which are completely avoided performing the calculation. The whole picture can be considered as a *renormalization without regularization and counterterms*.

A.1.2. The Birth of the Renormalization Group[P1–P3]

The Renormalization Group (RG) approach in theoretical physics has been known since the middle of the 1950s. The RG itself was discovered in 1953 by Stueckelberg and Petermann[P1] as a group of transformations exploiting the finite arbitrariness arising in scattering matrix elements S after removal of ultraviolet divergences and expressed via some finite constants c_i:

We must expect that a group of infinitesimal operations $P_i = (\partial/\partial c_i)_{c=0}$ exists, satisfying

$$P_i S = h_{i_e}(m, e) \partial S(m, e, \ldots)/\partial e,$$

thus admitting a *renormalization of e*.

These authors introduced a *group of normalization* given by infinitesimal operations P_i (i.e., as a Lie group) connected with coupling constant e renormalization.

In the next year Gell-Mann and Low,[P2] by manipulating with Dyson renormalization transformations written down in a regularized form, obtained functional equations for QED propagators in the UV limit. For example, for the renormalized photon propagator transverse amplitude d they got an equation in the form

$$d\left(\frac{k^2}{\lambda^2}, e_2^2\right) = \frac{d_C(k^2/m^2, e_1^2)}{d_C(\lambda^2/m^2, e_1^2)}, \qquad e_2^2 = e_1^2 d_C(\lambda^2/m^2, e_1^2) \qquad \text{(A.1)}$$

with λ the cut-off momentum and e_2 the physical electron charge. The appendix to their paper contains a general solution (by T. D. Lee) of this functional equation for the photon amplitude $d(x, e^2)$ written in two equivalent forms:

$$e^2 d(x, e^2) = F[xF^{-1}(e^2)]$$

and

$$\ln x = \int_{e^2}^{e^2 d} \frac{dx}{\psi(x)} \tag{A.2}$$

with

$$\psi(e^2) = \frac{\partial(e^2 d)}{\partial \ln x} \qquad \text{at } x = 1.$$

The solution (A.2) provides the means for qualitative analysis of a short-distance behavior of electromagnetic interaction in terms of ψ properties. In Ref. P2 two possibilities were discussed: infinite or finite charge renormalization:

Our conclusion is that the **shape** *of the charge distribution surrounding a test charge in the vacuum does not, at small distances, depend on the coupling constant except through the scale factor. The behavior of the propagator functions for large momenta is related to the magnitude of the renormalization constants in the theory. Thus it is shown that the unrenormalized coupling constant* $e_0^2/4\pi\hbar c$, *which appears in perturbation theory as a power series in the renormalized coupling constant* $e_1^2/4\pi\hbar c$ *with divergent coefficients, may behave either in two ways:*
 It may really be infinite as perturbation theory indicates; or
 it may be a finite number independent of $e_1^2/4\pi\hbar c$.

The latter possibility corresponds to the case when ψ has a zero at some finite point[2] $\psi(\alpha_\infty) = 0$.

It is notable that Ref. P2 neither paid attention to the group nature of the analysis performed and the results obtained, nor mentioned Ref. P1. The authors also did not realize that the Dyson transformations they used were valid only for the case of the transverse gauge of electromagnetic field. Probably due to this, they did not succeed in correlating their results with standard perturbation theory calculations and did not discuss the ghost-trouble possibility.

The final step was made in 1955 by Bogoliubov and Shirkov (Ref. P3.)[3] Using the group properties of finite Dyson transformations for coupling constants and field function, they obtained group functional equations for QED propagators and vertices in the general (i.e., massive) case, e.g.,

$$d(x, y; e^2) = d(t, y; e^2)d\left[\frac{x}{t}, \frac{y}{t}; e^2 d(t, y; e^2)\right]$$

for the above-mentioned photon propagator amplitude (which also depends on, besides $x = k^2/\mu^2$, the mass argument $y = m^2/\mu^2$; μ being some reference momentum value). Here the term *renormalization group* and the notion of *invariant charge*[4] were introduced.

In modern notation the last equation[5] is just the equation for the effective electromagnetic coupling $\bar{\alpha}(x, y; \alpha = e^2) = \alpha d(x, y; \alpha)$:

$$\bar{\alpha}(x, y; \alpha) = \bar{\alpha}\left[\frac{x}{t}, \frac{y}{t}; \bar{\alpha}(t, y; \alpha)\right]. \tag{A.3}$$

By differentiating the functional equations, Bogoliubov and Shirkov first obtained differential group equations in the standard Lie (i.e., ordinary nonlinear) form like, e.g.,

$$\frac{\partial \bar{\alpha}(x, y; \alpha)}{\partial \ln x} = \beta\left[\frac{y}{x}, \bar{\alpha}(x, y; \alpha)\right] \tag{A.4}$$

and for the electron propagator amplitude $s(x, y; \alpha)$:

$$\frac{\partial s(x, y; \alpha)}{\partial \ln x} = \gamma\left[\frac{y}{x}, \bar{\alpha}(x, y; \alpha)\right] s(x, y; \alpha) \tag{A.5}$$

with

$$\beta(y, \alpha) = \frac{\partial \bar{\alpha}(\xi, y; \alpha)}{\partial \xi}, \qquad \gamma(y, \alpha) = \frac{\partial s(\xi, y; \alpha)}{\partial \xi} \qquad \text{at} \qquad \xi = 1,$$

that was the explicit realization of the differential equations mentioned above in the given quotation from Ref. P1. These results provided the conceptual relation between the Stueckelberg–Petermann and the Gell-Mann–Low approaches.

A.1.3. Creation of the RG Method in the Mid-1950s[P3–P5]

A second important contribution of Ref. P3 consisted in proposing a simple algorithm for improving an approximate perturbative solution by combining it with the Lie equations:[6]

Formulas (4) and (5) show that to obtain expressions for $\bar{\alpha}$ and s valid for all values of their arguments one has only to define $\bar{\alpha}(\xi, y, \alpha)$ and $s(\xi, y, \alpha)$ in the vicinity of $\xi = 1$. This can be done by means of the usual perturbation theory.

In the succeeding publication (Ref. P4), this algorithm was effectively used for the UV and infrared (IR) asymptotic analysis of QED in a transverse gauge. Here the one-loop

$$\bar{\alpha}_{RG}^{(1)}(x, 0; \alpha) = \frac{\alpha}{1 - (\alpha/3\pi)\ln x}, \tag{A.6}$$

and two-loop UV expressions

$$\bar{\alpha}_{RG}^{(2)}(x, 0; \alpha) = \frac{\alpha}{1 - (\alpha/3\pi)l + (3\alpha/4\pi)\ln[1 - (\alpha/3\pi)l]} \tag{A.7}$$

for the photon propagator as well as the IR asymptotic expression

$$s(x, y; \alpha) \simeq (x/y - 1)^{-3\alpha/2\pi} = (p^2/m^2 - 1)^{-3\alpha/2\pi}$$

for the QED spinor propagator amplitude were obtained.

At that time these expressions at one-loop level were known from the results of the Landau group. It should be noted here that in the middle of the 1950s the problems of UV asymptotic behavior in local QFT were quite topical. At that time an essential progress in QED short-distance analysis was achieved by Landau and co-workers[O4] by solving some approximate version of the Schwinger-Dyson equations involving only two-point functions (i.e., dressed propagators) $\Delta_i(\ldots, \alpha)$ and the three-vertex function Γ (the so-called three-gamma equations). For these objects the authors succeeded in obtaining explicit asymptotic expressions for QED propagators that (in modern language) sum up leading UV logarithms.[7] However, the Landau approach gave no simple way to construct the next approximation.

The answer to this question was given by the newly born RG method. The simplest UV asymptotic results for QED propagators obtained in Ref. P4 like, e.g., Eq. (A.6), precisely corresponded to the results of the Landau group. In the RG approach this equation can be obtained by a few lines of calculation, starting from the one-loop perturbation expression

$$\bar{\alpha}_{PTh}^{(1)}(x, 0; \alpha) = \alpha + \frac{\alpha^2}{3\pi}l + \cdots \qquad \text{with} \qquad l = \ln x,$$

used as an input on the right-hand side of Eq. (A.4) for the group generator $\beta(0, \alpha) = \psi(\alpha)$ calculation.

However, if we start with the second-order, i.e., two-loop, perturbative input:

$$\bar{\alpha}_{PTh}^{(2)}(x, 0; \alpha) = \alpha + \frac{\alpha^2}{3\pi}l + \frac{\alpha^2}{\pi^2}\left(\frac{l^2}{9} + \frac{l}{4}\right) + \cdots$$

we arrive at the second RG approximation [Eq. (A.7)], corresponding to

the summation of the *next-to-leading* UV logarithms. This proves that the RGM is a regular method within which it is rather simple to estimate the region of validity of results obtained. This second-order RG expression [Eq. (A.7)] for effective coupling, first obtained in Ref. P4, contains nontrivial log-of-log dependence which is now well-known of the two-loop approximation for the QCD running coupling.

Quite soon this approach was formulated (Ref. P5), for a renormalizable QFT model with two coupling constants g and h; that is, of pion–nucleon interaction with pion self-interaction.[8] Here the coupled system of two functional equations:

$$\bar{g}^2(x, y; g^2, h) = \bar{g}^2\left[\frac{x}{t}, \frac{y}{t}; \bar{g}^2(t, y; g^2, h), \bar{h}(t, y; g^2, h)\right],$$

$$\bar{h}(x, y; g^2, h) = \bar{h}\left[\frac{x}{t}, \frac{y}{t}; \bar{g}^2(t, y; g^2, h), \bar{h}(t, y; g^2, h)\right]$$

was first obtained.

The corresponding system of nonlinear differential equations from Ref. P5 was used in Ref. P6 for UV analysis of the renormalized model of pion–nucleon interaction based on one-loop perturbative calculations. Thus in Refs. P3, P4 and P5 the RG approach was directly connected with the practical calculation of UV and IR singularities. From that time this technique, that is known under the name the Renormalization Group Method (RGM), became the only means for asymptotic analysis in local QFT.

A.1.4. Other Early Applications of RG

The first important theoretical application of the Renormalization Group technique was made (Ref. P7) in the discussion of a current issue for renormalized local QFT connected with the so-called *ghost-trouble problem* (also known as the "zero-charge" or "Moscow pole" trouble). This phenomenon, first found[O5,O6] in QED, was claimed[O6,O7] to be a proof of an inner inconsistency of QED, and later on, of local QFT in general. The RG analysis of the problem performed in Ref. P10 on the basis of Eq. (A.2) revealed that any inference based on finite order perturbation calculations cannot be considered as a complete proof. This conclusion precisely corresponds to the impression that can be drawn from comparing Eqs. (A.6) and (A.7). This result (in the mid-1950s) was of major importance,

as it restored among the experts the reputation of local QFT. Nethertheless during the next decade, the applicability of QFT to microparticle physics remained under suspicion in a wide theoretical community.

The RG analysis of QED was generalized for the arbitrary covariant gauge case by Logunov (Ref. P8). The point is that the charge renormalization transformation involves only the transverse part of the photon propagator. Due to this, in a nondiagonal (e.g., Feynman) gauge, the Dyson transformation is of a more complicated form. The author proposed to resolve this issue by treating the gauge parameter as a second coupling constant.

Ovsiannikov (Ref. P9) found the general solution of the functional RG equations in the massive case expressed as

$$\Phi(y, \alpha) = \Phi\left[\frac{y}{x}, \bar{\alpha}(x, y; \alpha)\right]$$

in terms of an arbitrary function of two arguments Φ, reversible in its second argument. In the course of his reasoning he used the differential group equations in the linear partial form

$$\left\{x\frac{\partial}{\partial x} + y\frac{\partial}{\partial y} - \beta(y, \alpha)\frac{\partial}{\partial \alpha}\right\}\bar{\alpha}(x, y; \alpha) = 0,$$

which are now known as the Callan–Symanzik equations.

These "pioneer period" results were summarized in a chapter *Renormalization Group* of the text monograph[R2(a)] first published in 1957 (which was then translated into English[R2(b)] and French[R2(c)]), and soon obtained the status of QFT folklore.

A.1.5. Further Development of RG in QFT

The subsequent decade represented a "rather quiet" period, during which there was practically no important conceptual advance in RG. One exception was the Weinberg paper (Ref. P10), where the idea of the fermion *running mass* was proposed. This can be related to the Ref. P8 viewpoint, and formulated as: Every parameter standing in the Lagrangian should be considered as a (generalized) coupling constant and appropriately treated in the RG approach. However, the results obtained in this new framework just repeated the old ones. For example, the most popular expression for the running fermion mass:

$$\overline{m}(x, \alpha) = m_\mu \left[\frac{\alpha}{\overline{\alpha}(x, \alpha)} \right]^\nu,$$

summing leading UV logs, was known for the electron mass operator in QED (with $\nu = 9/4$) since the mid-1950s (See Ref. P4.)[O4]

New possibilities for RG physical application in particle theory were opened up by the discovery[O8] of the short-distance (light-cone) operator expansion. The point is that the RG transformation, formulated as a Dyson transformation for the renormalized vertex function, involves the simultaneous rescaling of *all* its invariant (usually momentum squared) arguments. This makes it impossible, e.g., to study physical UV asymptotics (under which some of the momenta squared should be kept fixed on the mass shell). The Wilson trick of dividing/separating arguments of a multiargument function allows us to overcome this trouble in a number of physically important cases (Ref. P11).

The end of a quiet period was clearly marked by the year 1971 due to the application of the RGM technique to the new-born nonabelian gauge quantum fields, where the famous phenomenon of asymptotic freedom was discovered (Ref. P12). The one-loop RG expression for the QCD effective coupling $\overline{\alpha}_s$:

$$\overline{\alpha}_s^{(1)}(x, \alpha_s) = \frac{\alpha_s}{1 + (\beta_1/4\pi)\ln x},$$

due to the positivity of β_1, the one-loop perturbation coefficient has a remarkable UV asymptotic behavior. In contradistinction with Eq. (A.7), as $Q^2 \to 0$ it goes to zero. It is important to stress that this discovery technically became possible due to the use of the RGM method and should be considered as its most important physical application in particle physics.

A.2. RG in Critical Phenomena and Other Fields

A.2.1. Spin Lattices

K. Wilson succeeded (Ref. P13) in transferring the RG philosophy from the relativistic quantum field domain to quite another arena of modern theoretical physics, namely, the analysis of phase transition phenomena in spin lattice systems. This new version of RG was based upon Kadanoff's

trick[O9] of spin blocking (or "decimation") with simultaneous finite renormalization of a coupling constant.

To perform the blocking, one has to average over the block constituents. The procedure diminishes the number of degrees of freedom and simplifies the physical system, while preserving its long-range properties. However, this step is just the creation of another theoretical model for the same physical phenomena, based on preserving the long-range properties of a big statistical system.

To get, after averaging, a system formally similar to the initial system, one has to omit some terms in the new effective Hamiltonian, the terms that are unimportant for infrared properties. At the end of this Kadanoff–Wilson procedure we arrive at a new model system that formally differs by the elementary scale and the coupling constant value. One can repeat this blocking operation again and again to get a discrete set of models. Such a transition from one given model to another is, from a physical point of view, an approximate and nonreversible procedure. Hence the Renormalization Group here is physically approximate, and formally not a group but a semigroup.

This construction, evidently free from any connection with UV infinities, appeared to be much more physically transparent, and hence it was understandable to a broad theoretical audience. Due to this, quite rapidly in the course of the 1970s, the RG conception and algorithms were successfully transmitted into new theoretical fields like polymers (Ref. 14), noncoherent transfer phenomena, (Ref. 15) and others. However, besides the construction quite parallel to Kadanoff–Wilson blocking, in some important cases tighter connections with *the classical RG* of QFT, type have been established.

A.2.2. Turbulence

Turbulence has been done with the help of the functional integral representation. For example, the classic Kolmogorov-type turbulence problem was connected with the RG approach by the following steps (Ref. P16):

1. Define the generating functional for correlation functions.
2. Write for this functional the path integral representation.
3. Find the equivalence of the classical statistical system to some quantum field theory.
4. Construct the Schwinger–Dyson equations for this equivalent QFT.

5. Apply the Feynman diagram technique and perform the finite renormalization procedure.

6. Write down the standard RG equations and use them to find fixed point and scaling behavior.

The physics of renormalization transformation in the turbulence problem is related to a change of UV cutoff in the wave-number variable.

A.2.3. Paths of RG Expansion

We see that the RG has expanded in diverse fields of physics in two different ways: (1) the direct analogy with Kadanoff–Wilson construction (averaging over some set of degrees of freedom) in polymers, noncoherent transfer, and percolation; i.e., constructing a set of models for a given physical problem. (2) Search for the exact RG symmetry directly or by proof of the equivalence with QFT: e.g., in turbulence (Ref. P16), plasma turbulence (Ref. P17), and phase transition (based upon the continuous spin-field model).

What is the nature of the symmetry underlying the Renormalization Group?

a. In QFT the RG symmetry is an *exact symmetry of a solution* formulated in its natural variables.

b. In turbulence and some others, it is a *symmetry of an equivalent QFT model*.

c. In polymers, percolation, etc. (with Kadanoff–Wilson blocking), the RG transformation is an operation involving transitions between different auxiliary models (especially constructed for this purpose). Here one has to define an ordered set \mathcal{M} of models M_i.

The RG transformation is

$$R(n)M_{(i)} = M_{(n-i)},$$

relating different models. Thus the RG symmetry "exists" only inside this set \mathcal{M} of models.

Let us also make a comment about the mathematical difference between different renormalization groups. In QFT the RG is an exact continuous symmetry group. On the other hand, in critical phenomena, polymers and some other similar cases (with *averaging* operation) it is

an approximate, discrete semigroup. We should add that in dynamical chaos theory, where some people use RG ideas and terminology,[R13] the functional iterations do not form any group at all. Sometimes researchers in these fields use rather different formulations and terminology. Such expressions as "real-space RG," "Wilson RG," "dynamic RG," "Monte Carlo RG," and "RG chaos" are in use.

However the positive answer to the question "Are there different renormalization groups?" implies only just differences formulated between cases (a), (b), and (c).

A.2.4. Two Faces of RG in QFT

As was mentioned above in Sec. A.1.1, an important notion in QFT is the invariance with respect to renormalization ambiguity, i.e., renorminvariance. This implies that physical results are independent of the choice of renormalization scheme and of reference momentum value. The latter just corresponds to the symmetry underlying the RG. However, the RG transformation in QFT can be formulated in two different ways.

An essential feature of QFT is the presence of virtual states and virtual transitions. In QED, e.g., the processes of virtual transition of a photon into an electron–positron pair and vice versa can take place. This process of vacuum polarization leads to several specific phenomena, and particularly to the notion of effective charge. In classical electromagnetism, a test electric charge in the polarizable medium attracts adjacent opposite sign charged particles so that the charge is partially screened. In QFT, the vacuum, i.e., the interparticle space itself, stands for the "polarizable medium." Due to the vacuum fluctuation the charge is screened. It was first shown by Dirac in 1933[09] in momentum space that the Q^2 dependence of an electron charge is given by

$$e(Q^2, \Lambda^2) = e_0 \left\{ 1 + \frac{\alpha_0}{6\pi} \ln \frac{Q^2}{\Lambda^2} + \cdots \right\}, \tag{A.8}$$

expressed here in terms of the bare electron charge $e_0 = \sqrt{\alpha_0}$ and of Λ, the cutoff momentum.

The first approach of using the RG idea in this problem was done by Stüeckelberg and Peterman (Ref. P1). In their pioneering investigation the RG transformations were introduced rather formally within the renor-

malization of an infinities procedure, the result of which contains finite arbitrariness. Just this "degree of freedom" in *finite renormalized* expressions was used by Bogoliubov and Shirkov (Ref. P3). Roughly speaking, this corresponds to the change ($\Lambda \to \mu$) of the degree of freedom parameter. Instead of Eq. (A.8) we now have the "finite representation"

$$e(Q^2, \mu^2) = e_\mu \left\{ 1 + \frac{\alpha_\mu}{6\pi} \ln \frac{Q^2}{\mu^2} + \cdots \right\} \qquad (A.9)$$

with $e_\mu = \sqrt{\alpha_\mu}$ being a physical electron charge, as measured at $Q^2 = \mu^2$. Here, the RG symmetry is formulated in terms of the Q scale and μ represents the reference point.

Another picture was used by Gell–Mann and Low. In their paper the short-distance behavior in QED was analyzed using the "Λ degree of freedom." In this approach the electron charge is given by the "singular representation" [Eq. (A.8)].

We can draw a physically simple picture (as can be extracted from Wilson's Nobel lecture) to this approach. Effectively one can imagine an electron of finite size, smeared over a small volume with radius $R_\Lambda = \hbar/c\Lambda$, $\ln(\Lambda^2/m_e^2) \gg 1$. The electric charge of such a nonlocal electron is considered as depending on the cut-off momentum Λ so that this dependence accumulates the vacuum polarization effects which take place at distances from the point electron smaller than R_Λ. We have the set of models with nonlocal electrons possessing electric charge $e_i = \sqrt{\alpha_i}$ correponding to the different values of the cutoff Λ_i.

Here, α_i depends on R_i and the vacuum polarization effects in the excluded volume R_i^3 should be subtracted. In this picture the RG transformation can be imagined as a transition from one value of the smearing radius $R_i = \hbar/c\Lambda_i$ to another R_j, simultaneously with a corresponding change of the effective electron charge value

$$e_i \equiv e(\Lambda_i) \to e_j = e_i \left(1 + \frac{\alpha_i}{6\pi} \ln \frac{\Lambda_j^2}{\Lambda_i^2} + \cdots \right)$$

that can be obtained from Eq. (A.8). In other words, the RG symmetry here is the symmetry of operations in the space of models of nonlocal QED, constructed in such a way that at large distances every model is equivalent to the real local one. It is correct to say that the Renormalization Groups in the two approaches are different from each other.

A.2.5. Functional Self-Similarity or Synthesis

An attempt to analyze the relation between these formulations, based on general and simple grounds, was undertaken about 10 years ago (Ref. P18). As was shown there, it is possible (see also our review papers R7, R8, and R15 to discuss all these different faces of RG in general terms of mathematical physics.

Generally, the symmetry underlying the RG can be discussed with the help of a one-parameter continuous transformation R_t for two quantities x and g, written down in the form

$$R_t: \{x \to x' = x/t, g \to g' = \bar{g}(t,g)\}. \qquad (A.10)$$

Here x is a basic variable that undergoes the scaling transformation and g some physical quantity that transforms in a more complicated functional way.

To form a group, the transformation R_t should satisfy the composition law

$$R_t R_\tau = R_{t\tau}$$

that yields the functional equation for \bar{g}:

$$\bar{g}(x,g) = \bar{g}\left[\frac{x}{t}, \bar{g}(t,g)\right]. \qquad (A.11)$$

This is just the functional equation (A.3) for the effective coupling in QFT for the massless case, i.e., at $y = 0$. It is also completely equivalent to the Gell-Mann–Low functional equation (A.1). Thus we see that the RG functional equation has no other content but the group composition law.

In physical problems the second argument g of the RG transformation is usually the boundary value of some dynamical function, i.e., of some solution to problem considered. This means that the symmetry underlying the RG approach is just the symmetry of the solution (not of the equation!) of a given physical system, involving a transformation of boundary condition parameters.

For illustration imagine some one-argument solution $f(x)$ that can be fixed by the boundary condition $f(x_0) = f_0$. Represent this given solution formally as a function of boundary parameters as well: $f(x) = f(x, x_0, f_0)$. (This step is equivalent to an *embedding* operation.) The RG transformation then corresponds to the changeover of the way of parameterization

of the given solution, say from $\{x_0, f_0\}$ to $\{x_1, f_1\}$. In other words, the argument x value at which the boundary condition is given does not need to be x_0, but we may choose another point x_i. Suppose now that the function f can be written as $F(x/x_0, f_0)$ with a property $F(1, \gamma) = \gamma$. The following equality:

$$F\left(\frac{x}{x_0}, f_0\right) = F\left(\frac{x}{x_1}, f_1\right),$$

depends on the fact that under such change of a boundary condition the form of the function itself is not modified.[9] Noting $f_1 = F(x_1/x_0, f_0)$, and in terms of $\xi = x/x_0$ and $t = x_1/x_0$, we obtain $F(\xi, f_0) = F[\xi/t, F(t, f_0)]$, equivalent to Eq. (A.11). The group operation can now be defined quite analogously to Eq. (A.10):

$$R_t: \{\xi \to \xi/t, f_0 \to f_1 = F(t, f_0)\}.$$

Hence in the simplest case, the renormalization group can be defined as a continuous one-parameter group of specific transformations of some solution to the physical problem, a solution that is fixed by its boundary value. The RG transformation involves boundary condition parameters and corresponds to the change in the way of imposing those conditions for *the same* solution.

Partial transformations of this kind have been known for a long time. Suppose that function F is a power function of the first argument, i.e., has a form $F(z, f) = fz^k$, k being a number. In this case the group transformation takes the form

$$P_t: \{z \to z' = z/t, f \to f' = ft^k\}.$$

That is well-known in mathematical physics as a self-similarity transformation. This transformation P_t can be related to as a power self-similarity transformation and the more general one R_t as a *functional self-similarity* (FSS) transformation (Ref. P18).

A.3. Summary

Now we can answer the question about the physical nature of the symmetry underlying the functional self-similarity and renorm-group transformations. Consider first the case when RG is equivalent to FSS. As was

explained it is **not** a symmetry either of a physical system or of equation(s) of a given problem, but rather the symmetry of solution(s) considered as a function of essential physical variables and of appropriate boundary value(s). It can be defined as an invariance property of some physical quantity, expressed by such a solution, with respect to the way of imposing boundary conditions. Changing of this way is just the group operation, and generally the group property in this context can be considered as a transitivity property of such operations.

Let us also note here that the important underlying property of a physical system is its homogeneity. However, it can be broken by a discrete way. Suppose that this discrete inhomogeneity can be related to some value of the x variable, say $x = y$. For this case, the RG transformation would be written down in the form

$$R_t: \{x' = x/t, y' = y/t, g \to g' = \bar{g}(t, y; g)\}.$$

The group composition law now precisely yields the functional equation (A.3).

Hence the FSS symmetry is a very simple and usual property in physical phenomena. It can be "discovered" in varied and numerous problems of mathematical and theoretical physics: e.g., in classical mechanics, radiation transfer, classical hydrodynamics, and so on.[R7,R10] Quite recently there appeared interesting attempts (Refs. 19 and 20) to use the RG = FSS technology in problems of classical mathematical physics, in particular for solving nonlinear differential equations.

On the other hand, in the "Kadanoff–Wilson case" it is a symmetry inside a set of models constructed to describe some physical phenomena, a symmetry exploiting the way these models are parameterized. Let us also note that the RG Method is a regular method of improving approximate solutions by its "marriage" with group symmetry. The RGM is effective in the case of solutions with singularity as far as it retains the correct singularity structure.

Acknowledgments. It is a pleasure to thank Professor Laurie Brown and Doctor Helmut Rechenberg for stimulating discussions and useful advices. The support of Ludwig-Maximilian-University.in Munich, where this paper has been completed, is also acknowledged.

Notes

1. These degrees of freedom correspond to different momentum scales and to a variety of renormalization schemes.
2. α_∞ being the so-called fixed point of RG transformation.
3. See also the review paper R1 that was published in English in 1956.
4. That is now widely used under the name of effective or running coupling constant.
5. In the massless case $y = 0$ it is equivalent to the Gell-Mann–Low Eq. (1).
6. This quotation from the review paper R1, that follows the Russian original text of Ref. P3, is given here in the usual modern notation.
7. These results were obtained in an arbitrary covariant gauge.
8. Here it is essential, that for renormalizability of Yukawa PS–PS πN interaction $\sim g$ it is necessary to add the quartic pion self-interaction with an independent, i.e., second, coupling constant h. This point was not quite well understood at that time—compare the given equations with Eqs. (4.19)'–(4.21)' in Ref. P2 or with Eqs. (21)–(24) in Ref. O7.
9. As, e.g., in the case of $F(x, \gamma) = \Phi(\ln x + \gamma)$.

References

ORIGINAL PAPERS CONTRIBUTING TO RG

P1. Stueckelberg, E. C. G. and A. Petermann (1953), "La normalisation des constantes dans la theorie des quanta", *Helv. Phys. Acta* **26**, pp. 499–520.
P2. Gell-Mann, M. and F. Low (1954), "Quantum electrodynamics at small distances", *Phys. Rev.* **95**, pp. 1300–1312.
P3. Bogoliubov, N. N. and D. V. Shirkov (1955), "On the Renormalization Group in quantum electrodynamics", *Dokl. AN SSSR* **103**, pp. 203–206 (in Russian), see also the review paper R1.
P4. Bogoliubov, N. N. and D. V. Shirkov (1955), "The RG application to the improvement of perturbation theory results" **103**, pp. 391–394 (in Russian), see also R1.
P5. Shirkov, D. V. (1955), "Two-coupling RG in the pseudoscalar meson theory," *Dokl. AN SSSR* **105**, pp. 972–975 (in Russian), see also R1.
P6. Ginzburg, I. F. (1956), *Dokl. AN SSSR* **110**, p. 535 (in Russian), see also exposition of this paper in the text monograph R2.
P7. Bogoliubov, N. N. and D. V. Shirkov (1955), *Dokl. AN SSSR* **105**, pp. 685–688 (in Russian), see also the exposition of this paper in R2.
P8. Logunov, A. A. (1956), *Zh. Eksp. Theor. Phys.* **30**, pp. 793–794 (in Russian), see also R2.
P9. Ovsiannikov, L. V. (1956), *Dokl. AN SSSR* **109**, pp. 1112–1115 (in Russian), see also R2.
P10. Weinberg, S. (1973), *Phys. Rev. D* **8**, p. 3497.
P11. Altarelli, G. and G. Parisi (1977), *Nucl. Phys. B* **126** p. 298.

P12. Gross, D. and P. Wilczek (1973), *Phys. Rev. D* **8** p. 3633; Politzer, H. (1973), *Phys. Rev. Lett.* **30**, p. 1346.

P13. Wilson, K. (1971), "RG and critical phenomena," *Phys. Rev. B* **4**, pp. 3174–3183.

P14. De Gennes, P. G. (1972), *Phys. Lett. A* **38**, p. 339; de Cloiseaux, J. (1975), *J. Phys. (Paris)* **36**, p. 281, see review R4.

P15. Bell, T. L. et al. (1978), "RG approach to noncoherent radiative transfer," *Phys. Rev. A* **17**, pp. 1049–1057; Chapline, G. F. (1980), *Phys. Rev. A* **21**, p. 1263.

P16. DeDominicis, C. and P. Martin (1979), *Phys. Rev. A* **19**, pp. 419–422; Adjemian, L., A. Vasiljev, and M. Gnatich (1984), *Teor. Mat. Fiz.* **58**, p. 72; **65**, p. 196, see also R14.

P17. Pelletier, G. (1980), *J. Plasma Phys.* **24**, p. 421.

P18. Shirkov, D. V. (1982), "Renormalization Group, invariance principle, and functional self-similarity," *Sov. Dokl.* **263**, pp. 64–67; see also Shirkov, D. V. (1984), in *Nonlinear and Turbulent Processes in Physics*, R. Z. Sagdeev, ed., New York: Harwood, vol. 3, pp. 1637–1647.

P19. Goldenfeld, N., O. Martin, and Y. Oono 1990, "Intermediate asymptotics and Renormalization Group theory," *J. Sci. Comput. U.S.A.* **4** pp. 355–372.

P20. Kovalev, V. F., S. V. Krivenko, and V. V. Pustovalov, "The RG method based on group analysis", in R12, pp 300–314.

REVIEW PAPERS AND BOOKS ON RG THEORY

R1. Bogoliubov, N. N. and D. V. Shirkov (1956), "Charge Renormalization Group in quantum field Theory", *Nuovo Cimento.* **3**, 845–863.

R2a. Bogoliubov, N. N. and D. V. Shirkov, *Vvedenie v Teoriu Kvantovannych Polej*, four Russian, Nauka: Moscow, 1957, 1973, 1976, 1984.

R2b. Bogoliubov, N. and D. Shirkov, *Introduction to the Theory of Quantized Fields*, two American editions, New York: Wiley, 1959, 1980.

R2c. Bogolioubov, N. N. and D. V. Shirkov, *Introduction á la Theorie des Champes Quantique*, Paris, Dunod.

R3. Wilson, K. and J. Kogut (1974), "The RG and the ε expansion," *Phys. Rep. C* **12**, pp. 76–199.

R4. De Gennes, P. G. (1979), *Scaling Concepts in Polymer Physics*, Ithaca: Cornell. University Press.

R5. Hu, B. (1972), "Introduction to real-space RG ...," *Phys. Rep.* **91**, pp. 233–295.

R6. Oono, Y. (1985), *Adv. Chem. Phys.* **61**, p. 301.

R7. Shirkov, D. V. (1988), "Renormalization Group in modern physics," *Int. J. Theor. Phys. A* **3**, pp. 1321–1341 and pp. 1–32 in R12.

R8. Zinn-Justin, J. (1978), *Quantum Field Theory and Critical Phenomena*, Oxford: Clarendon.

R9. Belokurov, V. V. and D. V. Shirkov (1991), *The Theory of Particles Interactions*, New York: American Institute of Physics, see Chap. 3.

R10. Shirkov, D. V. (1992), *Renormalization Group in Different Fields of Theoretical Physics*, KEK Report 91–13 (Feb).

R11. *Renormalization Group, Proceedings of* 1986 *Dubna Conference*. D. Shirkov, D. Kazakov, and A. Vladimirov, eds., Singapore: World Scientific, 1988.

R12. *Renormalization Group '91, Proceedings of* 1991 *Dubna Conference*, D. V. Shirkov and V. B. Priezzhev, eds., Singapore: World Scientific, 1992.

R13. Chirikov, B. V. and D. L. Shepelansky, "Chaos border and statistical anomalies," in R11, pp. 221–250.

R14. Vasiliev, A. N., in R11, pp. 146–159.

R15. Shirkov, D. V., in R12, pp. 1–10.

OTHER RELATED PUBLICATIONS

O1. Stueckelberg, E. C. G. (1951), *Phys. Rev.* **81**, p. 130; Stueckelberg, E. C. G. and J. Green (1951), *Helv. Phys. Acta* **24**, p. 153.

O2. Bogoljubov, N. N. and D. V. Schirkow (1955, 1956), *Fortschr. Phys.* **3**, pp. 439–495; **4**, pp. 438–517 and, especially, the chapter "Singular functions and regularization" in R2.

O3. Bogoliubov, N. N. and O. S. Parasiuk (1955, 1957), *Dokl. AN SSSR* **100**, pp. 25, 429; *Acta Math.* **97**, 227; also see the chapter "*Removal of divergencies from S matrix*" in R2.

O4. Landau, L. D. et al. (1954), *Dokl. AN SSSR* **95**, pp. 497–499, 773–776, 1117–1120; **96**, pp. 261–264 (in Russian), see also the English review paper O7.

O5. Fradkin, E. S. (1955), *JETP* **28**, p. 750 (in Russian).

O6. Landau, L. D. and I. Ia. Pomeranchuck (1955), *Dokl. AN SSSR* **102**, p. 499 (in Russian), see also O7.

O7. Landau, L. D. (1955), "On the quantum theory of fields," in *Niels Bohr and the Development of Physics*, W. Pauli et al, London: Pergamon, pp. 52–69.

O8. Wilson, K. (1969), *Phys. Rev.* **179**, pp. 1499–1515.

O9. Kadanoff, L. (1966), *Physica* **2**, p. 263.

O10. Dirac, P. A. M. (1934), in *Theorie du Positron*, 7-eme Conseil du Physique Solvay, Paris: Gautier-Villars, pp. 437–465.

Name Index